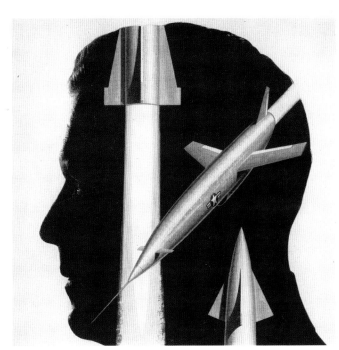

ANOTHER SCIENCE FICTION
ADVERTISING THE SPACE RACE 1957–1962

Megan Prelinger

ANOTHER SCIENCE FICTION
ADVERTISING THE SPACE RACE 1957–1962

ANOTHER SCIENCE FICTION © 2010 Megan Prelinger

page 1: Detail, page 72
pages 2–3: Detail, Texas Instruments ad, *Fortune*, December 1957
page 5: Detail, Grove Valve and Regulator Company ad, *Aviation Week*, April 18, 1960
pages 6–7: Detail, Hoffman Electronics Corporation ad, *Aviation Week*, April 13, 1959
page 240: Detail, Goodyear Aircraft ad, *Aviation Week*, October 21, 1957

Blast Books gratefully acknowledges the generous help of
Dwayne Day, Donald Kennison, Scott Pace, and Ken Siman.

Library of Congress Cataloging-in-Publication Data
Prelinger, Megan Shaw.
 Another science fiction : advertising the space race 1957–1962 / Megan Prelinger.
— 1st ed.
 p. cm.
 Includes bibliographical references and index.
 ISBN 978-0-922233-35-9
1. Astronautics—Social aspects—United States—History—20th century. 2. Space
race—United States—History. 3. Astronautics in mass media. 4. Astronautics in
art. I. Title.
 TL789.8.U5P74 2010
 629.40973'09045—dc222009046413

Published by Blast Books, Inc.
P. O. Box 51, Cooper Station
New York, NY 10276-0051
www.blastbooks.com

Edited and designed by Laura Lindgren

Printed in China

10 9 8 7 6 5 4 3 2 1

Dedicated to Z., *sine qua non.*

INTRODUCTION

"Inflatable space hotels are now in orbit!"
"Water has been found on Mars!"
"A new lunar base is under development!"
"Invisible wars are being conducted in space!"

Teaser lines of yesterday's sci-fi pulps? No, today's news. The interplay between the real and the imagined in space is as dynamic in the twenty-first century as in the days of Flash Gordon. Today's breakthroughs are only the most recent wave of rapid technological development and geographic expansion into space.

The human desire to reach into space extends far back in time. Literature of the eighteenth and nineteenth centuries expressed that wish in a handful of novels featuring space travel and imagined technologies. Mary Shelley, Jules Verne, and H. G. Wells were among the writers who invented a new literary genre: science fiction. As industrialization radically altered the contours of nineteenth-century life, some writers imagined it would allow the conquest of outer space. In the first half of the twentieth century science fiction evolved into a medium for exploring dreams and anxieties about technology, society, and the future. Space became the realm in which authors strove to portray and understand the rapid changes that were occurring in all three dimensions.

Science fiction flourished in 1920s and '30s pulp magazines such as *Amazing Stories* and *Astounding Stories*, in tales exploring utopian and dystopian daydreams of technologically enhanced life. Space adventures anchored these magazines, and their vivid cover illustrations, characterized by semi-realistic, semi-surrealistic figurative paintings and drawings, coalesced into a distinct visual style.

OVERLEAF PRECEDING: Hoffman Electronics recruitment ad. *Aviation Week*, April 13, 1959

OPPOSITE: Willi K. Baum's illustration for Martin depicts the astronaut on his upward journey.
Aviation Week, April 11, 1960

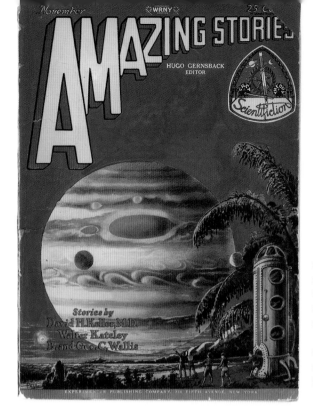

LEFT: Capturing stories in midstride, the covers of magazines such as *Amazing Stories* and *Astounding Stories* familiarized readers with the look of chunky rockets, Earthlike foreign planets, lunar bases, and tentacled space aliens. Artist: Frank R. Paul, November 1928

OPPOSITE: The finned rocket became dissociated from war and reassociated with the grand adventure of space. This is the image that drove space-related advertising. *Aviation Week*, December 21, 1959

The technological eruption of the mid-twentieth century associated with World War II once again abruptly changed the industrialized world. Tools developed in service of war threw open the doorways of possibility. The atom and the rocket motor, weapons of mass destruction during the war, aroused in some a postwar potential akin to the possible futures envisioned in the pulps. Synthetics and plastics and new gadgetry featuring miniaturization and automation, new materials designed for the war effort, percolated into everyday life in the 1950s. Because its landscape and infrastructure were largely untouched by the war's devastations, the United States was better able than the rest of the world to take advantage of these postwar developments. The contours of daily life shifted shape once again and science fiction literature entered a heyday.

Times were changing too for three sectors of American society in particular: the military, research science, and industry. The military was responding to the new cold war, a sharp turn in geopolitics following the very hot World War II. The development of the rocket motor during World War II had enabled massive destruction, and it also poised postwar military engineering to pursue a more sophisticated device: missiles. Militarized through two world wars, research science had lost some of its civil standing, and scientists were eager in the 1950s to transform the fruits of war into peaceful research yields. To that end they engaged a broad spectrum of space-related scientific and engineering investigations. Private industry built the products of both military and civil-scientific research, and in a few years all three sectors made strides into new phases of space-oriented research and development.

Concurrently, science fiction writing mushroomed in the 1950s. New magazines appeared everywhere, and suddenly real-life journeys into space seemed possible, even inevitable. Space became a real place in the popular cultural imagination. By the mid-1950s science fiction and technological development were on a convergent course.

Doorway to space With man's metal messengers orbiting beyond the moon, man himself cannot be far behind. His thin-skinned carrier will contain myriad parts and assemblies, each with watch-like precision less tolerant of error than anything before.

Ex-Cell-O's corporate family specializes in this kind of accuracy. For more than 35 years Ex-Cell-O has contributed pioneering ideas, precise parts and assemblies—first to the aircraft industry and now the soaring rocket and missile field. If your program is on the threshold of the Doorway to Space, Ex-Cell-O design, development, and manufacturing may provide the key to the precision needed on the other side of the moon.

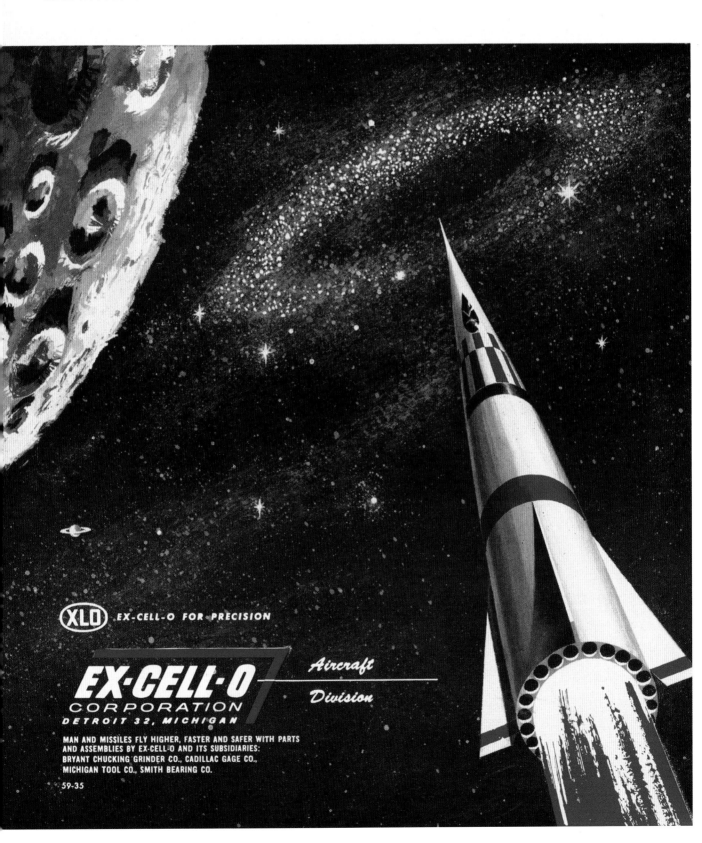

(XLO) EX-CELL-O FOR PRECISION

EX-CELL-O
CORPORATION
DETROIT 32, MICHIGAN

Aircraft
Division

LEFT: "Nonfiction" space books, too, romanticized our future in lunar bases and Martian colonies; some like Frank Tinsley's book published in 1958 even borrowed the look and feel of the pulps. Authors, including scientists, writers, and engineers as prominent as Arthur C. Clarke, became professional space popularizers and cultural personalities.

OPPOSITE: Established in 1924, *Aviation Week* (renamed *Aviation Week & Space Technology* in 1960) was the premier aircraft industry trade weekly magazine, with articles about flight engineers, designers, pilots, manufacturers, and aircraft-related politics during its early decades. In the 1950s it nimbly incorporated the booming missile industry into its mission. In 1956 *Missiles and Rockets* began publication as a competitor to *Aviation Week*.

PAGES 16–17: Marquardt Aircraft Company recruitment ad. *Aviation Week*, February 23, 1959

Prewar graphic depictions of space and space exploration were created by science fiction illustrators and a handful of technical space artists. Imagined interplanetary rockets resembled everything from submarines to the 1938 Cadillac. Following the war, the finned tail of the German V-2 rocket dominated in ideas of what interplanetary rockets would look like. As military engineers adapted the V-2, it was also popularized in a wave of films such as *Destination Moon* (1950), comics such as Hergé's Tintin adventure series also called *Destination Moon* (1953), and books for children and young adults about space exploration. The finned rocket became more than an icon of war—it became an icon for the grand exploration of space.

In October 1957 the USSR took the world by surprise with the launch of *Sputnik 1*, the first satellite. Space abruptly became *real*. And urgent. Science fiction boomed, and across the country in drafting rooms, machine shops, and laboratories another response was building: a new industrial world. Space would become more than an arena for postwar research; it would be the next big business. President Eisenhower declared space a national priority, and in spring 1958 Congress passed the National Aeronautics and Space Act, declaring the United States a spacefaring nation. Prior to Sputnik America's early space initiatives were accomplished through the army, air force, and navy. But the efforts of these defense agencies were largely underfunded and widely dismissed as "science fiction." Space had been a mere footnote for the military. After Sputnik, meeting the USSR's technological accomplishment became a mandate. At the same time, the cultural turn toward civilian-driven space-directed research demanded a new agency to host a new civil space program. In the summer of 1958 the National Aeronautics and Space Administration (NASA) was created out of its much smaller predecessor, the National Advisory Committee for Aeronautics (NACA).

The turn toward space in military engineering, civil science, and private industry created a bustling locus for space-related activity. Two trade magazines, *Aviation Week* and

October 28, 1957 75 Cents

AVIATION WEEK
A McGRAW-HILL PUBLICATION

NATO Finishes
Fighter Trials
•
Tracking Camera
Follows ICBM

Missile Tracker's Moon Photograph

This Issue:
ELECTRONICS AND GUIDANCE

missiles and rockets
INCLUDING MISSILE ELECTRONICS
MAGAZINE OF WORLD ASTRONAUTICS
AN AMERICAN AVIATION PUBLICATION
FEBRUARY 1958

Missiles and Rockets, chronicled the booming new sector of industry. *Missiles and Rockets* was more freewheeling than *Aviation Week* (later *Aviation Week & Space Technology*). In *Missiles and Rockets*'s flagship issue, October 1956, publisher Wayne W. Parrish wrote:

> This is the age of astronautics. This is the beginning of the unfolding of the era of space flight. This is to be the most revealing and the most fascinating age since man first inhabited the earth.... The visionaries who long ago dreamed of the conquest of space have been succeeded by scientists and industrialists who have transformed a fantasy into a vast and important industry.... Shortly the first satellite vehicles will be hurtled aloft by powerful rockets to bring back the known from the unknown.

At its inception NASA had an annual budget of just $100 million a year, only half of which was earmarked for space projects,[1] but by 1960 it had risen to $802 million.[2] Between 1958 and 1962 government funding earmarked for the civil space program grew fantastically. By 1962 the budget had doubled to $1.7 billion.[3] The national defense budget too was climbing to fund the missile race against the USSR. Companies whose research or production were applicable to this new field scrambled to compete for contracts. Well-established Douglas Aircraft was already engaged in space research in the 1940s through RAND, its research and development division, later the RAND Corporation. Lockheed Aircraft, closely allied with the air force, had built airplanes since the teens as had Martin Aircraft, and both were well positioned. These titans of industry— now Lockheed Martin—today form the industrial backbone of U.S. geopolitical influence, but in the 1950s they were just two aircraft companies reinventing their mission. In the advertising pages of *Aviation Week* and *Missiles and Rockets* they were joined by dozens of other smaller companies (see pages 14–15) each pursuing a slice of the new fiscal pie.

Recruitment for men and women to join the aerospace industry constituted a veritable gold rush. NASA alone recruited three thousand scientists and engineers during fiscal year 1962, and NASA outsourced to private industry 88 percent of the work that it coordinated. The largest companies expanded their workforces, while small- to medium-sized companies saw their workforces totally transformed. The new industry was financially robust: Marquardt Corporation, a smaller military aircraft company, won a contract in 1958 for a new military space plane, boosting its sales for 1959 to $70 million, 40 percent higher than 1958.[4] Recruitment fairs were stock in trade among the strategies for building a new workforce, but the telling legacy of the massive recruitment drive is found in the hundreds of printed advertisements in *Aviation Week* and *Missiles and Rockets*. Hunting for untold stories of the cold war that I hoped I might find in these magazines, I little expected that the advertising in their pages would seize my attention more than the articles themselves. Alongside reports on cold war missile intrigue and plans for interplanetary exploration, visionary ads opened a different window onto history.

Prior to Sputnik the ads in these magazines were more sedate, predominantly black-and-white, sometimes duotone or three-color, representing their products without necessarily linking them, through word or image, to the broader cultural context of future space technology. After autumn 1957 there was a dramatic shift, and these ads now told stories with action scenes depicting industry's hopes for the future. Pulp science fiction's visual vernacular of rockets and moonscapes forms the departure point for a wide range of styles. By 1959 aesthetically sophisticated, imaginative graphic design and illustration present fantastic visions of possible near futures based on part real, part imagined imminent technological transformations. Collectively, the ads defined the new industry's hoped-for scope of work, while also building an American cultural phenomenon and infusing excitement into readers who were being recruited to

build a new workforce for the human future in space. The future imagined by industry tends to run a few steps ahead of proven technological developments.

The history of the early space age that emerges from the advertisements is as much cultural as it is technological. Space was breaking out of the confines of genre-bound science fiction to become a mass civic objective; it was becoming an inevitable and even essential destination for human discovery. The most complex ads are in fact ideological statements using art and design (often drawing on science fiction's visions of future technology) to persuade the audience of the imperative need for funding to build the human future in space. The visual discourse in these ads falls in the gray area between fact and fiction, drawing on science fiction vernaculars to tell true stories of emerging technology in the years immediately following the launch of Sputnik: *another science fiction*.

Each advertisement represents a three-way collaboration between the artist, advertising agency art director, and sponsor corporation. The balance of influence between these three contributors varies, as ad agencies differed widely in size and structure, and artists too differed in their authority in the commercial art field. Graphic artists working for industry, then as now, were commonly contractually prohibited from signing their works-for-hire, to prevent an artist's public identity from interfering with the corporate identity being presented in the ad. As graphic design historians Johanna Drucker and Emily McVarish have noted, "Many commercial artists remained largely anonymous, their identities swallowed or erased by the system of production."[5]

My efforts to locate as many artists and informants within the advertising and aerospace industries as possible yielded mixed results. Most ad agencies of the era have either vanished or long ago been folded into larger agencies or corporations that did not maintain histories of their legacy components. Most sponsor corporations followed the same path. Those that still exist are now twenty-first-century mega-

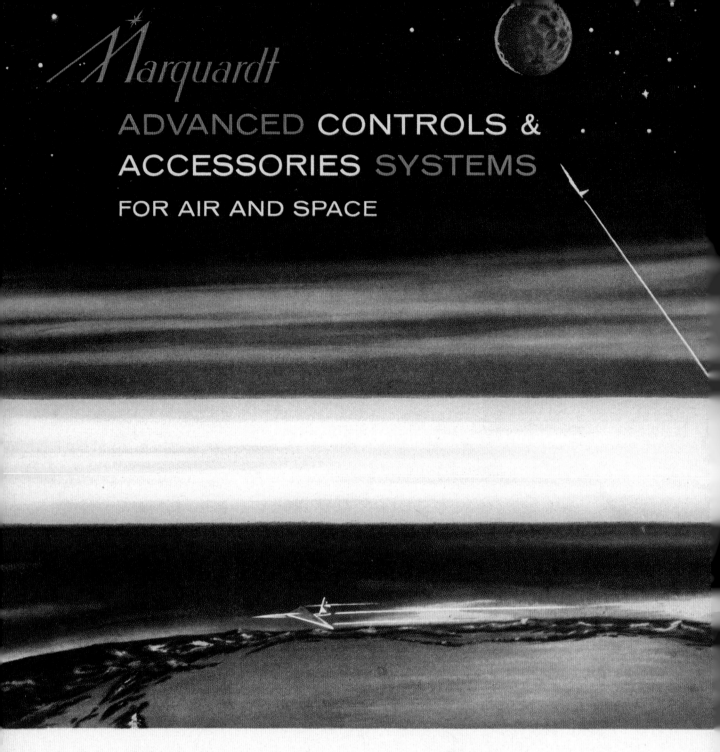

Marquardt
ADVANCED CONTROLS & ACCESSORIES SYSTEMS
FOR AIR AND SPACE

F-108, NUCLEAR TURBOJET, AND RAMJET PROJECTS OFFER CHALLENGING OPPORTUNITIES TO PROFESSIONAL ENGINEERS AND SCIENTISTS

Advanced projects for air and space operations now underway in the Controls and Accessories Division at Marquardt Aircraft offer engineers and scientists challenging opportunities in a variety of technical areas. Here, where we are dealing with development problems on high-performance systems with stringent design and reliability requirements, professional engineers will find real challenge and opportunity for accomplishment.

Project personnel are currently working in such areas as the engine control system for the G-E nuclear turbojet; inlet control systems for the McDonnell F-4H, North American F-108 and the North American Hound Dog missile; the fuel control system for the supersonic Bomarc's ramjet engine; auxiliary power systems, pumps, and actuators; and are developing a unique and advanced space power unit.

C & A Division activities range in scope from preliminary design through final production.

Professional engineers and scientists capable of making contributions in these and related areas are invited to investigate the employment opportunities at Marquardt. You will find a combination of significant, active projects and a lively interest in new ideas, creating an environment for professional growth. May I suggest you write Mr. Floyd Hargiss, Professional Personnel Department, 16551 Saticoy Street, Van Nuys, California?

Roy E. Marquardt, *President*

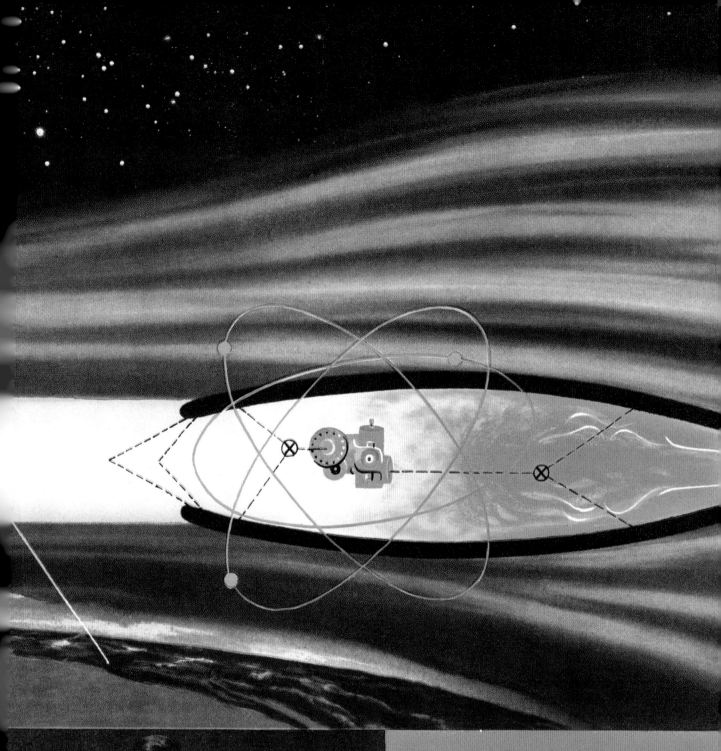

◄ C & A Division engineers made many contributions to the "state of the art" when they developed the fuel control system for the supersonic ramjet engine.

Marquardt
AIRCRAFT CO.

VAN NUYS AND POMONA, CALIFORNIA—OGDEN, UTAH

Fantastical hopes for electro-particle propulsion and 25,000 MPH speeds are promoted here alongside the equally distant promise of live, on-the-spot space junk remediation. The Bosch ARMA Corporation built computers for inertial guidance systems on rockets and specialized in computer miniaturization. Artist: Frank Tinsley, *Missiles and Rockets*, May 23, 1960

corporations and largely deaf to research queries. However, a handful of key informants within the aerospace industry and advertising, as well as Willi K. Baum, a surviving mid-century graphic designer, generously made themselves available to me for this book.

Five dimensions of the cultural history of the early space race are told through the chapters in this book. In the political and cultural landscape of the earliest years of human activity in space, satellites lacked the glamour associated with interplanetary travel, but they were the first spacecraft, and today they are the most numerous and the most powerful type of spacecraft. Their early history is also the history of the overlap of military, civil-scientific, and commercial interests in space that continues today.

After satellites came the notion that human spaceflight—as opposed to robotic exploration—was essential and inevitable. Human spaceflight was hotly contested, and advertisements presenting early "nonfiction" images of space travelers document a time just before the term *astronaut* was coined from *astronautics*, navigation of the stars.

The technology of spacecraft is explored in ads that anticipate the design and function of future spacecraft. Engineering systems were expressed in alternatives ranging from the proven to the utterly fantastical. Focused on the history of rocket propulsion technology, these ads make frequent references to the pulp science fiction visual vernacular. They also reach furthest and most confidently into the future, anticipating interplanetary and intergalactic travel.

Other ads less technologically oriented are meant to construct space as a new place in the cultural imagination. These ads reflect humankind's impulse to imbue unknown spaces with a sense of familiarity. Off-Earth worlds are imagined with such comforts as gravity and breathable atmospheres. The anticipation is that outer space will be easily constituted as a new land, ready to receive established patterns of human habitation. The American West appears frequently in science fiction symbolizing new horizons, and this ur-motif is part of visualizing space as well. Road building and settlement congestion are remapped onto space—for better or for worse.

The modern advertising duality of design and persuasion led some artists who anticipated space to reject the science fiction vernacular. The last chapter of this book

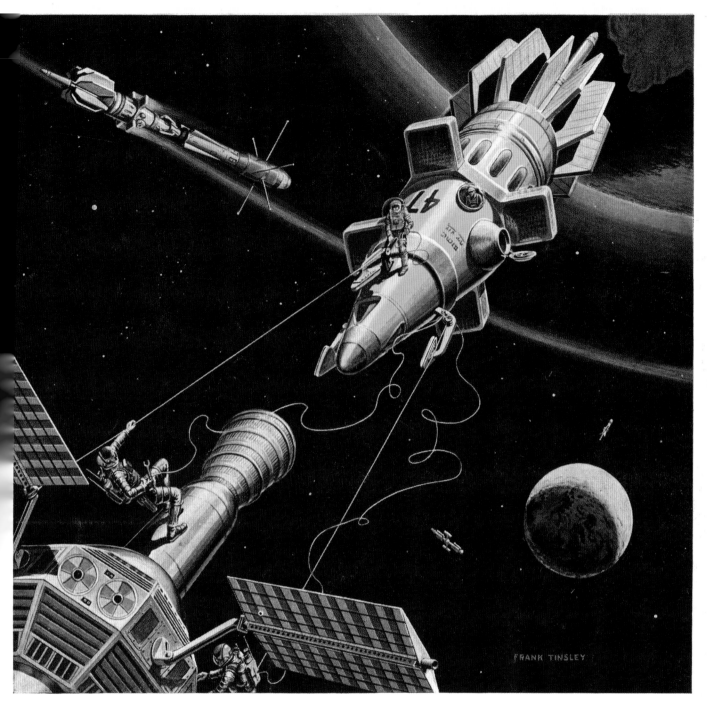

FRANK TINSLEY

STEPS IN THE RACE TO OUTER SPACE

Breaking a Space Traffic Jam

By 1970 our solar system will be filled with expended satellites—whirling aimlessly in space with dead batteries and electronic equipment, their missions long since completed.

As space traffic increases, these derelicts will have to be captured and broken out of orbit to keep flight paths clear. For this task, special towboats will be designed and crews trained.

Here, step by step, is an account of such satellite capture and destruction:

1. The towboat, driven by electro-particle propulsion, rockets into space at speeds reaching 25,000 m.p.h. Its reversible engines enable it to slow as it approaches the radar-located satellite, and match the derelict's speed as it moves into orbit behind it.

2. Crewmen attach lines to the satellite (as in illustration). Then they haul the towboat forward and its nose cone is clamped to the satellite's rocket nozzle.

3. The towboat's engines are then switched to full reverse and the linked machines gradually lose momentum, nosing into a spiral path toward the Earth below.

4. When a safe point is reached, the towboat automatically releases the satellite and it is consumed by friction as it

plunges into the heavier atmosphere. The towboat, regaining its speed, moves on to its next assignment—breaking a traffic jam in some other congested point in space.

———

ARMA, now providing the inertial guidance system for the ATLAS ICBM and engaged in advanced research and development, is in the vanguard of the race to outer space. For this effort, *ARMA* needs scientists and engineers experienced in astronautics. *ARMA*, Garden City, New York. A Division of American Bosch Arma Corporation.

AMERICAN BOSCH ARMA CORPORATION

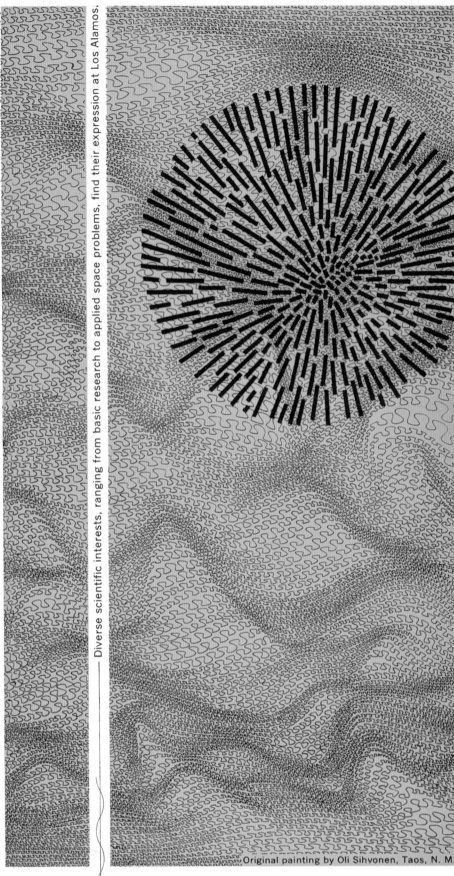

Diverse scientific interests, ranging from basic research to applied space problems, find their expression at Los Alamos.

Original painting by Oli Sihvonen, Taos, N. M.

For employment information write: Personnel Director, Department 60-14

los alamos
scientific laboratory
OF THE UNIVERSITY OF CALIFORNIA

LOS ALAMOS, NEW MEXICO

Here the golden dunes and huge sun of the New Mexico desert
are abstracted in a modern style by the noted Southwest painter
Oli Sihvonen. The intersection of avant-garde Southwest artists
and the Los Alamos Scientific Laboratory is a unique tale in
the history of recruitment literature development. *Missiles and
Rockets*, February 1, 1960

explores ads created by artists who drew freely from modern fine art movements:
minimalism, abstraction, and expressionism. The work of industry was expressed in
colorful, unique, and visually arresting ways. As a group these ads position industry
as part of the larger culture of modernism. Many of them sprang from unusual
relationships between artist, agency, and industry.

These revealing artifacts from fifty years ago provide a map to understanding
some of the dynamics of contemporary space politics and the uneasy balance of
power between military and civilian interests in space. Often civilian research–oriented
enterprises are foregrounded in the promotion of dual-use, predominantly military
technologies. As this book shows, events that are sometimes reported in contemporary
media as if they were happening for the first time in fact have historical precedents.

The dramatic opening acts of this period in history must be made visible to be able
to see that present-day events are continuations of historical narratives established
a half century ago. Contemporary inflatable space hotels, lunar bases, and wars
conducted in orbital space are all iterations of plans laid long ago.

By looking at today—and tomorrow—through a lens of rich historical evidence, it
becomes clear that *we are still in the early space age*. The dramas that played out in the
earliest days of space exploration are still at work in society. Historical awareness might
help in planning for tomorrow and spurring a new audience to think critically about
space. Space buffs too will find the material gathered in this book inspirational.

The thrilling tradition of graphic arts for industry that flourished in the mid-
twentieth century is abundant in weekly and monthly periodicals from thirty, fifty, and
a hundred years ago. These graphics capture a history more ephemeral than what is
presented in books, as some ideas and plans flit through history too briefly to enter the
more permanent records. Legacy periodicals are a gold mine of untold stories.

In speaking of the "early space race" in this book, I refer specifically to the five-
year period of time that followed the launch of Sputnik in October 1957. The tectonic
effect of Sputnik was to break completely the barrier between science fiction and
technological fact. With that launch, aerospace trade industry advertising transformed
almost overnight into an artistic expression of tremendous vitality and symbology.

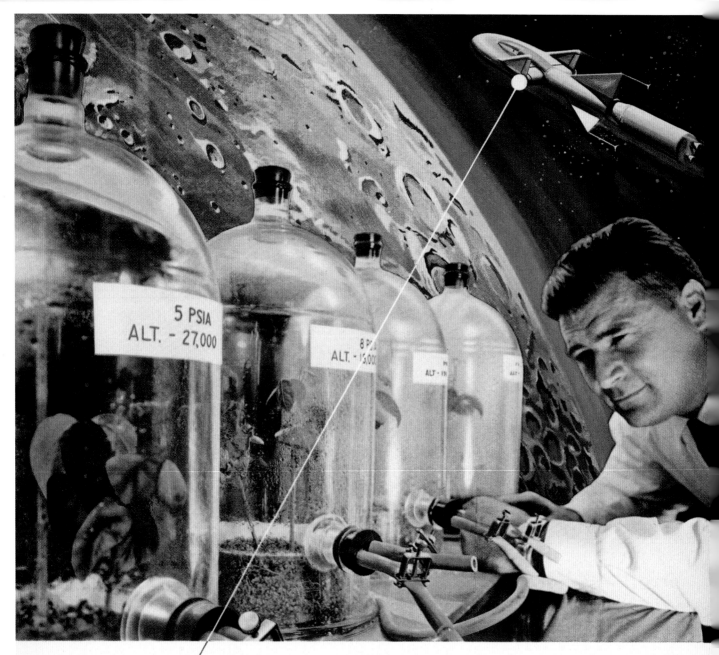

MOON GARDEN

You can't grow anything on moon soil . . . but Republic is . . . raising turnips, carrots, beets and snap beans in its lunar greenhouse experimental garden. ➤➤➤ Republic is working on lunar garden studies as part of a research program to determine the feasibility of establishing a base on the moon. ➤➤➤ Hyman Stein, manager of space projects and studies for Republic's Applied Research and Development Division . . . and his "green thumb staff" (Bill Taufman seen here), maintain a constant, studious vigil over these tests. ➤➤➤ A basic aim is to determine at how low a pressure vegetables can be grown to maturity. The lower the pressure, the less weight of the greenhouse structure. And weight is critical in delivering a payload to the moon. ➤➤➤ These experiments will determine whether significant increases in crop production can be obtained by lengthening the working day as past tests indicate. Our Moon Garden studies are but one of many bold concepts under development as part of Republic's multi-million dollar exploration into the realm of advanced aircraft, missiles, space travel and space.

REPUBLIC AVIATION

FARMINGDALE, LONG ISLAND, N. Y.

Designers and Builders of the Incomparable **THUNDER-CRAFT**

Experiments being carried out in Republic's preliminary laboratory will be housed in our new 14 million dollar research and development center, scheduled for operation early in 1960.

In 1959 the U.S. Army was planning a lunar base, developed by
Wernher von Braun, to be called Project Horizon. On Horizon,
the army would grow food for astronauts in hydroponic tanks.
Here scientist Bill Taufman of army contractor Republic Aviation
experiments with growing food in lunar soils. *Aviation Week*,
November 16, 1959

USSR cosmonaut Yuri Gagarin was the first human being to enter orbital space,
in April 1961. Most of the ads in this book predate that triumph, and all predate
NASA's Project Apollo, which would send astronauts Neil Armstrong, Buzz Aldrin,
and Michael Collins on their lunar landing mission in 1969. By the time that funding,
infrastructure, and technological acumen were aligned to enable a push to place man
on the Moon, these ads were no longer needed. The start of the 1962–63 fiscal year
marked the first time in five years that budgets for NASA's human spaceflight program
began to level off. NASA's first human spaceflight project, Project Mercury, had been
conceptualized, designed, and successfully executed in 1962, and the second, Project
Gemini, was well under way. The third and most ambitious, Project Apollo, had also
begun. The unfettered spending growth of the first five years came to a stop as other
evolving elements in the broader budget were considered. In the summer of 1962 the
first commercial telecommunications satellite was launched, making the interests of a
powerful third stakeholder more formidable among the space-invested parties.

In July 1962 NASA announced its decision that the Apollo program would use a two-
piece Lunar Orbiter and Lunar Excursion Module (LEM) to send astronauts to the Moon.
Although the public had little comprehension of this means of transport, it instigated
another fundamental shift in how space travel was represented within the aerospace
industry. Gone was the classic finned rocket that for twelve years had been an icon in
the visual language of space exploration and the human future in space. At the same
time the aerospace industry's hiring wave plateaued with the crystallization of the
manned lunar space program. Trade advertising very quickly lost its gleam. Fantastical,
modernist, ideologically exuberant advertisements were a thing of the past, of the five-
year period of soft delineation between science fiction and technological reality.

Bracketed by Sputnik's launch and NASA's LEM announcement, the years from
1957 to 1962 saw the launch of the first human orbital and suborbital spaceflights and
the rapid evolution of federal leadership of the civil space program. It was an incredibly
complex historical period rich with a marvelous outpouring of symbolic imagery
representing space.

And now, for the journey...

1. Satellites in the Sky

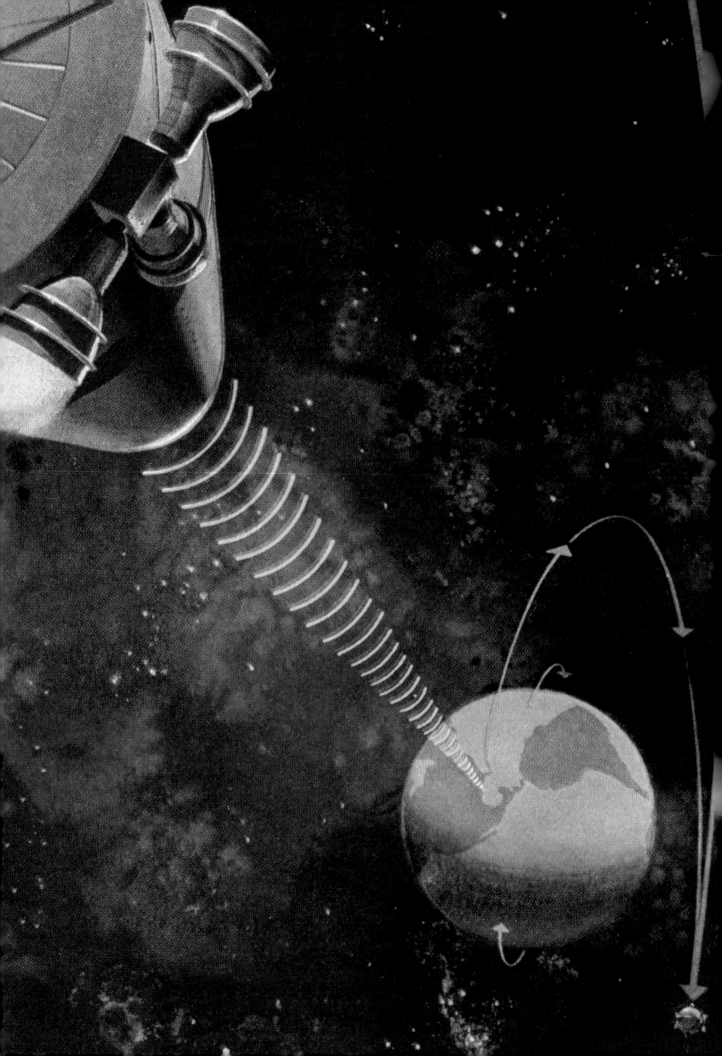

A New Age of Discovery

In *Around the World in 80 Days*, Jules Verne's fictive explorer Phileas Fogg marked with his journey an earthbound historical moment at the twilight of the European era of exploration and colonization in the late nineteenth century. The novel documents the time when global circumnavigation had ceased to be a feat of exploration and, thanks to the technological progress of the industrial revolution, was transformed into travel. The reference to Verne in the Ex-Cell-O Corporation ad on page 29 draws a parallel between Verne's era and the beginning of space exploration. This ad is an invocation of literary and technological history that relates the satellite era to a deep historical context. The text and graphics of the ads in this chapter constitute a record of the incipient aerospace industry coming to terms with new technology. Many of the ads, like the Ex-Cell-O Corporation's, present one stated objective, such as engineer recruitment, but carry a subtext of promotion of the company's role in and the cultural importance of space exploration.

Even after centuries of seafaring exploration the poles remained vastly unmapped. In the 1870s and early 1880s it became apparent that the Earth is too large to be surveyed and understood through uncoordinated, separate national efforts. A consortium of international geophysical scientists concluded that international cooperation in polar exploration would yield a wealth of knowledge that no single country could gain working alone. Inspired by scientific visionary Karl Weyprecht, twelve countries participated in establishing polar research stations, a project called the first International Polar Year of 1882–83. This marked the beginning of an end to the great competition between European states to map and control the Earth.

The International Geophysical Year

Between the second International Polar Year, in 1932, and the end of World War II, technological advances, especially in air flight and rocketry, rapidly altered possible means of exploration. Scientists met in 1950 to plan the International Geophysical Year (IGY) of 1957–58, a time frame selected to correspond with maximum solar flare

OVERLEAF PRECEDING: Detail, page 38.

OPPOSITE: Detail, page 33.

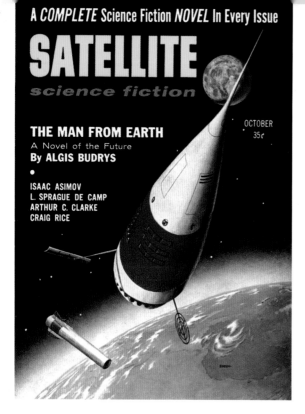

LEFT: In 1956 the pulp magazine *Satellite Science Fiction* started its three-year run in the months leading up to Sputnik and the first two years of active satellite competition between the U.S. and USSR. The first issue's cover features an imaginative Explorer-like satellite by the renowned science fiction artist Ed Emshwiller. October 1956

OPPOSITE: The first U.S. satellite, Explorer, shown soaring over Earth, was famous for being able to circumnavigate the globe in just under an hour and a half, a close parallel to Verne's eighty days. Ex-Cell-O Corporation here shows off its long history in industry and its contribution to Explorer. *Aviation Week*, March 14, 1960

activity. The two previous International Years had focused on the Earth's poles, but new technology would now allow for exploration not only of the poles but of the whole Earth including its atmosphere and troposphere. More than sixty thousand scientists in sixty-six countries collaborated during the eighteen-month IGY between July 1957 and December 1958 to survey, sample, analyze, and chart Earth and its atmosphere in areas that had been previously unknowable through land-based sensing methods.

At the start of the IGY on July 1, 1957, outer space was dark and quiet. No spacecraft plied the solar system except in the plans of engineers at work on satellite technology in obscure laboratories. Both the USSR and the United States sponsored satellite development in their participation in IGY, but satellite technology was as yet unrealized. The USSR's surprise launch of *Sputnik 1* in October 1957 changed everything. Between that momentous first launch and the 1962 launch of *Telstar 1*, the first active communications satellite, the three forces—military, scientific, and commercial—that ushered in the space age each took over distinct uses of satellite technology.

Satellites

The term *satellite* refers to any object that orbits a planet. The Moon is a natural satellite; the International Space Station is a manned satellite. In 1870 Edward Everett Hale published his orbital drama "The Brick Moon." This story presciently told of a group of space pioneers who built an Earth-orbiting spacecraft out of brick. The story cannily anticipated the use of ceramics to shield spacecraft from heat during their transit through the friction of layers of Earth's atmosphere. In the wake of *Sputnik 1*, satellites defined the space race in the American public eye, and the word *satellite* came to be widely used as shorthand for unmanned mechanical satellites.

Satellite Science Fiction was a small pulp magazine published from 1956 to 1958. Like the more widely read *Analog*, *Satellite* published articles about science fact alongside

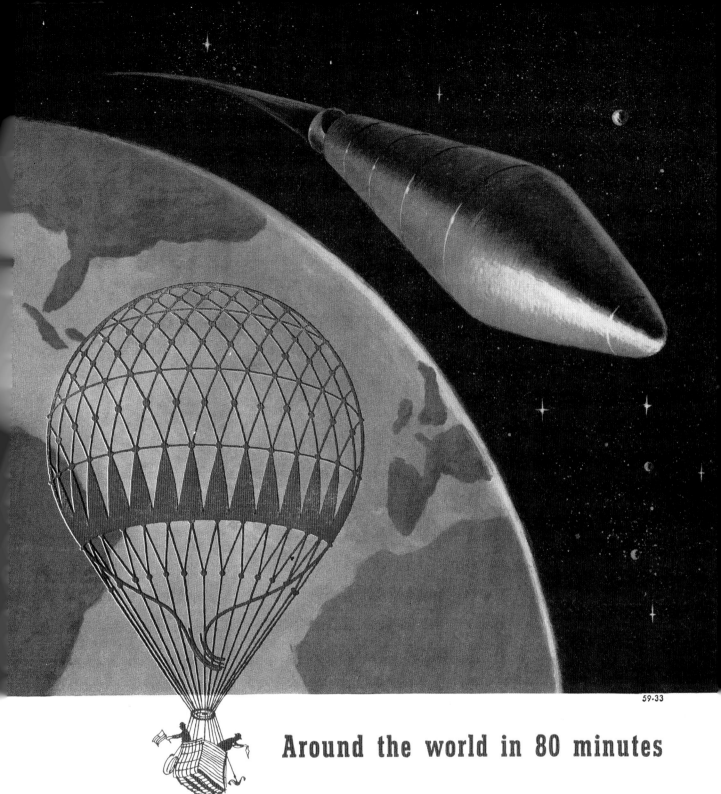

Around the world in 80 minutes

Phileas Fogg needed eighty days to see what the Explorer scans in minutes. Ex-Cell-O Corporation was not then in business to help speed his trip—it was 1923 that Ex-Cell-O started making aircraft parts to tolerances until then deemed impossible in production.

Forty years of Ex-Cell-O experience in high-precision design and manufacturing have helped hurl the Explorer into the sky—have helped guarantee that Ex-Cell-O rocket and missile components embody the delicate strength essential in space.

Twenty-four Ex-Cell-O facilities in the United States specialize in accuracy by the ounce or by the ton ... for the future.

EX-CELL-O FOR PRECISION (XLO)

EX·CELL·O
CORPORATION
DETROIT 32, MICHIGAN

Aircraft Division

59-33

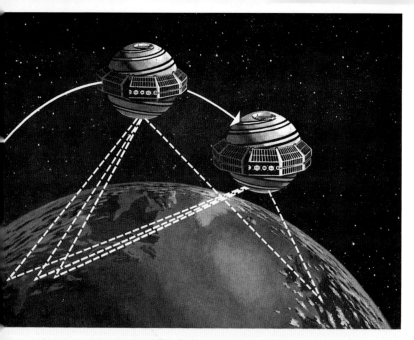

Now! Cubic SECOR can determine intercontinental distances with unprecedented accuracy!

LEFT: The army-sponsored geodetic satellites shown in this 1960 Cubic Corporation advertisement have transmission beams that reach to Earth in neat compasslike triangles. The SECOR program, launched in 1962, allowed the first exact mapping of island locations and plotted the entire Earth's surface, creating a network of data that would contribute to the future global positioning system (GPS). The final design would be cuboid. *Missiles and Rockets*, July 18, 1960

OPPOSITE: The satellite advertised here used an RCA Vidicon to take pictures from orbit and transmit them, live, back to Earth. Not quite television as we think of it—the ideas behind the Vidicon technology had been developed for satellite espionage but rejected in 1955. The Vidicon was incorporated into the TIROS weather satellite (see page 46). *Missiles and Rockets*, February 29, 1960

fiction. In the preface to the second issue (December 1956) the publisher, Leo Margulies, wrote a tongue-in-cheek analogy between the magazine and its namesake technology.

> The second man-made SATELLITE is hereby launched on its globe-girdling orbit, just as SATELLITE #1, its tour of duty gloriously completed, is finally consumed by the Earth's atmosphere, especially in dense pockets around the newsstands.[1]

When the first, and shortly thereafter the second, actual satellites were launched ten and eleven months later, Margulies congratulated himself for predicting the events.

Arthur C. Clarke, a contributor to *Satellite*'s first issue, had published an article in October 1945 in *Wireless World* titled "Extra-Terrestrial Relays: Can Rocket Stations Give World-wide Radio Coverage?"[2] In it, the prolific scientist and sci-fi author argued that satellites were possible—even inevitable—and that they would come to be widespread and revolutionize culture. At a hearing before the U.S. Congress in 1959, he asserted:

> Of all the applications of astronautics during the coming decade, I think the communications satellite most important. The use of satellites for TV and radio relaying was, I believe, first suggested by myself...and it is now widely conceded that this may be the only way of establishing a truly global TV service. The political, commercial, and cultural implications of this, however, do not yet seem so thoroughly appreciated.[3]

The Dual Origins of a Dual Use Technology

Konstantin Tsiolkovsky, a Russian, and Robert H. Goddard, an American, pioneered high-altitude rocket development in the 1920s and '30s. In the 1940s Wernher von Braun of Germany built on their work, and while an agent of the Third Reich von Braun perfected

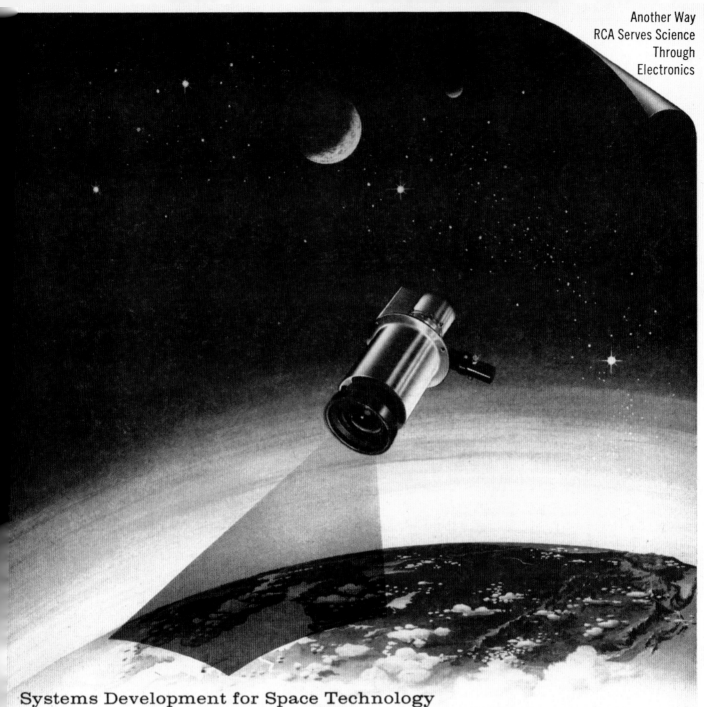

Systems Development for Space Technology

TELEVISION CAMERAS

Design a miniaturized camera system for taking "snapshots" from a satellite. Drastically reduce bandwidth to conserve power, yet maintain high resolution picture quality. The entire unit must operate unattended in a space environment.

Astro-Electronic Products Division took these demands in stride and developed several electronic camera systems scheduled for use in space science experiments. One of them is pictured above.

A special, ruggedized ½-inch Vidicon gives this compact camera a TV resolution capability of 500 lines. Because still pictures are to be transmitted, video bandwidth is cut to 62.5 kc by using a very slow (2 sec.) scanning rate. A specially designed, ruggedized shutter, designed for minimum of 100,000 operations, immobilizes the image and eliminates smear. The camera, less lens, is only 5 inches in length and weighs approximately 2 lbs. The transistorized camera electronics, including the power converter, is housed in a container measuring 6 x 6¼ x 3 inches.

Such a camera can be used to look at the earth's cloud cover from space, map the moon, study the solar system, or monitor the space vehicle itself. 1-inch Vidicon versions of these cameras are capable of 800 to 1,000 lines resolution. This is typical of the way AEP approaches problems, going beyond the bare requirements to develop space systems which can adapt to meet the needs of tomorrow.

 RADIO CORPORATION OF AMERICA
Astro-Electronic Products Division ***Princeton, N.J.***

AM and FM Command Receivers—Another AEP Capability

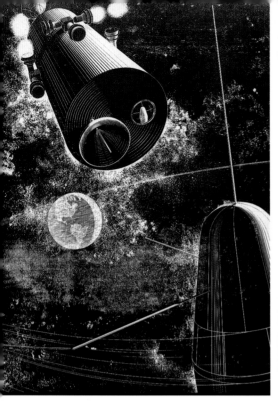

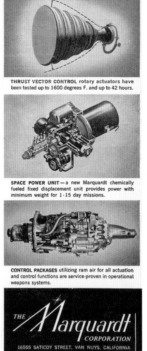

The satellite depicted here is similar to other artists' speculations about what the top-secret Corona satellite might look like. The actual Corona design was, however, quite different. Most likely created by artist Ken Smith, who elsewhere signed his distinctive work, this ad promotes Marquardt's program in small reaction-control engines, which contributed technology to many satellites of the 1960s. *Aviation Week*, **June 27, 1960**

the ballistic missile, first known as the V-2 rocket. The technology that enabled the satellite was conceived in the crucible of war: the V-2 was built by Nazi slave laborers[4] and was used to destroy London and Antwerp during World War II.

Satellites require rockets to launch. With Germany's terrible success with the V-2 humankind had the ability to hurl objects thousands of miles into open sky and into space. It was a new kind of flight, qualitatively different from airplane technology, not to mention hot air balloons. During Germany's defeat von Braun and dozens of his colleagues were corralled by the U.S. military and brought to the United States. Placed in positions of authority in American military and rocket development, they were critical in jump starting the U.S. rocket program that allowed the United States entry into the satellite race.

Although the IGY was an international cooperative effort, the race between the United States and the USSR to launch a satellite became a militarized competition between superpowers with all the attendant drama and intrigue. The launch of *Sputnik 1* was received as a military challenge in the United States, and rocket technology efforts were stepped up in civil-scientific geophysical exploration and strictly military applications.

The development of rocket launch technology also led to a widespread belief that the cold war would escalate into a competition for a military presence on the Moon. Both sides pursued the satellite race toward that end and as an end in itself. The peaceful IGY activities in the midst of the cold war underscores the duality of the uses of mapping and remote sensing for peaceful purposes or in intense competition for military superiority.

The U.S. Navy developed the Vanguard satellite program for the IGY. In a crash program after Sputnik, the army developed the competing Explorer series. Under intense pressure to meet the Russian challenge, the navy launched its first satellite while the whole world watched.

The military also had their own interests in space. RCA's ad for a satellite camera system (page 31) refers to a technology that was originally developed for a U.S. Army

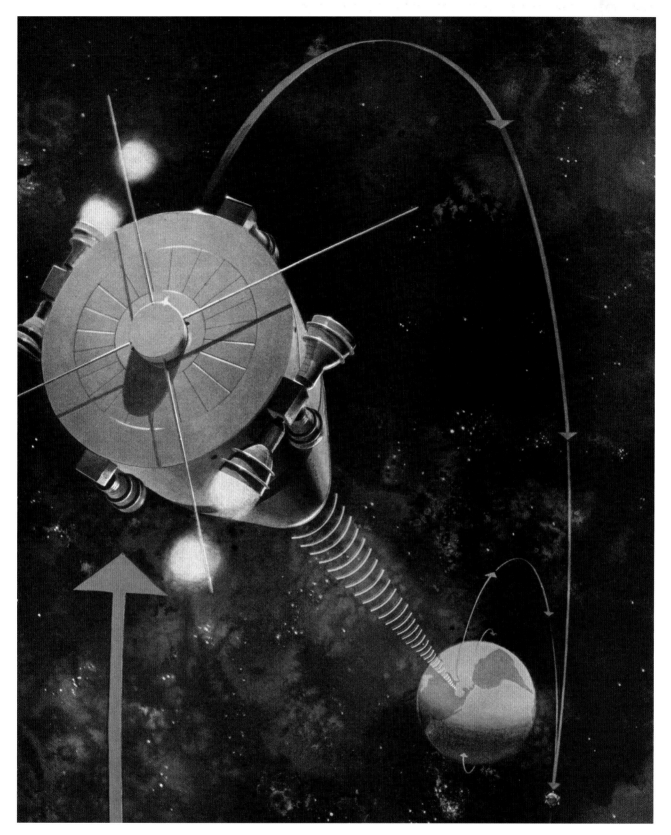

Marquardt ran this ad (and the ad on page 32) around the same time as the first successful launch of the Corona spy satellite. The modest 200- or 300-mile distance between Earth and the satellite's orbit is exaggerated here to look more like several thousand miles spanned by the precise beam of the camera lens. As recruitment ads, these were designed to attract staff to Marquardt's sizable operation. Four thousand people joined its ranks in the late 1950s. *Missiles and Rockets*, February 20, 1961

CONTROLS & ACCESSORIES DIVISION

THE *Marquardt* CORPORATION

16555 SATICOY STREET, VAN NUYS, CALIFORNIA

ASTRO ◆ COOPER DEVELOPMENT DIVISION
◆ OGDEN DIVISION ◆ POMONA DIVISION
◆ POWER SYSTEMS GROUP

CORPORATE OFFICES: VAN NUYS, CALIFORNIA

*POSITION—ATTITUDE—TRAJECTORY CONTROL SYSTEM

Radiometers
Honeywell has produced infrared radiation measuring instruments (typical shown) for a wide range of applications thru the spectral band from 0.7 to 40 microns.

Honeywell

H HONEYWELL *Military Products Group*

weather satellite but was later transferred to NASA. But it hints at the chief military application for satellite technology: intelligence. Early suggestions that nuclear bombs might be dropped from satellites onto enemy countries turned out to be impractical. Instead, a more passive military activity rules the satellite sky: surreptitious mapping and imaging.

Television broadcasting through satellite technology was widely advertised. As Philip Taubman discovered when he excavated the U.S. satellite espionage program of the 1950s, imaging companies, RCA in particular, had been involved at the planning level of satellite development since the early 1950s.[5] As RCA's ad on page 31 explains, the advertised satellite will transmit pictures back to Earth through video uplink. Not quite broadcasting as we know it—not yet. Surveillance. Intelligence gathering funded and impelled the competing army and navy programs, and that is how television technology first became embedded, in the mid-1960s, in satellite design.[6]

The publication of RCA's ad (page 31) in *Missiles and Rockets* was prescient: two months later a U-2 spy plane was shot down over the USSR, ending for good the long-running flyover surveillance program and ushering in the era of satellite surveillance in its stead. The secret Corona spy satellite—declassified and revealed only in 1995—greatly superseded the U-2 program.

The top-secret Corona program would seem an impossible topic for advertising imagery, but in 1958, to the concern of the CIA, an illustrated feature in *Popular Science* described a "seeing eye" satellite known by its nicknames "Pied Piper" and "Big Brother."[7] With sketches showing an elongated bell-shaped satellite with a gently domed tip, the article explained how the satellite's cameras would be able to scan the Earth's entire surface and send images to Earth, either by physical tape or by image transmission technology yet to be developed. *Popular Science*, however, emphasized the satellite's usefulness as a mapping tool and instrument of weather observation. A few months later *Aviation Week* ran a more revealing article, also with an elongated, inverted bell-shaped satellite, naming the air force as the agency in charge of "Pied Piper"[8] and declaring that the satellite would be able to "photograph any portion of the earth as the latter revolves on its axis beneath the orbital path."

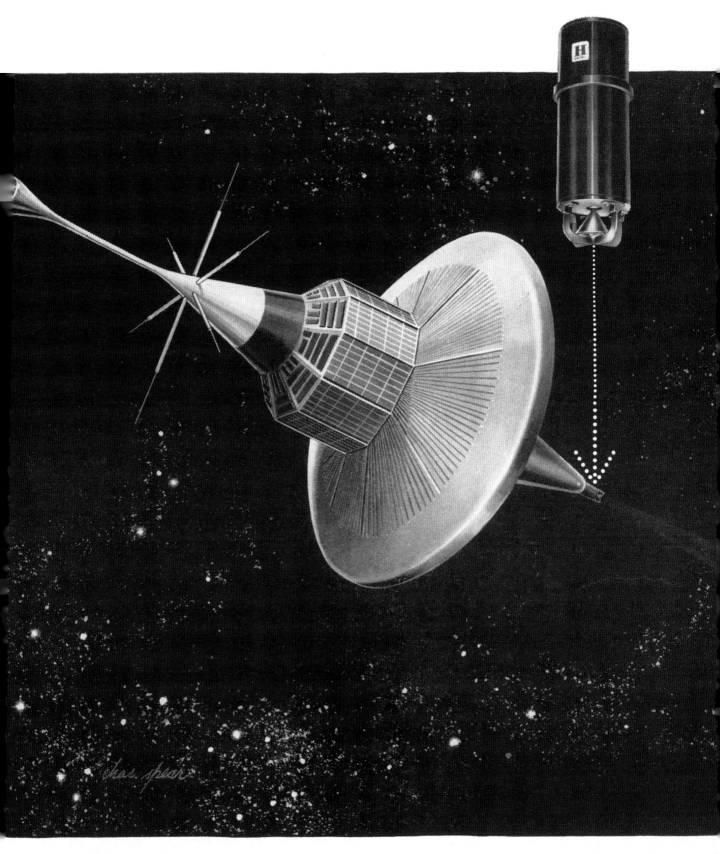

chas. spear

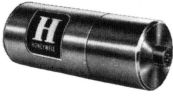

IR Detectors Typical Honeywell IR detector and preamplifier combination. This PEM (photo-electro-magnetic) cell operates at ambient conditions, non-cooled, and has a spectral response from 1-6 microns. Honeywell also produces cooled detectors for military and space applications.

Communications Honeywell's MAXSECOM* (Maximum Security Communications) transmits voice or coded intelligence via modulated infrared energy. Line-of-sight transmission gives security not obtainable in radio link. Solid state electronics and semiconductor modulator unique to MAXSECOM provide for compact, rugged, portable transceiver design. *Trademark

Three days after the publication of the June 1958 *Aviation Week* article, CIA director
Richard M. Bissell wrote a memo to his staff requesting an evaluation of the information
revealed.[9] In a two-page memo[10] the agency's director of administration remarked that
"While the subject article stirs a self-conscious reaction in the breasts of those connected
with Corona, as being completely revealing, objective appraisal seems to indicate that
the story is a cleverly written combination of a few primary facts intermingled with a
considerable amount of editorial speculation and obvious deduction." The memo further
remarks that *Aviation Week* was not the only culprit: "...in magazines other than *Aviation
Week* [i.e., *Popular Science*]...there have appeared references..."

Five months later the CIA and the air force waged a successful disinformation
campaign recasting "Pied Piper" as a satellite called "Discoverer." It was admitted
that "Discoverer" had a camera, but its stated principal objective was science and
engineering research. *Aviation Week* ran a story,[11] and in 1960 the real, secret Corona
satellite—and its doppelgänger—was launched.[12] Marquardt's advertisements on pages
32 and 33 were doubtless in sync with industrywide awareness of the acknowledged
but unadvertised "Discoverer" launches, but the focus of the camera's beam (page 33)
suggests that the cameras of "Discoverer" had earthbound objectives. This disinformation
campaign was successful enough that at a 1959 congressional hearing some committee
members complained that the launch of "Discoverer" had not been coordinated with the
Smithsonian's "Operation Moonwatch" public program for citizen science.

Vanguard

The army's Explorer satellite beat the navy's Vanguard to the punch in the tight early
race to join *Sputnik 1* in orbit, while Vanguard had the strongest connection to the
IGY research projects. It showcased the postwar trend in electronics miniaturization.
As an IGY project, the spherical Vanguard was fitted with instruments to measure
phenomena such as solar radiation and micro-meteors.[13] It also had a Varian-built
magnetometer to study the Earth's magnetic field[14] and small radio transmitters to
send data back to Earth. The ads on pages 37 and 38 each depict Vanguard's familiar
spherical shape and call it a "moon." Both ads were published on the brink of the

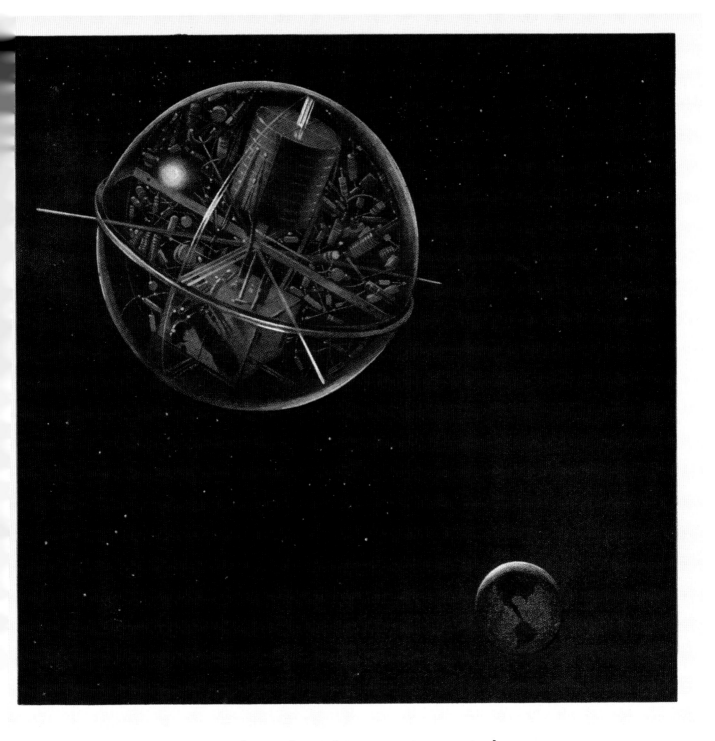

Putting a voice in the man-made moon

America's first man-made satellite will soon be launched into outer space where, traveling in its own orbit, it will circle the earth.

Deep inside will be sensitive electronic instruments which will "observe" cosmic activity and "report" findings back to us. Scientists believe that many a mystery of the universe may thus be solved.

Without electrical insulation of exceptional qualities, such as CDF supplies, the equipment inside these man-made moons could never operate.

But producing top-quality insulation for electronic wonders is just one of the exciting things going on today at CDF. Vital electrical parts for automobiles, aircraft, guided missiles—these are also being made better at CDF. As a subsidiary of the Budd Company, CDF is ever widening its field of operations.

Under Budd management, CDF products are better than ever . . . and with CDF can-do, your products will be better than ever. Drop us a line to start the ball rolling.

CONTINENTAL · DIAMOND FIBRE
A SUBSIDIARY OF THE BUDD COMPANY · NEWARK 8, DELAWARE

General Electric Company has built one of the rocket engines that will launch the earth satellite in Operation Vanguard. A new fuel developed by Shell Research provides the power.

How to launch a new moon

IN THE almost airless troposphere 300 miles above the earth, the first man-made moon will soon ease into its orbit. At five miles a second, it will whip around the earth some fifteen times a day.

The engine for the first and biggest of the three rockets that will carry this satellite to outer space is now being built by General Electric. It is powered by a product of Shell Research called *UMF**. This new fuel is actually a highly specialized kerosene. It is refined in a closely controlled operation that gives it the characteristics needed for rocket use.

When burned with liquid oxygen, *Shell UMF* provides the tremendous thrust that accelerates the whole rocket assembly to 4000 miles an hour in just two minutes. And because *UMF* performs consistently in test after test, even at great speeds and altitudes, scientists can make the precise calculations vital to success in the final launching.

Development of better fuels for every use is an example of Shell Research in action. This kind of leadership insures more for your money in every product you buy under Shell's name and trademark.

*Reg. U.S. Pat. Off.

Leaders in Industry rely on Shell Industrial Products

satellite age—after October 1957 the term *satellite* entered mainstream use. When
Continental-Diamond Fibre's ad (page 37) was republished in 1959, the headline copy
was changed to "Meet temperature demands of the satellite age with CDF laminates
and tapes." In the intervening months the shock of Sputnik had thrust the new
terminology into common parlance.

Vanguard was more widely promoted to the public than Explorer, and in the
Smithsonian Institution's IGY project Operation Moonwatch, promoted alongside
Vanguard in educational literature,[15] thousands of citizen scientists tracked satellites.
The Vanguard name and image overtook the Explorer in the public eye and in the attention
of industry. Explorer's orbit decayed decades ago, and it burned up in the atmosphere.
Although *Vanguard 1*'s scientific mission was exhausted after 111 days in space, its body
remains in perpetual orbit around Earth. It is our oldest piece of space junk.

Beyond the IGY

The complicated politics between the U.S. Army and Navy and between civil-scientific
and military-scientific interests in the first year of the satellite age made apparent
the urgent need for a separate institutional entity to conduct civil space exploration,
and in the summer of 1958 Congress created the National Aeronautics and Space
Administration. NASA was established to "arrange for participation by the scientific
community in planning scientific measurements and observations to be made through the
use of aeronautical and space vehicles."[16] To most people, the term *vehicles* suggested
huge rockets that someday would transport people to the Moon. But in these early years
vehicles referred to satellites, and human spaceflight and robotic interplanetary probes lay
in the future. Rocket engineering was within the military's purview, while NASA's earliest
strength was in observational and telecommunications satellites.

Established and emerging technology companies vigorously competed for NASA
contracts in the new "gold rush" as government monies flowed into the space race.
Companies displayed themselves to many audiences at once: to job seekers the ads
were recruitment pitches; to competitors the ads staked territory; to NASA they pitched
readiness to achieve whether already contracted for satellite work or not.

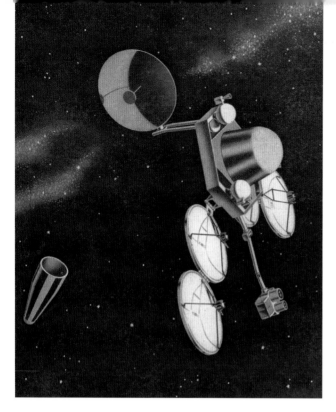

LEFT: A power supply for satellites with a forward-looking central "face" and "arm" with outstretched sensors, this device looks much like a fielder's mitt ready to catch an outfield ball. *Missiles and Rockets*, October 16, 1961

OPPOSITE: No animation of satellites matches illustrator John Huehnergarth's series of illustrations for Nems-Clarke advertisements bringing inanimate objects cartoonishly to life. *Missiles and Rockets*, February 26, 1962

The scientific knowledge yielded by the IGY demanded a follow-up generation for continued geophysical research. OGOs, "orbiting geophysical observatories," showcased NASA's early strength. The two ads on page 42 depict a single satellite design in an orbital position relative to Earth; (left) its brick-shaped central body hugs an orbital circle with wide, flat solar arrays unfolded facing the sun. In the illustration at right the perspective has shifted and the satellite is "upright." The verticality of the satellite's "body" anthropomorphizes the craft, which "keeps its eye on the ball."

These images introduce the human body as a motif in the visualization of the new space industry. Mapping a recognizable body onto a satellite naturalizes it and positions it as an extension of our senses. Satellites become not mysterious but an extension of human ability, actors in the early space age dominated by 1960 by publicity surrounding the prospect of human spaceflight. These images anticipate the contemporary emerging space environment in which the solar system is gradually becoming wired with robotic observers that enable us to see farther into space.

Telecommunications

Launched in 1960 by NASA with ground infrastructure support from television giant Philco, the huge reflective passive telecommunications satellite Echo (page 45) was the first use of satellite telecommunications technology: it broadcast President Eisenhower's Christmas message to the nation. And yet it was incredibly simple. Little more than a hundred-foot balloon, Echo used its reflective exterior to bounce a radio message from one point on Earth to another. Using it was like sending Morse code signals by bouncing the sun's rays off a mirror.

Broadcasting magazine, the organ of the radio and television industry, barely took notice of Echo, running a mere eighty-word story covering its first launch and successful transmission.[17] Anxious about the ramifications of changing technology, the

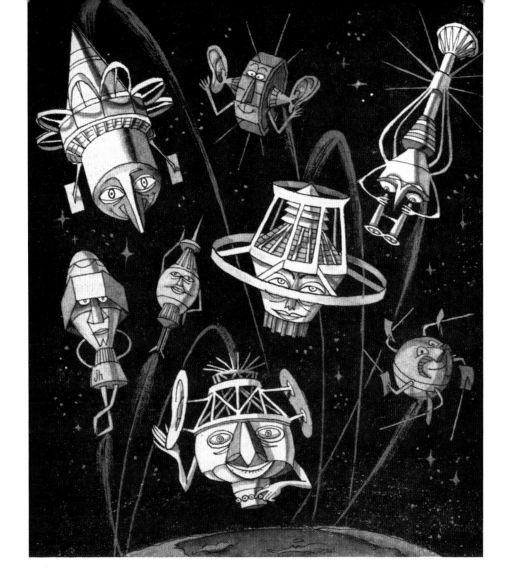

Togetherness, with Greater Isolation...
by new NEMS-CLARKE® Multicoupler

Another new addition to the Nems-Clarke line of telemetry equipment is the Solid State Multicoupler, SSM-101. It accepts the output of an antenna-mounted preamplifier and provides eight outputs with a minimum isolation between any two outputs of 50 db. The gain is held to approximately unity and is flat within 3 db across the band.

The SSM-101 is designed for use in the 225-260 megacycle telemetry band but can be supplied to cover other bands between 55 and 300 megacycles. Input and output connections are made at rear of the unit through type C connectors. Its integral power supply will also energize the Nems-Clarke Solid State Preamplifier, SSP-101.

Write for Data Sheet 899.
Vitro Electronics, 919 Jesup-Blair Dr.
Silver Spring, Maryland
A Division of Vitro Corp. of America

VISIT VITRO AT I.R.E. SHOW
Booth 3821-3823.

Specifications	
1. Pass Band 225-260 megacycles	
2. Uniformity response within 3 db	
3. Gain approximately unity	
4. Isolation . between outputs 50 db minimum	
5. Receiver outputs 8	
6. Impedance Designed to operate in 50 ohm system	
7. Power source 115 v, 60 cps. . . approximately 6 watts	
8. Connectors type C	

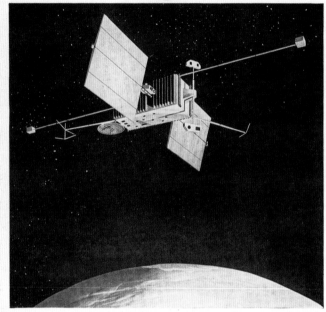

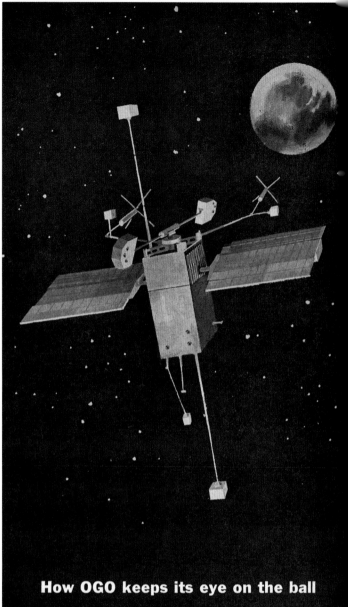

ABOVE AND RIGHT: These illustrations from 1961 realistically depict the near-future OGO satellite. STL was a subsidiary of Thompson Ramo Wooldridge, which was the systems integrator for the ICBM and provided overall U.S. Air Force support for missiles. The first OGO (so dubbed for "orbital geophysical observatory" by NASA) was successfully launched in 1964. The sixth and last was turned off in March of 1972. They are all presumably still up there, orbiting. *Aviation Week*, April 24, 1961; *Missiles and Rockets*, November 27, 1961

OPPOSITE: Bulkier than the OGO, the Nimbus satellite series, also launched in 1964, had a more modest scope of work. Nimbus satellites were designed to collect atmospheric data for the National Oceanic and Atmospheric Administration (NOAA). Nimbus data made multiday weather forecasting possible. The "blades" of the "windmill" are solar arrays that supply power to the conical craft. Nimbus was redeveloped in the 1970s as the Landsat satellite series, which remain in operation today. Artist: Paul Calle, *Aviation Week*, December 18, 1961

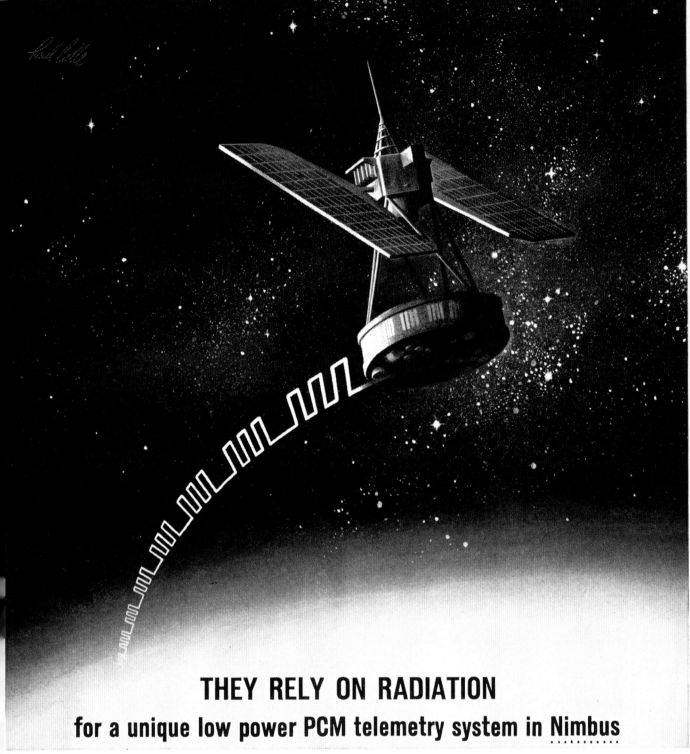

THEY RELY ON RADIATION
for a unique low power PCM telemetry system in Nimbus

When *Nimbus* — the meteorological Satellite System being developed by the Goddard Space Flight Center of the National Aeronautics and Space Administration — begins sending its global weather reports to earthbound meteorologists, a Radiation PCM telemetry system will prepare data on the status and condition of the satellite for transmission. Other Radiation-produced systems in the *Nimbus* ground stations will process these data.

Innovations in the spaceborne system will slice power requirements to a fraction of that needed for current PCM equipment. In fact, data from 650 transducers will be digitized with only *1.0 watt* . . . compared to many times that required in present systems.

The idea is as simple as turning off the lights in an unused room: just switch off the power during the microsecond intervals between pulses. Its execution wasn't that simple, but

Radiation engineers, working under the first contract ever awarded for a satellite PCM system, achieved the result— and a notable advance in the state-of-the-art.

The *Nimbus* system embodies PCM experience dating back to 1951, when Radiation contracted for the first airborne PCM system. This fast-growing company offers attractive career opportunities in a broad spectrum of scientific and engineering specialties. For details on Radiation write Dept. AW-122 Radiation Incorporated, Melbourne, Florida.

Radiation is an equal opportunity employer.

RADIATION
INCORPORATED

telecommunications industry took some time to warm to the possibilities suggested by satellite technology. Promoting its Thor rocket as a launch vehicle for Echo (page 48), Douglas Aircraft, on the other hand, did not hold back in its enthusiasm. Echo's actual accomplishment on its first mission was modest, but Douglas Aircraft was looking ahead to telecom, seeing just over the horizon and into the future.

Douglas's in-house think tank evolved into the RAND Corporation, and its 1946 research document "Preliminary Design for a World-Circling Spaceship" had first presented the promise of the satellite age to industry. The long-reaching view expressed in its routine advertisements is not surprising. In 1959 Douglas looked into the future again and saw "How satellites can give us low cost emergency telephone service" (page 49). In this ad, Douglas was doubtless referring to the developing interest of AT&T, through its Bell Laboratories, in satellite technology and in a share of the coming satellite telecommunications industry. Bell Laboratories worked on Echo and later the Telstar satellite; AT&T's house journal, the *Bell Telephone Magazine*, tended to write about satellites with a sense of entitlement and ownership that rankled other players in the rapidly growing field.[18]

In 1962 AT&T backed a congressional initiative to establish an international telecommunications satellite corporation of which they would be the major U.S. partner. That the proposed corporation was to be half publicly held and to incorporate partnerships with French and British post office agencies did little to dispel concern among broadcasting interests that AT&T was extending its telephone monopoly into space and broadcast television. The resulting entity, Comsat, has had a complex life. It offered AT&T a monopoly of sorts for a time, but in the early 1960s none of the parties involved could accurately anticipate how ubiquitous and relatively accessible satellites would become. By the mid-1960s the major U.S. television broadcast networks were angling for and getting their own satellites, sidestepping Comsat. In the decades since, telecommunications satellites have come to number in the thousands. In 1998 Comsat was privatized, not by the long since reorganized AT&T but into the hands of military-industrial and aerospace giant Lockheed Martin.

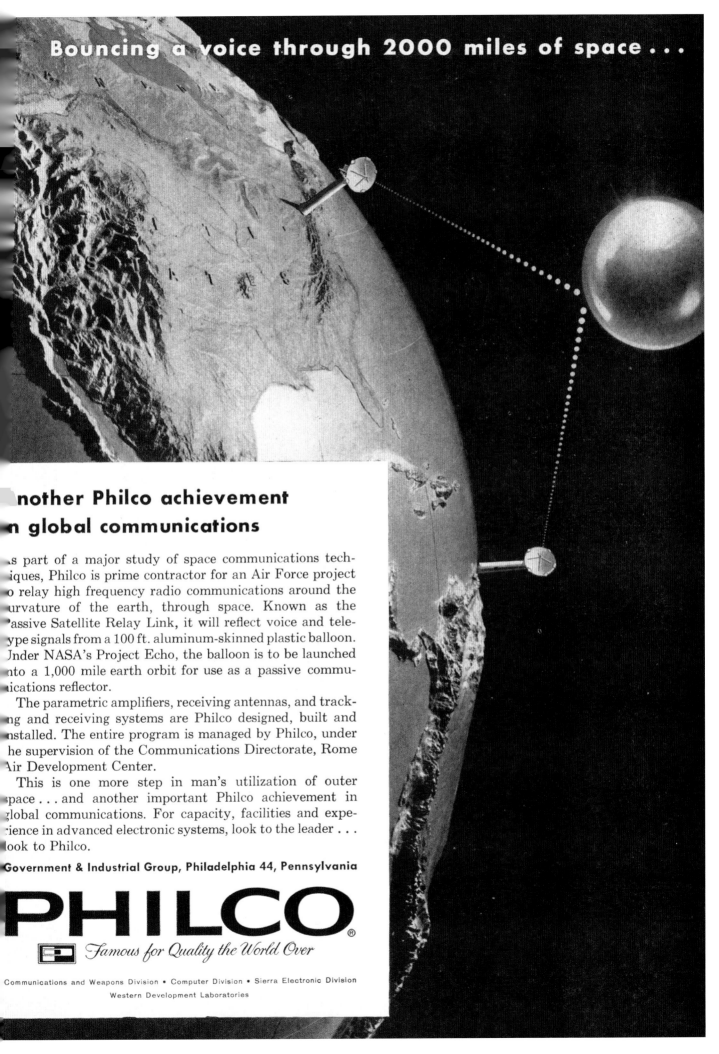

Bouncing a voice through 2000 miles of space...

nother Philco achievement n global communications

s part of a major study of space communications tech-iques, Philco is prime contractor for an Air Force project o relay high frequency radio communications around the urvature of the earth, through space. Known as the 'assive Satellite Relay Link, it will reflect voice and tele-ype signals from a 100 ft. aluminum-skinned plastic balloon. Jnder NASA's Project Echo, the balloon is to be launched nto a 1,000 mile earth orbit for use as a passive commu-ications reflector.

The parametric amplifiers, receiving antennas, and track-ng and receiving systems are Philco designed, built and nstalled. The entire program is managed by Philco, under he supervision of the Communications Directorate, Rome Air Development Center.

This is one more step in man's utilization of outer space ... and another important Philco achievement in global communications. For capacity, facilities and expe-ience in advanced electronic systems, look to the leader ... look to Philco.

Government & Industrial Group, Philadelphia 44, Pennsylvania

PHILCO®

Famous for Quality the World Over

Communications and Weapons Division • Computer Division • Sierra Electronic Division
Western Development Laboratories

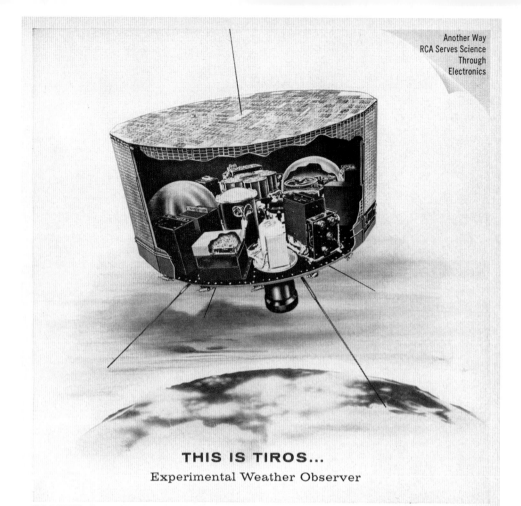

ABOVE: TIROS (Television Infrared Observation Satellite), the first weather-observing satellite, was created by RCA in partnership with the federal Advanced Research Projects Agency (ARPA) and later transferred to NASA. RCA and NASA used the term *television* in the general sense of images transmitted over distance. TIROS's camera was attached to a recorder that could hold up to thirty-two still images that were transmitted by radio signal to a recording tape on the ground. In its first year, *TIROS I* sent more than 22,000 weather images to scientists on Earth. *Aviation Week*, May 16, 1960

OPPOSITE: The satellite's function as a relayer of messages over long distance is conveyed by the comparison to the pony express, the original fast mail delivery service begun in 1860, in which relay riders carried messages by horseback. In this ad the Earth hangs above the earthbound riders, just as the satellite orbits Earth. *Aviation Week*, December 14, 1959

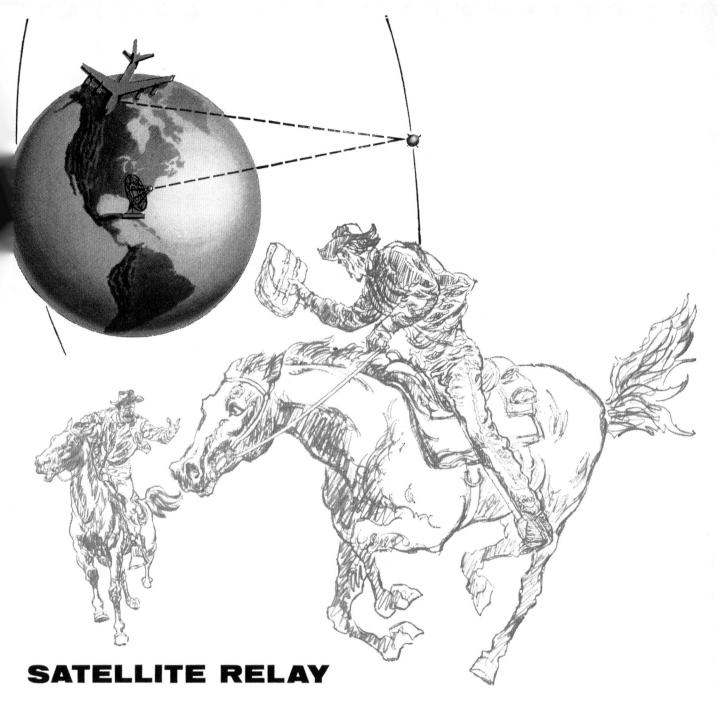

SATELLITE RELAY

. . . for modern long-range communications

Pony Express riders began an American tradition for the reliable relay of important messages over long distances. Today, Bendix is proud of its role in extending this tradition to SAC communications through the active radio relay satellite program.

Under Project STEER, Bendix has prime responsibility for the entire communication system. STEER will use polar orbit satellites to relay commands and pilot messages between Air Force ground stations in the United States and SAC bombers ranging on global missions. The ideal vantage point of a satellite relay will permit utilization of line-of-sight advanced UHF techniques. The fading and interference problems inherent in the ionospheric transmissions of present HF long-range communications will be avoided.

Other space age projects at the Bendix Systems Division include magnetohydrodynamics, highly reliable radiation-resistant communication equipment, interpretation and prediction of infrared reconnaissance, new satellite stabilization techniques, and communication methods to penetrate the ionized shock layer surrounding hypersonic vehicles. Additional projects involve satellites for weather and ground infrared reconnaissance, and for radio navigation.

Opportunities are open to better engineers and scientists interested in participating in advanced space programs in an ideal scientific climate.

Bendix Systems Division
ANN ARBOR, MICHIGAN

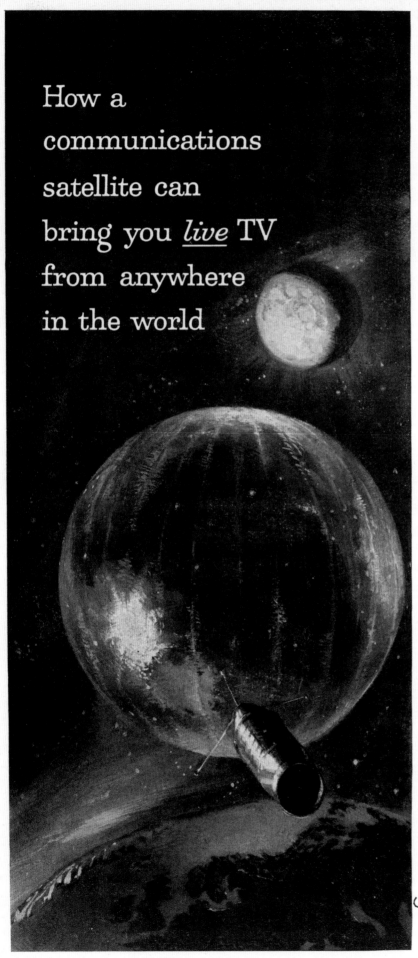

How a communications satellite can bring you *live* TV from anywhere in the world

World-wide <u>live</u> TV, with no cable or radio relay costs, can develop from outer-space research by government and industry

Among the peaceful applications for scientific break-throughs being made in the study of outer space is a communications satellite.

Using inflated plastic satellites, boosted toward orbit by the Air Force *Thor* rocket, a global TV network could be established. TV signals would bounce to satellite and back to your station, giving you a front-row seat at events anywhere in the world. Cost should be a fraction of coaxial cables and microwave relays now used.

Practicality of *Thor* for this purpose is based on its demonstrated reliability. With Douglas responsible for airframe fabrication and assembly and test of the entire system, *Thor* has helped launch 84% of all payload weight put into space by the U. S.; is the key booster in the Air Force "Discoverer" firings; launched the first nose cone recovered at ICBM range.

Thor is another product of the imagination, experience and skills which Douglas has gained in nearly 20 years of missile development.

Foil-covered satellite, folded like a pocket raincoat, would balloon out in orbit as an inexpensive TV relay station

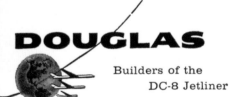

DOUGLAS

Builders of the
DC-8 Jetliner

MISSILE AND SPACE SYSTEMS • MILITARY AIRCRAFT • TRANSPORT AIRCRAFT • AIRCOMB • GROUND SUPPORT EQUIPMENT

How satellites can give us low cost emergency telephone service

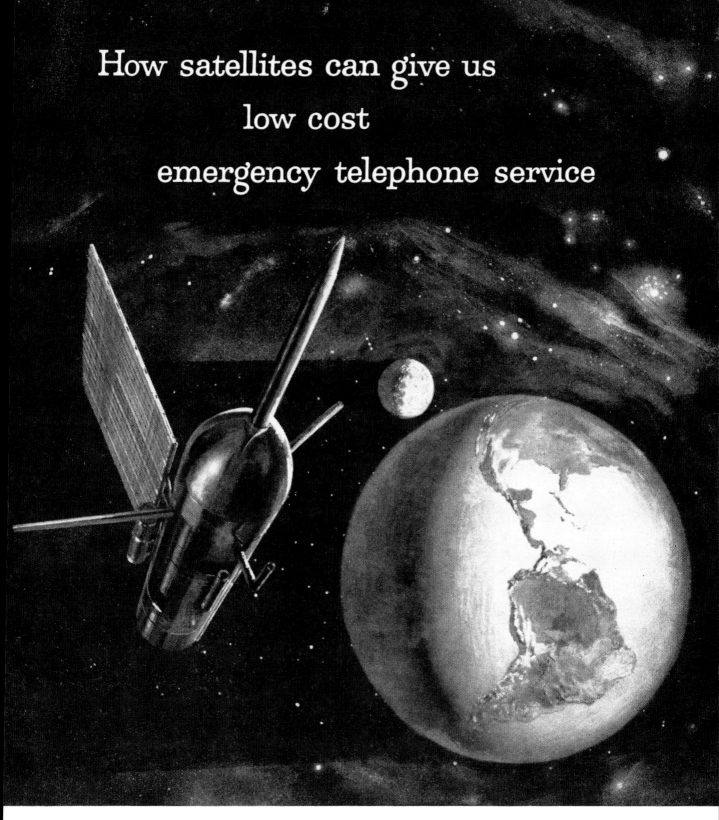

OPPOSITE: Depicting Echo in space, this ad's copy promises not delivery *to* any destination in the world, but broadcast *from* anywhere in the world. In other words, that all stations, from MSNBC to Al Jazeera, would one day be broadcast worldwide, quite a statement in a day when color television was in its infancy. *Aviation Week*, November 30, 1959

ABOVE: Emergency GPS-based roadside assistance, anyone? Few users of this service or of in-car navigation probably think of it as 1960 science fiction brought to life. The ads that Douglas, a titan of aircraft and rocketry (since merged with Boeing), ran in early space age aerospace industry periodicals tended toward futuristic ideas. *Missiles and Rockets*, January 11, 1960

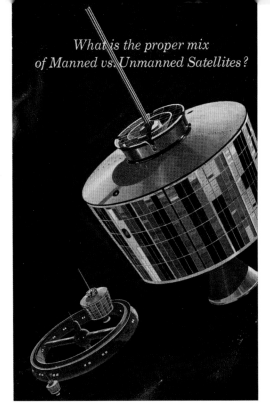

What is the proper mix of Manned vs. Unmanned Satellites?

LEFT: In a recruitment ad, Hughes Aircraft Company contemplated the future. An "unmanned" satellite is pictured in the foreground (kin to the TIROS); the wheel-shaped manned space station in the background followed a historical trajectory very different from the satellite. *Missiles and Rockets,* February 13, 1961

OPPOSITE: Visionary illustrator and science writer Frank Tinsley, who contributed many imaginative articles to pulp science journals in the 1950s, hypothesized a TIROS look-alike escape satellite. Here the satellite is deployed to rescue the crew of a space station after their home has been struck by an unseen object. *Aviation Week,* March 14, 1960

Satellites and the Future

In the mid-1950s the term *satellite* was still being used interchangeably to refer to (manned) orbiting space stations and to mechanical orbiting spacecraft. In Hughes's advertisement (above) the two kinds of satellites are clearly distinguished from each other and a question is posed to the readership: How will the two types interoperate in space in the future? Remarkably, the nearly insurmountable technological hurdles and prohibitive expense entailed in the design and construction of habitable space stations were not yet obvious in 1961. It was widely expected that such stations would become common in the near future and perhaps even outdo mechanical satellites for basic technological operations.

In *Escape in Space* (page 51) Frank Tinsley conceived, possibly in collaboration with the ad's sponsors at American Bosch ARMA Corporation, the idea of a "super satellite" of the future. The highly fantasticized vision of future emergencies and dramatic rescues in the advertising copy is consistent with Tinsley's writing, pointing to the likelihood that his influence extends beyond the image. Bosch ARMA's ad anticipates the problem that concerned the space community in 1960 and that we still face today on a scale scarcely imaginable a half century ago: the waste bin of the near-Earth orbital environment.

Satellites in the Sky

It's been a half century since satellites moved off the drawing boards of engineers and into the sky. In that time all of the uses for satellites both suggested and imagined in these advertisements have come to pass. Satellites are the most numerous form of spacecraft, and their applications have been proxies for earthly conflicts over space ever since *Sputnik 1*'s launch. The twelve-year race between the United States and the USSR to reach the Moon was simple compared to the battle for satellite supremacy. Once the United States reached the Moon the race was over and the "losing" competitor

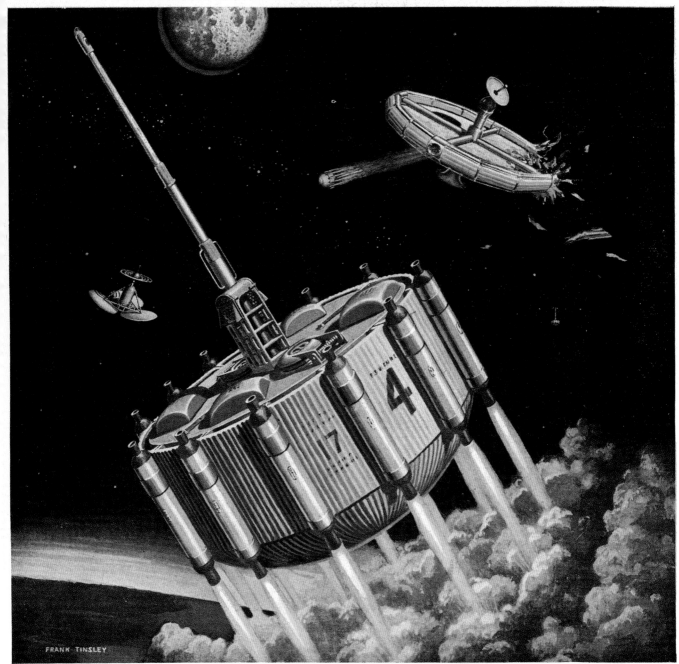

FRANK TINSLEY

STEPS IN THE RACE TO OUTER SPACE

Escape In Space

The space-assembled super satellites of the future will periodically encounter disaster—collision, mechanical failure, military attack, or the long chance of being hit by a meteorite. When this happens, "life boats" like the one shown here will bring their crews safely back to earth.

Here is the operational sequence of an escape in space:

1. Crew members don pressure suits and strap themselves into decelleration beds within the pressure-intact unit.

2. At the "Abandon Ship" signal, low-power, RATO-type launching rockets blast the sealed capsule from the threatened station (upper right illustration).

3. Acting on orders from an astrogational computer, the retro-rockets check the capsule's speed and break it out of orbit. (Foreground. Note details of offset heat shielding, hatches, slow-down parachute covers.)

4. As the capsule enters the outer atmosphere, the heat shield protects the astronauts. The life boat's momentum slows even further, and the shield is jettisoned as it cools.

5. Four parachutes are released, acting as air brakes. After a computed interval, other chutes are released.

6. The capsule lands in a predetermined

sea rescue area, and a ring of flotation bags inflate. A radio broadcasts the craft's location, and a bright sunshade serves as a visual and radar target for rescuers.

———

ARMA, now providing the inertial guidance system for the ATLAS ICBM and engaged in advanced research and development, is in the vanguard of the race to outer space. For this effort, *ARMA* needs scientists and engineers experienced in astronautics. *ARMA*, Garden City, New York. A Division of American Bosch Arma Corporation.

AMERICAN BOSCH ARMA CORPORATION

Prying saucer!

LEFT AND OPPOSITE: Using eyes to suggest the sense of seeing, here the dishes are effectively incorporated into another body, be it owl or human, that animates the machine. The owl symbolizes intelligence gathering through visual perception, evoking the climate of concern along with the balance of state powers that underlay the early U.S. satellite effort. Artist: Soisson, *Aviation Week*, May 9, 1960; *Aviation Week*, March 7, 1960

largely withdrew. By contrast, the Sputnik launch spurred a half century of satellite one-upmanship that still has no end in sight, and within fifteen years the sparring spread beyond the two superpowers throughout the industrialized world.

That competition is public in the commercial realm, but as a military tool satellite use continues to be shrouded in secrecy. The U.S. government's "black budget" is completely hidden from the public and is accountable only to a few members of Congress. In publicly known military projects satellites are coming to be overshadowed by technologies that will turn individual soldiers into cyborgs. Less useful in the "global war on terror" than in the cold war that hatched them, satellites were blamed by some in the early 2000s for creating a false perception that threats against the United States were knowable.[19]

Much has been done to cultivate satellites as observational platforms for RF-spectrum intelligence, real-time imaging, and photographic remote sensing. Not only has the GPS become ubiquitous, but remote sensing technology developed to spy on governments has created a worldwide civil liberties problem, as the entire Earth's surface has become visible to anyone with a broadband connection. More people now are spooked by seeing their homes and cars parked in driveways on Google Earth than were "spooked" by the spook industry of the 1950s and '60s.

With these shifts, satellite use has become fragmented. In the 1950s the United States and the USSR held each other—and the world—in the grip of their face-off. The optimism in the postwar boom years in the United States contrasted sharply with the worldwide undercurrent of anxiety about the atomic threat. A tension between military and peaceful uses for new technologies likewise was present in the burgeoning space industry. Since the 1950s, these conflicts have fractured and become more complex.

Satellites still play a dominant role in territorial competition among nation-states both in space and through the use of space. China became the latest country to destroy

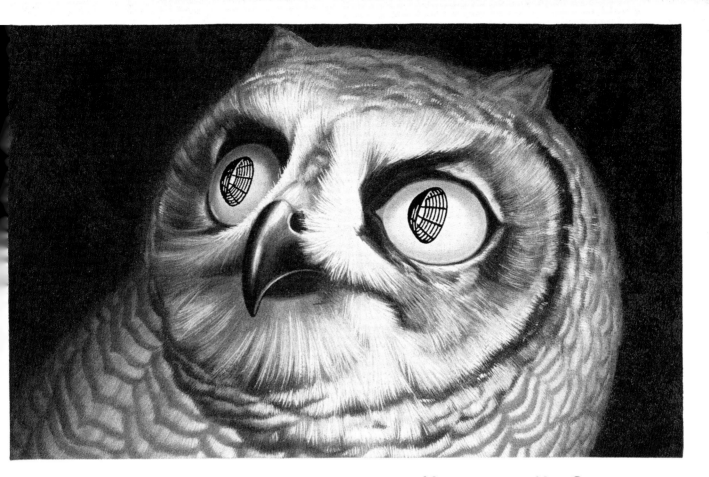

Marvelous new "eyes" for our defense...through

hallicrafters QRC *

Some dark night, America's defense may well rest upon our ability to "see" what our enemies are up to. This is the urgent mission of Electronic Reconnaissance—uncanny "eyes" with which we can detect enemy electronic signals, *and determine exactly the location, type and capability of the signal source.*

Since 1952 Hallicrafters, through its *Quick Reaction Capability Program, has been instrumental in the rapid development and continuous improvement of Electronic Reconnaissance systems.

Today Hallicrafters QRC is being applied effectively to an increasingly broad area of military electronics, including airborne ECM, communications, SAGE and missile systems.

Put this dynamic design and production force to work now. From single circuit to complete system . . . for land, sea, air or space application . . . you'll get reliable answers quickly and efficiently.

ENGINEERS: Join our rapidly expanding QRC team now. For complete information address inquiries to: William F. Frankart, Director of Engineering.

hallicrafters h company

MILITARY ELECTRONICS DIVISION CHICAGO 24, ILLINOIS

U R G E N T P R O B L E M S R E L I A B L Y S O L V E D

LEFT: Varian Associates is the engineering firm responsible for the Klystron tube technology that drove radar systems during World War II. This ad for a radar transmitter at the Arecibo Observatory in Puerto Rico suggests that the dish *is* the human eye of the future. *Missiles and Rockets*, October 2, 1961

OPPOSITE: The Swiss-American graphic artist Willi K. Baum depicted the dish as a device through which we may gaze to the Andromeda galaxy, 1959. Courtesy of the author

a satellite (one of its own that had been retired) with a ground-based missile, in January 2007, and is by some measures now among the most dominant in the military satellite world. Although satellites may be in decline as offensive tools, the vulnerability of all satellites exposed by China's demonstration has shifted the ground in the struggle for satellite superiority. In April 2008 the U.S. Air Force ran a television recruitment commercial promoting careers in *defending* satellites from attack.[20] The ad was soon satirized in a Capital One credit card commercial.[21]

The debris generated by China's successful test temporarily increased by 25 percent the amount of space junk in orbit. This is perhaps even more important than the implications of China's military might, as space junk will remain in orbit causing problems long after the balance of power between nation-states has shifted again and again. The problem of space junk binds satellites to the environmental issues of space and reflects the extremes of utopian and dystopian promises of space.

In the future that began with these advertisements and that many still dream toward, space is above all *wide open* to exploration and inquiry, not crowded with space junk. The collective dream of looking outward into space that began with the IGY has continued unabated, and satellite-based observations have yielded some of the most exciting space research of the late twentieth and early twenty-first centuries. Data and images collected by NASA's Hubble space telescope and other sky-observing satellites such as the international Fermi Gamma-Ray Space Telescope have changed the way that scientists and the public think about outer space. Through the use of satellites, space probes, and lunar and Martian landers and rovers, space has become vastly more vivid, exciting, complex, and accessible than ever. But the problem of space junk creates a new tension. The long-dead push–pull between competing cold war superpowers that brought about the space age has yielded to this subtler tension between two extremes.

HE MARTIN METHOD: *Space Communications*

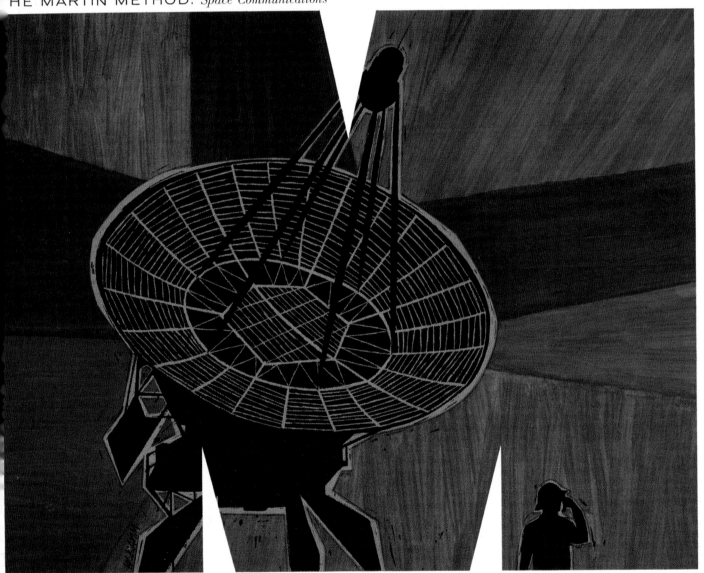

Another program at Martin offering unique opportunities to engineers and scientists who want to advance in the professional fields as rapidly as their capabilities permit. Perhaps you should do it now. Just write to N. M. Pagan, Director of Technical and Scientific Staffing, (Dept. 2A) The Martin Company, P.O. Box 179, Denver 1, Colorado.

MARTIN
DENVER DIVISION

2. The Human Body in Space

The Reach

In the summer of 1958, six months after the first successful U.S. satellite launch, the dramatic image of a hand reaching toward space first appeared in aerospace advertising (page 60). Pointing to the Moon, the hand dared readers to imagine the next frontier now that satellites had opened up space. The "big reach" into space represented by such advertising imagery reflects the centrality of the human experience in emerging space exploration. These pictures say not only that the Moon is the next step but that *mankind is going there* (and our small engine parts will help!).

The Human Body as a Symbol for Manned Spaceflight

Even at the onset of the satellite age, human spaceflight—termed "manned spaceflight" at the time—was still the stuff of fiction to most. It abruptly became a reality in 1961 as millions worldwide watched newsreels of the jubilant cosmonaut Yuri Gagarin returning from space. The success of the Soviet Union in sending a human being into space redefined everyone's notion of human space travel as a possibility into which anyone could project him- or herself. The United States' Project Mercury took on the glow of inevitability: it would soon be America's turn.

In 1957 virtually everyone who would come to work on Mercury or its successors, Gemini and Apollo, was yet to become employed in the aerospace field. Industry employment nationwide that year numbered only in the tens of thousands. Project Mercury, initiated in 1958, succeeded in placing astronaut John Glenn into orbit around the Earth on February 20, 1962. During those four years the burgeoning aerospace industry saw a tremendous growth spurt. By 1961 McDonnell Aircraft accounted for two hundred thousand people connected with the development of Project Mercury.[1] Those numbers continued to grow, as in May 1961 President Kennedy declared the U.S. goal to land a man on the Moon by 1970.[2] Kennedy's announcement was coordinated with a significant budgetary increase for NASA:[3] its 1962 budget for human spaceflight was

OVERLEAF PRECEDING: Detail, page 83.

OPPOSITE: Detail from an advertisement for Ex-Cell-O Corporation's precision rocket and missile parts. *Aviation Week*, February 16, 1959

An advanced concept

The Singer Manufacturing Company announces the formation of its Military Products Division, which through its three functional units, Haller, Raymond & Brown, Inc., Diehl Manufacturing Company, and Singer Bridgeport Division, can efficiently handle complex electro-mechanical and electronic programs from concept to completion.

THE SINGER MANUFACTURING COMPANY
Military Products Division
149 BROADWAY, NEW YORK CITY 6, N. Y.

LEFT: Look where we're going next! asserts this advertisement from the Singer Manufacturing Company. *Aviation Week*, July 14, 1958

PAGE 58 AND OPPOSITE: The bold, red hands in these advertisements are neither planted nor superimposed onto terra firma but are one and the same with the rocket's trajectory. The precision workmanship and products of two small-parts manufacturers are advertised—the bold reach of small companies! Opposite: *Aviation Week*, August 17, 1959

126 percent higher than its 1961 budget.[4] This increase, and other successive increases in the early 1960s, allowed Project Apollo to meet Kennedy's goal with the landing of astronauts Neil Armstrong and Buzz Aldrin on the Moon on July 20, 1969.

As part of a massive recruitment effort, artists and copywriters channeled popular dreams about humanity's spacefaring future into visionary works. To entice the workers needed to build Project Mercury and the anticipated Project Apollo, the aerospace industry developed ads that associated each company's product with the astronaut's journey into space. The most recognizable image in the world, the human body was the natural motif of choice. The human body in space conveys the promise of the adventure and risk of traveling from Earth's safety to the precarious unknown and back again and of eventually domesticating space, making it home.

Disembodied parts as a design element had an antecedent in the surrealist art movement. Surrealism of the 1930s dissociated parts from wholes, routinely depicting fragments of the human body in aesthetic metaphors. In the 1940s mid-century modern design arose, featuring simple organic forms and spare lines. Exemplified by curvilinear shapes and soft forms, organic design[5] became familiar in furniture designs by Eames and Saarinen. The theory of organic design held that objects should be developed naturally and rationally into forms according to formation and ultimate use.[6] The human body was mapped onto manufactured furniture, for instance, and the form was an expression of function. In the same way, depictions of the human body and its component parts became integral to the design of our concept of space travel.

Just as the eye symbolized vision by satellite technology, hands, feet, and heads presented different humanized ideas of space travel. Full human figures filling an ad represented broader notions: space as the dangerous modern atomic age; space as a comfort zone that will warmly receive humankind; and space as a place where the

Reaching for the Moon, Mr Designer?

Here's a tip...Millions of Kaylock® nuts ago, a new aircraft fastener made its bow...the Kaylock H20, first lightweight, high tensile, all-metal, self-locking nut.

Its significant improvement over then-existing fasteners — lighter weight, greater strength, smaller envelope — won immediate acceptance by airframe weight engineers and designers.

Today, with a premium on weight and space savings in aero-space vehicles and engines, design engineers depend more than ever on Kaylock nuts. So here's a tip...

If you're reaching for the moon, Mr. Designer, reach for your up-to-the-minute Kaylock catalogs first. Chances are, *your* "brainchild" will *get there sooner.*

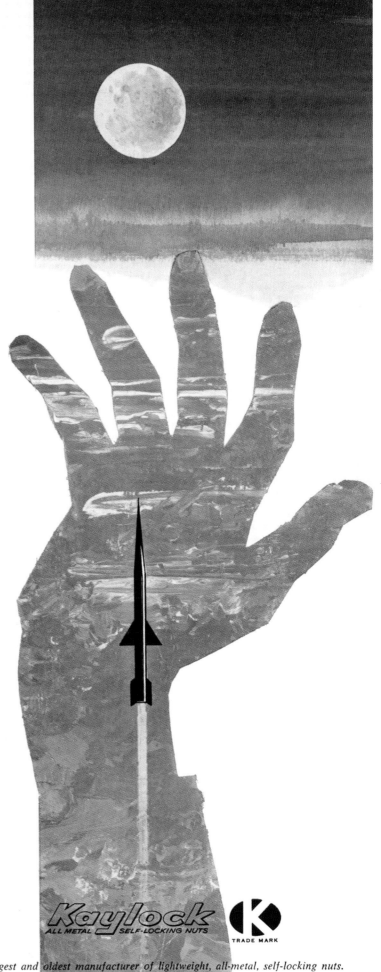

Fastener with a past — that's the Kaylock H20. A favorite callout of design engineers for the past 3 years, the H20 was the first high tensile, all-metal nut using the elliptical self-locking principle for which Kaylock nuts are famous. "Vital statistics" include:

Service Temperature: 550°F
Tensile Strength: 180,000PSI
Material: Alloy Steel

Ready to Help — Here are a few of the Kaylock external wrenching nuts built to meet rigid requirements in weight and space reduction.

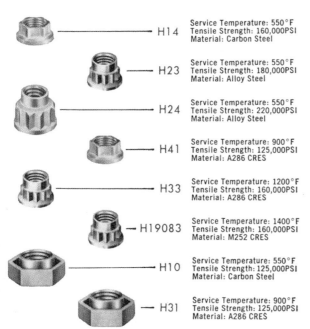

— H14 Service Temperature: 550°F
Tensile Strength: 160,000PSI
Material: Carbon Steel

— H23 Service Temperature: 550°F
Tensile Strength: 180,000PSI
Material: Alloy Steel

— H24 Service Temperature: 550°F
Tensile Strength: 220,000PSI
Material: Alloy Steel

— H41 Service Temperature: 900°F
Tensile Strength: 125,000PSI
Material: A286 CRES

— H33 Service Temperature: 1200°F
Tensile Strength: 160,000PSI
Material: A286 CRES

— H19083 Service Temperature: 1400°F
Tensile Strength: 160,000PSI
Material: M252 CRES

— H10 Service Temperature: 550°F
Tensile Strength: 125,000PSI
Material: Carbon Steel

— H31 Service Temperature: 900°F
Tensile Strength: 125,000PSI
Material: A286 CRES

Kaylock
ALL METAL SELF-LOCKING NUTS

K TRADE MARK

YNAR MFG. CO., INC.– KAYLOCK DIVISION • *World's largest and oldest manufacturer of lightweight, all-metal, self-locking nuts.*
ne office and plant: Write Box 2001, Terminal Annex, Los Angeles 54, California
ch offices, warehouses and representatives in Wichita, Kansas; New York, N. Y.; Atlanta, Georgia. Canadian Distributor: Abercorn Aero, Ltd., Montreal, Quebec.

new science of space medicine will grow. The body motif also convenes a synergy
between the idea of manned spaceflight and the aerospace industry's need to man
its workforces.

A Short History of Space Advocacy

A fever of space boosterism pervaded movies, music, magazines, and television
throughout the 1950s, and space advocacy was well established.[7] But it was a series
of articles published in *Collier's* magazine from 1952 to 1954 that pushed it into
the mainstream public eye. Written by the German émigré rocket engineer Wernher
von Braun and other leading space advocates such as Willy Ley and Fred Whipple,
the *Collier's* articles were illustrated by the top space illustrators of the day, Chesley
Bonestell, Rolf Klep, and Fred Freeman. They were grouped under the headline *Man Will
Conquer Space Soon*, and they presented human spaceflight as not only glamorous but
utterly inevitable. "Development of [a] space station is as inevitable as the rising of the
sun," von Braun wrote optimistically. "Man has already poked his nose into space and
he is not likely to pull it back."[8]

In the series, the engineers and illustrators detail the plan for human exploration
of space in clear, discrete steps. After rocket construction, an enormous orbital space
station was to be constructed to allow relocation of major preparations in staging
further explorations. From the space station, rockets would carry human space
colonists to the Moon and then Mars. This progression, known as the "von Braun
paradigm," has influenced public policy on space exploration to varying degrees ever
since. "[I]t will be almost impossible for any nation to hide warlike preparations,"[9]
von Braun wrote, describing the watchful eyes of the "spacemen" sentries who would
monitor the Earth's surface through space station cameras and telescopes. But von
Braun's prediction didn't take into account how quickly mechanical satellites would be
able to perform surveillance without armies of human sentries.

From 1955 to 1957 von Braun collaborated with Walt Disney on three one-hour
prime-time television specials.[10] "Man in Space," "Man and the Moon," and "Mars and
Beyond" presented a less militaristic, peace-oriented (for children) view of the same

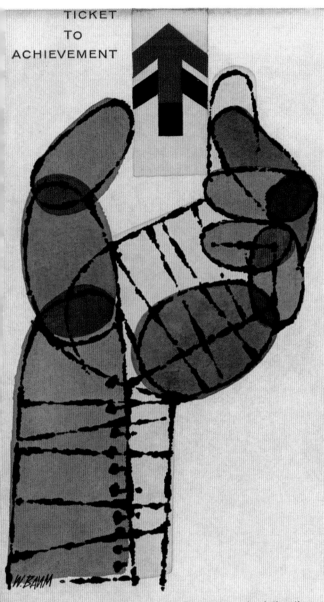

TICKET
TO
ACHIEVEMENT

W. BAUM

To the creative engineer, there is nothing more stimulating than to work in a creative environment. Space engineering programs now in progress at Martin-Denver demand unusual creativity and may be your ticket to the personal and professional achievements which you are seeking. Make your desires and qualifications known to N. M. Pagan, Dir. of Tech. and Scientific Staffing, The Martin Company, (Dept. CC7) P. O. Box 179, Denver 1, Colo.

MARTIN
DENVER DIVISION

TAKE A GIANT STEP

...into your future and seek out the professional opportunities awaiting creative engineers and scientists at Martin-Denver... For here exists the most challenging problems in space and human engineering. Join with us and communicate with N. M. Pagan, Director of Technical and Scientific Staffing (Dept. CC-10), The Martin Company, P. O. Box 179, Denver 1, Colo.

MARTIN
DENVER

paradigm of technological development. They also further solidified in the public eye the "natural" progress of sending humankind into space. Disney, like science fiction illustrators of the time, used the visual motif of the finned rocket, which came to be synonymous with human lunar and Martian exploration. In the von Braun–Disney episodes mechanical or robotic spacecraft are almost totally absent. Teams of human space workers staff *everything*. Although the term *astronaut* was not popular until the early 1960s, the crews of the ships, stations, and bases in the Disney shows were large—no two- or three-person teams went into space in the scenarios described in *Collier's* or in Disney's *Tomorrowland*, but teams of twenty, fifty, or a hundred.

NASA's three human spaceflight programs, Projects Mercury, Gemini, and Apollo, readily absorbed the hype that had built during the 1950s. The three programs successfully realized the emerging ideology behind the desire to send people into space. Then, in 1969, eleven years after NASA was founded, Apollo 11 reached the pinnacle of public spectacle—and historic breakthrough—by successfully landing astronauts on the Moon. The spectacle surrounding the Moon landing rewrote the history of the space program, or at least the version of that history that became public memory. The Moon landing almost entirely obscured the debate about the value of human as opposed to robotic spaceflight that arose in the media and in the scientific community and reached a fever pitch between 1959 and 1962. Public amnesia about this debate is understandable: the Moon landing established a standard of achievement that has driven our sense of human potential ever since.

The Raging Debate: Counter Opinions

The debate over human spaceflight is grounded in the wish to base space exploration on real-world scientific needs. The human spaceflight program of the 1960s in some ways confirmed many of its critics' judgments, even as it overwrote the record of their opinions. While spectacular, the Moon landing pointed to no clear direction for future spaceflight. No new life-forms were found in that historic trip to the Moon, nor were any remunerative resources to offset the expense of building permanent colonies. A chief criticism of the human spaceflight program was that it existed for its own sake,

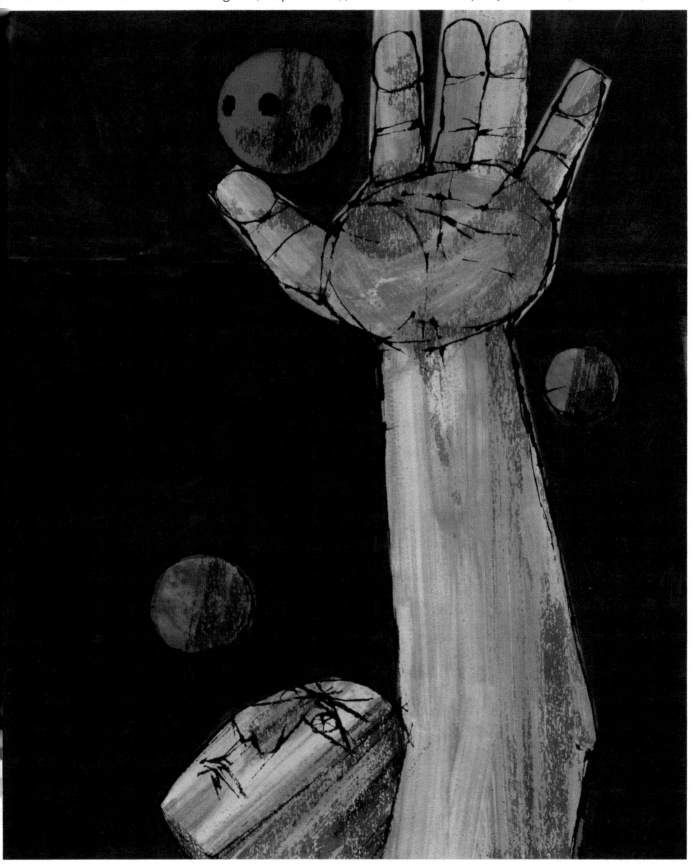

Toward the preparation of man for the first steps into deep space, the Martin space medicine research program and space ecology laboratory facilities — now in development at the Denver Division — are among the most advanced activities in the free world. Especially noteworthy is the Martin Lunar Housing Similator. This will be a self-sustaining environmental closed system which will permit advanced study of survival requirements and techniques applicable to airless lunar or planetary conditions.

THE FIRST STEP

Martin-Den is one of eight divisie of The Martin Compa

← **MARTIN**
BALTIMORE · DENVER · ORLANDO

rather than as a component of a larger scientific exercise. Its collapse in the 1970s bore evidence to the kernel of truth within that criticism.

Criticism started early and was much more public than the analogous commentary is today. As early as 1958 Cal Tech president Lee DuBridge was quoted in a *Time* article titled "Take Off That Space Suit"[11] as saying that "for most scientific explorations in space, the presence of man involves quite unwarranted complications and expense not justified by what he can contribute to the success of the venture."

In 1960 Dr. James Killian, scientific adviser to Eisenhower and chairman of the M.I.T. Corporation, opined, "True strength and lasting prestige will come from the richness, variety, and depth of a nation's total program.... Many thoughtful citizens are convinced that the really exciting discoveries in space can be realized better by instruments than by man."[12] In the same year *Science* magazine ran an editorial, "Space Exploration as Propaganda,"[13] while *Science Digest* in the following year printed an article by an IBM engineer condensed from IBM's house organ, *Think*, pointing out that space-bound payloads cost about $100,000 per pound and that instruments weigh drastically less than a man plus food and oxygen supplies.[14] In spring 1961 too *The Nation* quoted the twentieth-century science giant Dr. Vannevar Bush saying, "Putting man in space is a stunt. The man can do no more than an instrument, in fact can do less."[15]

The staggering cost of man-in-space plans received a full hearing in the court of public opinion. *U.S. News and World Report* took on the derailing of the human spaceflight program as something of an institutional imperative. In three years the magazine devoted thirty-seven pages to features scrutinizing the expense and extravagance of the program. Challenging headlines appeared in other national magazines in the same era: "Gathering Storm Over Space"; "The U.S. in Space: Anybody Happy?"; "Man-in-Space Program Wastes Money and Effort"; and "Pie in the Sky."[16]

The disagreement between space advocates and critics arose from the gap between scientific and human interests. Amid public vitriol, the very belief in human spaceflight became an ideology at risk. All the work achieved by space advocates might not survive the pressures of budgetary constraints and scientific rationality if the belief could not

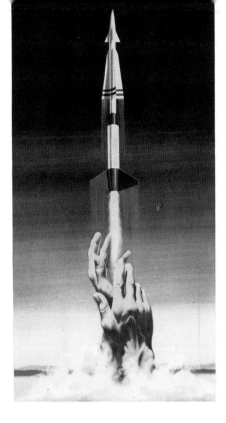

LEFT: The gesture of reach is transformed into a launch as a rocket erupts from hands in a Kelsey-Hayes ad for rocket parts. *Aviation Week*, July 13, 1959

OPPOSITE: Butterworth's ad presents a less contemplative vision, with an assertive gesture that reflects a military focus on rocket technology while calling to mind the Christian iconography of Jesus' hands disembodied and surrounded by heavenly clouds. *Missiles and Rockets*, July 20, 1959

be maintained. The two hundred thousand recruits hired during these years would be little needed if critics prevailed, given the substantially smaller budgets of mechanical and robotic space exploration programs.

Social historian Linda Billings has observed that the project of human spaceflight needs a working ideology to progress as a technological enterprise.[17] The body imagery in the ads appearing during this contested period takes on another layer of meaning. By creating an intimate, physical association between reader and product, they serve the cultural need Billings described: these ads promote the human experience as an essential component in space exploration.

The Reach Extends

The visual language of Butterworth's advertisement for its rocket parts (opposite) features billowy clouds and disembodied hands reminiscent of Christian iconography. An association is made between space—"the heavens"—and belief in the sacred. The Bomarc missile advertised, however, was nuclear-warhead capable. Although the missile's propulsion system did have civil applications, the "heavenly" space environment used to portray it here obscures its military use. As a graphic comment on the destructive power wrought by A bomb–capable missiles, this image perversely extends the optimism expressed by the reaching hands in other advertisements to the threat of nuclear war.

The Step

In 1961 when the ads for General Motors' lunar-rover development team (page 70) and Aerojet-General's California rocket engine factory (page 71) appeared, little was known about the Moon's surface. Scientists had hypothesized that it might be covered by a layer of dust some several inches deep.[18] Doubt existed in the scientific community

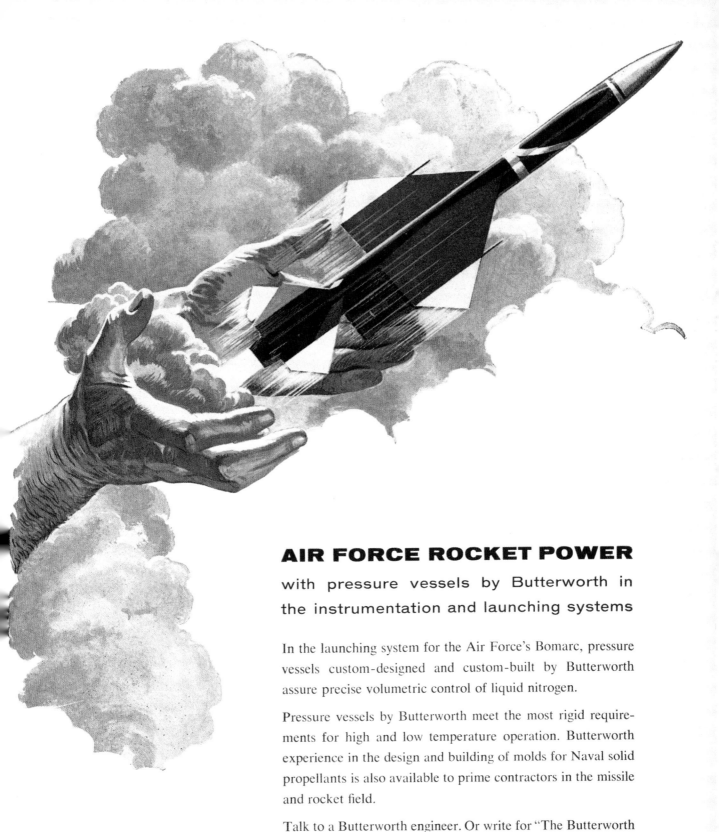

AIR FORCE ROCKET POWER

with pressure vessels by Butterworth in the instrumentation and launching systems

In the launching system for the Air Force's Bomarc, pressure vessels custom-designed and custom-built by Butterworth assure precise volumetric control of liquid nitrogen.

Pressure vessels by Butterworth meet the most rigid requirements for high and low temperature operation. Butterworth experience in the design and building of molds for Naval solid propellants is also available to prime contractors in the missile and rocket field.

Talk to a Butterworth engineer. Or write for "The Butterworth Story", a quick-tour of our complete metalworking facilities.

BUTTERWORTH
Division of VAN NORMAN Industries, Inc.
Metalworking for Industry Since 1820
H. W. BUTTERWORTH & SONS CO. • BETHAYRES, PA.

Circle No. 9 on Subscriber Service Card.

How
deep
is
moon
dust
...or
is
it
dust?

GM's DSD seeks an answer!

Scientific studies are now under way in GM's Defense Systems Division to determine the most efficient configurations for lunar-roving vehicles. Major factors under investigation include composition of the lunar surface together with the effects of large temperature ranges, lunar gravity . . . no atmosphere or humidity. Research in our Soils Laboratory on probable lunar conditions has led to a number of promising designs. Unusual studies like these, unusual facilities and unusually capable men present a great challenge and opportunity to scientists and engineers who are qualified to make a solid contribution at any level. DSD is now, as always, searching for new talent in these areas.

Scientific areas now under study: ■ Aero-Space Operations ■ Sea Operations ■ Land Operations ■ Biological Systems ■ Technical Specialties

Moon-Roving Concept—This early model moon rover utilizes the principle of the Archimedes screw . . . and is just one of a number of vehicle types under study for known lunar conditions.

GENERAL MOTORS

DEFENSE SYSTEMS DIVISION

DEFENSE SYSTEMS DIVISION OF GENERAL MOTORS CORPORATION • WARREN, MICHIGAN AND SANTA BARBARA, CALIFORNIA

Circle No. 57 on Subscriber Service Card

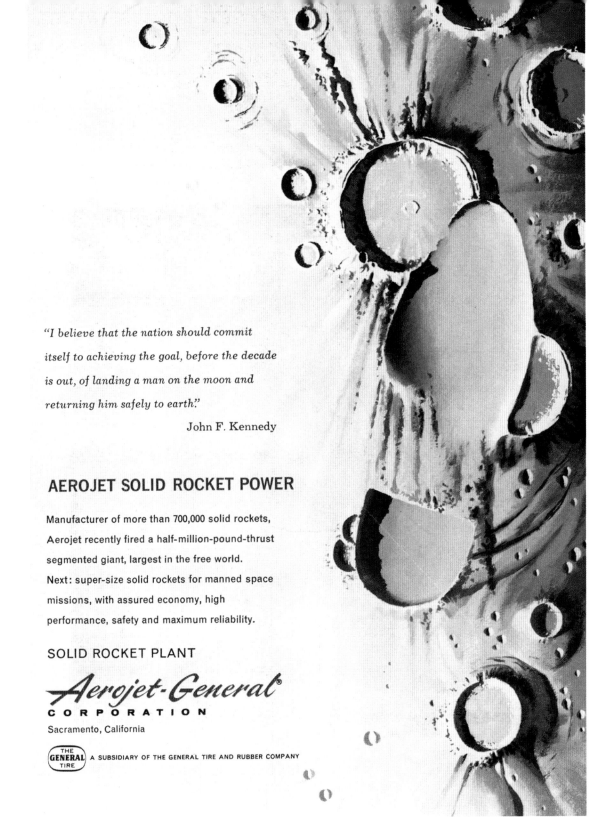

> "*I believe that the nation should commit itself to achieving the goal, before the decade is out, of landing a man on the moon and returning him safely to earth.*"
>
> John F. Kennedy

AEROJET SOLID ROCKET POWER

Manufacturer of more than 700,000 solid rockets, Aerojet recently fired a half-million-pound-thrust segmented giant, largest in the free world. Next: super-size solid rockets for manned space missions, with assured economy, high performance, safety and maximum reliability.

SOLID ROCKET PLANT

Aerojet-General®

C O R P O R A T I O N

Sacramento, California

(THE GENERAL TIRE) A SUBSIDIARY OF THE GENERAL TIRE AND RUBBER COMPANY

ABOVE AND OPPOSITE: The lunar surface footprint in Aerojet's rocket power ad (above) unmistakably supports a pro-manned spaceflight ideal. But having seen footprints on the Moon, we know that they differ from this image—astronauts did not wear wingtips to the Moon. General Motors' advertisement opposite pictures a more realistic assessment of lunar footwear. *Missiles and Rockets*, November 17, 1961; December 18, 1961

This is the first space that must be conquered

Two thousand years ago Lucan wrote about a trip to the moon. Today, the two thousand years of dreaming he inspired are close to fulfillment.

Experience in building things from dreams has always been part of Ex-Cell-O. Precision in design, precision in manufacture for forty years has been the Ex-Cell-O tradition. Now as we near the conquest of space, even more important becomes speed of translation from dream to reality. And for this Ex-Cell-O's history and facilities are yours for the asking.

EX-CELL-O FOR PRECISION (XLO)

 Aircraft Division

MAN AND MISSILES FLY HIGHER, FASTER AND SAFER WITH PARTS AND ASSEMBLIES BY EX-CELL-O AND ITS SUBSIDIARIES: BRYANT CHUCKING GRINDER CO., CADILLAC GAGE CO., MICHIGAN TOOL CO.

LEFT: Alongside its recruitment message Ex-Cell-O's ad engages the quest to turn dreams into reality through technology as it references the Roman legacy of curiosity about space. *Aviation Week*, March 16, 1959

OPPOSITE: The stern, fixed gaze of an astronaut tops a curious offer: "circular space computers are available free to interested persons." Artist: Willi K. Baum, *Aviation Week*, March 14, 1960

as to whether the surface that man, or a spacecraft, would set down on was solid. Some early plans called for unmanned missiles to shoot payloads of fluorescent paint or glitter onto the surface of the Moon so scientists on Earth could gauge the surface reaction. By December 1961 President Kennedy's commitment to land a man on the Moon by decade's end had rippled throughout the industry and catalyzed the mere reach into space to become a more certain step.

The Head

In 1946 the artist Herbert Matter created "Atomic Head" (detail, right), a profile silhouette of a human head filled with a photograph of a mushroom cloud whose cap occupies the cavity.[19] Matter's head is a locus of fear, a symbol of the overwhelming shock of the birth of the atomic age. Like Matter's portrait, the head in Ex-Cell-O's ad (above) is filled with explosives: two rockets and one earthbound missile. Unlike Matter's art, the intent here is to express man's imagination as the space of unlimited potential.

The rocket firing inside the head will remind some of the missile-predictive ability of Thomas Pynchon's Tyrone Slothrop, the antihero of *Gravity's Rainbow*. Pynchon had been a technical writer at Boeing before he published his first novel.

Aerospace recruitment ads are most seductive when aimed at engineers and scientists who all wanted to regard themselves as a creative contributor to the new space age—even those who wound up at desk jobs drafting new nut and bolt designs. The motif of the human head was a natural choice for sponsor corporations to appeal to their high hopes and entreat them to believe in, and join, their design teams.

Dating from 1959, the face in Temco's ad (page 74) is among the earliest and most personalized depictions of a person who might be or become an astronaut. The illustration seems vaguely genderless, more likely in the interest of presenting the most

THE NEW
IN VIEW!

At Martin-Denver exciting and vast new space engineer-
ing programs are in progress. These programs demand un-
usual creative talent. If you have this talent and want rapid
professional advancement, please make this known to N.
M. Pagan, Dir. of Tech. & Scientific Staffing, (Dept. CC8),
The Martin Company, P. O. Box 179, Denver 1, Colorado.

MARTIN
DENVER DIVISION

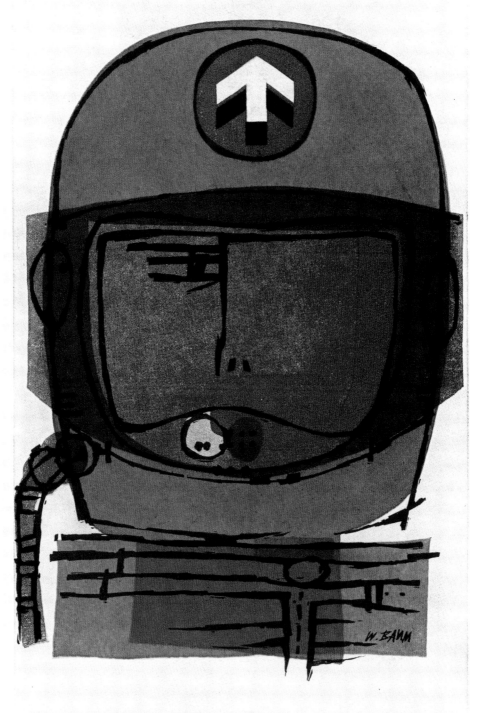

W. BAHM

LEFT: This ad from Temco features a personalized face, humanizing the technical work of building rockets and electronic components for the space race. *Missiles and Rockets*, January 26, 1959

OPPOSITE: The human eye symbolizes the human mind in this recruitment ad from Goodyear Aircraft. *Aviation Week*, November 25, 1957

generic, broadly identifiable human face possible than as an acknowledgment of the many women working in the early aerospace industry.

The Upright Body

Upright, forward-striding astronauts are widespread in the illustrations of commercial aerospace literature of the late 1950s. Each company sought to depict its own astronaut with the greatest appeal to promote its products, recruit its workforce, and solidify its name in the industry.

On a mission with a human crew, the vast majority of the budget and technology goes toward life support; scientific research and instrumentation are admittedly secondary. Research science and human spaceflight exist as separate budgetary line items and separate programs within NASA.[20] As a result, companies competed fiercely with one another for funding to develop life-support systems. Companies such as B. F. Goodrich that specialized in life-support systems sought at the dawn of human spaceflight to obtain development contracts that would have been drastically curtailed had human spaceflight's critics prevailed. Other companies that did not work in life-support-systems technology advertised with images of astronauts' bodies as a visual metaphor for the general mechanical systems of emerging spacecraft.

The Precarious Body

The outreaching hand pointing toward the Moon, the vision of lunar footprints—these are images that express ideas and emotions that defined the birth of the space age. But images that present the precariousness of humankind in space go beyond, depicting subtly powerful forces of the historical moment.

The juxtaposition of cold war anxiety about atomic apocalypse and the unprecedented postwar boom in the U.S. economy and in the birthrate created a

for minds with 20-20 vision

THE ABILITY to see clearly with the mind's eye is characteristic of most good engineers. Nowhere is it more highly prized than here at Goodyear Aircraft.

Our creative engineers are men of talent and training, of course. But beyond that, they are men gifted with an uncanny capacity to look ahead, think ahead and above all, see ahead.

Their materials are the progress of the past. Their genius is the promise of the future.

To fulfill that promise, our engineers have at their disposal the most modern facilities, including one of the largest computer laboratories in the world. They have unlimited opportunities in the field of their choice — whether it be airships, missiles, electronic guidance equipment, structures — or countless other challenging activities.

There are no limits, either, on individual thought, no barrier to the flow of inspiration.

If you have faith in your ideas and confidence in your ability to make them work, a rewarding career can be yours at Goodyear Aircraft. Our continued growth and diversification have required expansion of our engineering staffs in all specialties at both Akron, Ohio, and Litchfield Park, Arizona.

You'll find salaries and benefits agreeable. If you wish to continue your academic studies, company-paid tuition courses leading to advanced degrees are available at nearby colleges.

For further information on your career opportunities at Goodyear Aircraft, write: Mr. C. G. Jones, Personnel Dept., Goodyear Aircraft Corporation, Akron 15, Ohio.

They're doing big things at

GOODYEAR AIRCRAFT

The Team To Team With in Aeronautics

1958 Lightweight Full Pressure Suit

1934 Stratosphere Suit

At B.F. Goodrich the space age started in 1934

That was the year B. F. Goodrich developed the first rubber stratosphere flying suit for attempts at setting altitude records. Through the years this suit has been constantly improved to meet the needs of higher-flying pilots. And when the first man sets foot on the moon he will probably be wearing a modification of today's B.F. Goodrich Full Pressure Suit.

B. F. Goodrich engineers are working in many ways to help man break the bonds of earth—and return safely. Missile nose cones, improved solid fuels, propellant heaters, missile battery box heaters, instrument heaters, printed and etched circuits, stronger metal and plastic structural materials, insulating materials, precision rubber seals and gaskets, blind fasteners—these are only a few of the items that may help solve *your* space age problems. For specific R & D information, write: *B.F. Goodrich Aviation Products, a division of The B.F. Goodrich Company, Dept. AW-29A, Akron, Ohio.*

B.F.Goodrich *aviation products*

Look to Parsons
FOR PERFORMANCE...

SYSTEMS...*second to one*

Parsons' Electronics Division
is actively engaged in the
research, development, manufac-
ture and installation of
electronic systems for military
and commercial applications.
Current activities and fields of
interest include:

- *Systems Engineering*
- *Telemetry Systems*
- *Miss-Distance Indicator Systems*
- *Timing Systems*
- *Space Positioning Systems*

The Ralph M. Parsons
Company, Pasadena.
United States Offices: Los
Angeles, Houston, Huntsville,
New York, Washington.
International Offices: Ankara,
Asmara, Baghdad, Bangkok,
Cairo, Calgary, Dacca,
Jeddah, Karachi, New Delhi,
Paris, Teheran, Toronto.

PARSONS

WORLD-WIDE SERVICES: ELECTRONIC SYSTEMS AND COMPONENTS • ARCHITECT-ENGINEERING • PETROLEUM-CHEMICAL ENGINEERING
CONSTRUCTION • WATER DEVELOPMENT AND SYSTEMS • APPRAISALS AND ECONOMIC STUDIES • PLANT OPERATION • PERSONNEL TRAINING

OPPOSITE: B.F. Goodrich drew on its long history of
contributing to life-support suit technology in the creation
of this ad although it was by no means the longest-serving
company in aerospace. A 1934 Goodrich high-altitude
pressure suit is shown alongside an imagined future
astronaut. *Aviation Week*, February 23, 1959

ABOVE: In Parsons' Electronics Division ad an anatomical
view of the human body draws a parallel between the
nervous system of the body and Parsons' electronic systems
for military and commercial applications including space
positioning systems. *Missiles and Rockets*, April 27, 1959;
Aviation Week, May 16, 1960

IS GRAVITATION ELECTROMAGNETIC?

LEFT: A hapless astronaut in free fall above the Earth has no ship in sight and, positioned head-down aimed at Earth, he's facing imminent death through burn-up on reentry into the atmosphere. Yet his facial expression is as calm as the ad's recruitment copy. *Aviation Week*, November 14, 1960

OPPOSITE: "Which Way Is Down in Space?" Of course there is no up or down in space, even if the artificial gravity on *Star Trek* makes it seem as if there is. *Aviation Week*, June 6, 1960

tension that is reflected in depictions of proto-astronauts experiencing simultaneously supreme confidence and high anxiety.

Existentialist philosophy too was a recurring leitmotif in the intellectual life of the era. Martin Heidegger's idea of "thrownness" (*Geworfenheit*), described in *Being and Time*,[21] explored the abruptness of the arrival of human consciousness with birth and extrapolated that abruptness as a general sense of individual awe and unpreparedness in the face of life. The plight of the astronauts depicted in these illustrations calls to mind the specter of an abrupt toss of man into space with all the inherent loneliness of thrownness. Whether or not the artists were consciously thinking of existentialism, the astronauts in the advertisements here could hardly seem more unprepared to find themselves in space.

Existentialism spoke to the wider culture of the time too: as the perpetrator of nuclear war against Japan, Americans, second only to the Japanese, had to come to terms with the new machinery of atomic holocaust. Yet neither religion nor science could adequately make sense of the atomic threat, and by the late 1950s the American public was experiencing that threat from the USSR more urgently than it was suffering guilt over Hiroshima and Nagasaki. The solitary thinking of existentialism resonated more with the public than had other philosophical trends prior to the immediate postwar era.

Even at its most optimistic and forward-looking, American culture was beset with an underlying precariousness. The reach into outer space was the apex of America's progressive efforts, yet a sense of doubt colors the advertisements from companies competing to promote their abilities in sustaining human life in space. The art directors and illustrators of these ads responded to the precariousness of space exploration and used it to full effect.

Space medicine, from X-ray technology to eye-tumor detection, infiltrated everyday life more deeply than most other transfers to the general public of space-based

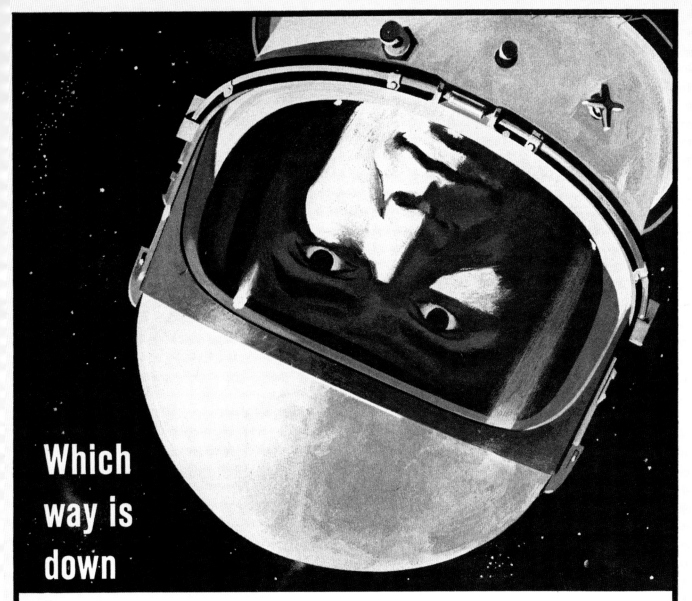

Which way is down in Space ?

GUIDANCE IN SPACE for manned and unmanned vehicles is one of the most challenging projects underway at Ryan Electronics today. Through advanced research and development, Ryan Electronics is solving the problems of missile and space guidance systems.

Some of the areas being explored include rendezvous terminal guidance, anti-satellite guidance, space vehicle landing aids, satellite communications, and mid-course guidance.

Ryan Electronics is also studying applications of continuous-wave doppler techniques to the terminal phases of space missions.

Ryan Electronics is the pioneer and recognized leader in continuous-wave doppler navigation systems—the most advanced, proved means of aerial navigation yet developed for modern flight. Automatic Ryan navigators, in wide use throughout the world, guide all types of aircraft—ranging from helicopters and slow flying reconnaissance aircraft to high altitude supersonic jets.

Now, through a major research and development program, Ryan is working to provide the best guidance for America's ventures in Space tomorrow.

RYAN OFFERS CHALLENGING OPPORTUNITIES TO ENGINEERS

RYAN ELECTRONICS

DIVISION OF RYAN AERONAUTICAL COMPANY • SAN DIEGO, CALIFORNIA

RYAN BUILDS BETTER

MAN IS K In the man-machine equation there are many variables, but the human factor is constant. Integrate man into a flight system, provide him with a safe environment, and he can go anywhere. Land anywhere.

At Grumman, one of our areas of major concentration has been perfecting the science of fitting man and machine together in an efficient, compatible arrangement. In short, providing crewmen ("k") with a safe environment. We've succeeded in doing this thousands and thousands of times for the hundreds of thousands of men who have manned our aircraft and weapons systems.

This experience is one of Grumman's most valuable assets. Coupled with advanced space facilities and equipment, it means, for one thing, we're well prepared to provide safe environment for the men who man America's space vehicles.

GRUMMAN

AIRCRAFT ENGINEERING CORPORATION
Bethpage · Long Island · New York

Visit Grumman Booth #355 at the A.R.S. Show, New York City, October 9th-15th.

The following text appears within the advertisement image:

MAN WITH A MISSION
...AND A MESSAGE

From the vast, eternal, "emptiness" of Space will come the message transmitted by this man and by the sensitive instruments about him. Within fractional seconds — almost instantaneously — Space secrets will be symbolically interpreted.

Thus is the mission given meaning. Though the lone man in Space will have ventured into a region darkened by eons of awe, the path behind him will be flooded with light . . . a light that focuses the message to the sensitive equipment below. This illuminating knowledge will light the way deeper — ever deeper — into the darkness that still lies ahead.

RADIATION INC.
MELBOURNE & ORLANDO, FLORIDA
PERSONNEL INQUIRIES INVITED

RADICORDER

The Quick-Look RADICORDER enjoys a variety of unique applications ranging from On-Off Operations, Discrete-Level Analog Recording, Alpha-Numeric Printing, to X-Y Plotting.

The direct electric-writing technique requires no chemical or other processing to provide immediate, real-time readout. The permanent-print record eliminates inflexible preprinted charts and is reproducible by the Xerox and other standard methods.

RADICORDER'S synchronous time and data recorder offers many outstanding features including logarithmic data presentations, variable chart speeds to 100 inches per second, true waveform reproduction, no undershoot or overshoot, plus a truly flexible time-scale presentation.

Complete information available. Write to Melbourne, Florida.

The RADICORDER is only one component representative of RADIATION'S capabilities in data acquisition, telemetry, radar, and associated fields.

ASTRIONICS • AVIONICS • INSTRUMENTATION

OVERLEAF PRECEDING: An astronaut, in cyan, yellow, and magenta, rotates against a star chart, indicating the whip-fast ride of the training seat that acclimatized astronauts to fast-changing G environments. The illustration style echoes the work of the famed graphic designer Bradbury Thompson. *Aviation Week*, October 9, 1961

LEFT: Alone and adrift in space, the astronaut in Radiation, Inc.'s ad has a mighty mission—to create a path of light in deepest space. In his fetal float he is reminiscent of *2001*'s astronaut Frank Poole cut loose by the murderous HAL 9000 computer, yet he seems strangely at peace. *Aviation Week*, March 16, 1959

OPPOSITE: In addition to navigation systems and rocket engines, Marquardt worked on life-support systems, metaphorically depicted here as a bell jar. Artist: Ken Smith, *Aviation Week*, January 9, 1961

technology.[22] It has made major contributions to general medicine, particularly in the study of baseline normal biometric readings. "[W]e find ourselves concerned principally with the study or care of the normal individual placed in an abnormal environment, whereas the Earthbound physician studies the response of an abnormal individual to a normal environment," explained Charles A. Berry, chief of Center Medical Programs at NASA Manned Spacecraft Center.[23]

In images such as those on pages 83 and 84–85, proto-astronauts of space medicine—signaled by their anatomical representations—seem to be surrounded by a safety bubble: an artificial atmosphere or amniotic sac? Stanley Kubrick's 1968 movie *2001: A Space Odyssey* plumbed the synergy between the unknowns of outer space and the confinement of the human embryo. The egg-shaped enclosure around the astronaut in Lockheed's space medicine ad (pages 84–85) seems to foreshadow the star child whose return to Earth is the climax of *2001*. Just as existentialism relates the entire condition of life to the condition of being a newborn, these proto-astronauts are as much thrust back in time to the fetal condition as forward in time toward a spacefaring human existence. These illustrations convey a sense of sanctuary against the mortal danger from which the advertised life-support systems protect the astronaut.

While lofty goals of space exploration and medical research are promised in these ads, another subtext is at work: the absorption of the worker into the corporate production system. In Aeronca's ad (page 87) the astronaut is stripped of the charisma and autonomy he possesses in more heroic characterizations of astronauts. Here he is cast as a worker, truly a subject of the "hand of the man," as he is placed onto the Moon like a toy soldier in a diorama. Similarly positioned, the astronaut in Ryan Electronics' ad (page 97) is restored at least his autonomy, if not his glamour.

Borrowing the notion of the precariousness of space exploration, America Fore presents a man out of his industry (page 86): this insurance company puts an average

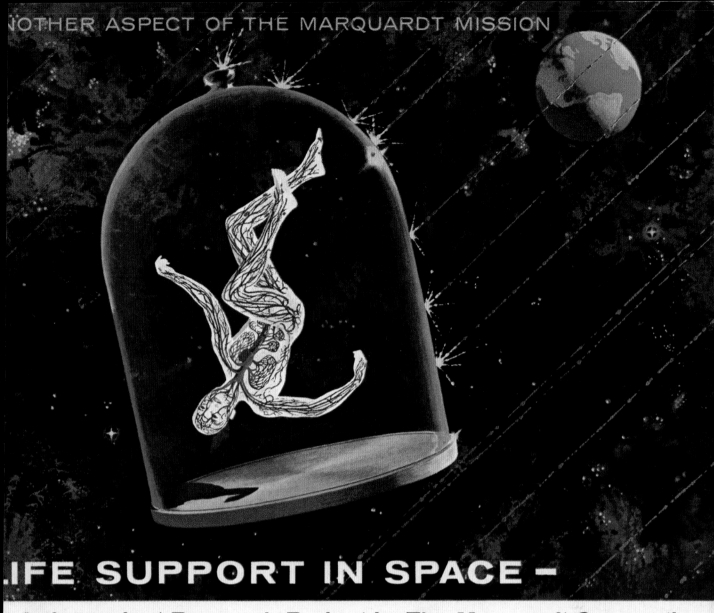

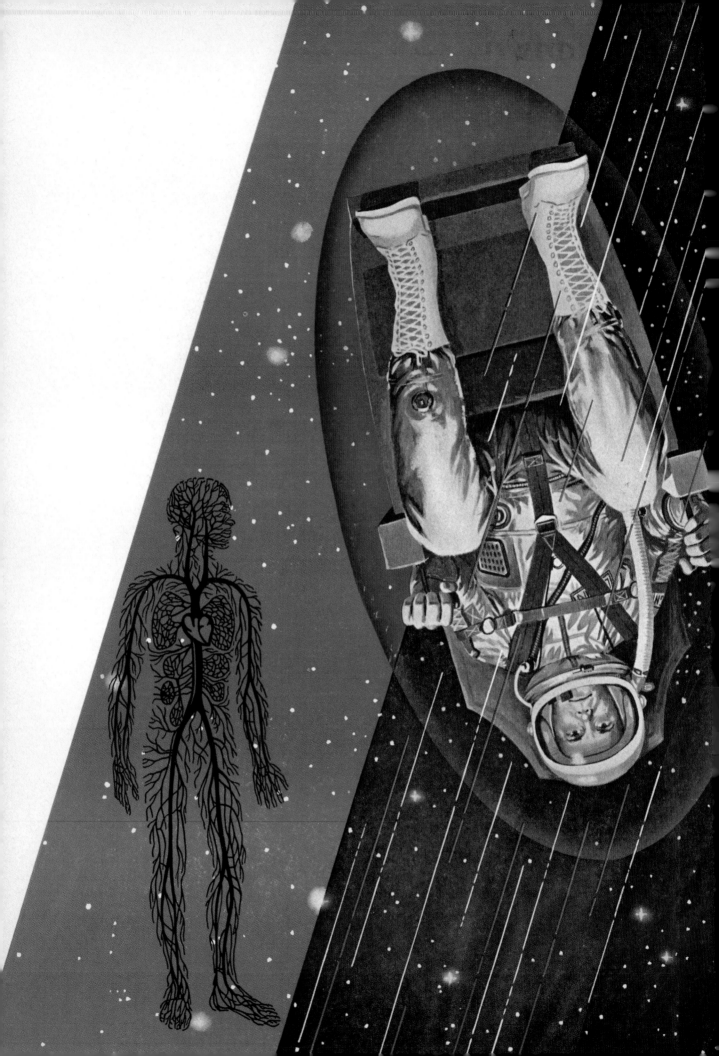

Pilâtre de Rozier and Marquis d'Arlandes (November 21, 1783), using a Montgolfier balloon, were the first to leave the earth to test man's physiologic reactions. This experiment was the forerunner of intensive Space Medicine studies of today.

SPACE MEDICINE

There is a relatively narrow zone above the surface of the earth in which man's physiologic mechanism can function. Hence the unrelenting search by Lockheed scientists into many aspects of Space Medicine.

Engineers already have equipped man with the vehicle for space travel. Medical researchers now are investigating many factors incident to the maintenance of space life—to make possible man's flight into the depths of space. Placing man in a wholly new environment requires knowledge far beyond our current grasp of human biology. Here are some of the problems under investigation: The determination of man's reactions; the necessity of operating in a completely closed system compatible with man's physiological requirements (oxygen and carbon dioxide content, food, barometric pressure, humidity and temperature control); explosive decompression; psycho-physiological difficulties of spatial disorientation as a result of weightlessness; toxicology of metabolites and propellants; effects of cosmic, solar and nuclear ionizing radiation and protective shielding and treatment; effects on man's circulatory system from accelerative and decelerative G forces; the establishment of a thermoneutral range for man to exist through preflight, flight and reentry; regeneration of water and food.

Exploration into unknown areas such as Space Medicine, provides endless stimulation to imaginative scientists and creative engineers. Research at Lockheed's Missiles and Space Division covers the entire spectrum—from pure basic research to development work, in support of current projects. Space Medicine is but one phase of Lockheed's complete systems capability in missiles and satellites. To maintain this position of leadership calls for an extensive research and development program— ranging from electrical propulsion research to advanced computer research, design and development. Typical current projects are: Man in space; oceanography; fuel cells; space station; space navigation; solid state electronics.

Engineers and Scientists: If you are experienced in work related to any of the above areas, you are invited to write: Research and Development Staff, Dept. F-29A, 962 W. El Camino Real, Sunnyvale, California. U.S. citizenship or existing Department of Defense industrial security clearance required.

Lockheed / MISSILES AND SPACE DIVISION

Systems Manager for the Navy POLARIS FBM; the Air Force AGENA Satellite in the DISCOVERER, MIDAS and SAMOS Programs; Air Force X-7; and Army KINGFISHER

SUNNYVALE, PALO ALTO, VAN NUYS, SANTA CRUZ, SANTA MARIA, CALIFORNIA
CAPE CANAVERAL, FLORIDA • ALAMOGORDO, NEW MEXICO • HAWAII

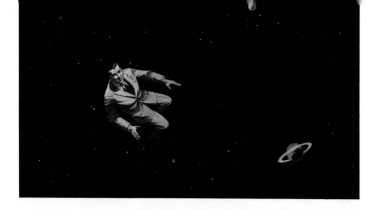

EVER FEEL "A MILLION MILES FROM NOWHERE"?

It's just about how you feel when you're far from home and an accident happens. Your greatest need is the help of someone who knows what to do and how to do it.

If you are insured in a company of the America Fore Group, you can be sure that no matter where you may be, such a friend is nearby and ready to come to your aid in case of need.

He will be one of America Fore's 40,000 agents or claims men located throughout the country—rendering the service and help you are entitled to expect when you are insured in a capital stock company with nation-wide facilities.

Remember, in the long run, the *best* insurance is the least expensive.

 For the name of a nearby America Fore agent call Western Union by number, ask for Operator 25.

★ The Continental Insurance Company
★ Niagara Fire Insurance Company
★ Fidelity-Phenix Fire Insurance Company
★ The Fidelity and Casualty Company of New York

America Fore
• INSURANCE GROUP •

OVERLEAF PRECEDING: Lockheed draws a line between the Montgolfier era and twentieth-century space medicine. *Missiles and Rockets*, June 13, 1960

LEFT: The insurance industry borrowed the metaphor of precarious and unpredictable space travel in this general advertisement for insurance. *Fortune*, April 1957

OPPOSITE: Caught midstride in his journey into space, this astronaut is upright but shipless! The oversized hand that reaches from Earth into space now has a specific mission: to place the tiny proto-astronaut on the Moon. *Aviation Week*, April 17, 1961

businessman into the free float of an astronaut to express anxiety about potential accidents when one is away from home—echoing the insecurity that suffused culture in general. The visions of glamour and adventure offered by space boosterism are subverted in the dull, down-to-earth selling of insurance.

At Home in Space

Although in 1958 and 1959 human spaceflight was still only a *possibility*, some advertisers were compelled to domesticate the vehicles that would bring man into orbit. These early efforts at the domestication of the space race aimed to make the strange familiar, the alien normal, and to naturalize spaceflight as a safe and foregone conclusion. In an early ad from Thiokol for its plasticizer used in making pressurized suits (page 89), the astronaut—a "space man" snug in an anti-G suit—is ensconced in a spacecraft with a huge picture window through which Earth is in clear view. The astronaut in Avion's ad for flight management display (page 95) too enjoys a large picture window at his side; a TV-like navigational screen glows in front of him.

The comfort of the astronaut is even greater in Stafoam's wide-angle view of a spacious cabin with plenty of elbow room for its three astronauts (page 90). This cabin resembles not so much the reality of Mercury or Gemini capsules as the well-appointed bridge of a ship, or even a home kitchen. The support beams that frame the window and the domestic look of the roll-front cabinet behind the floating astronaut lend this spaceship a downright homey feel. Cozier still is the vision for the lone astronaut in Melpar's ad (page 88) for microwave antennas. Earth and the Moon are comfortingly framed together in the TV-screen of a window, and an object resembling a reading lamp hangs over the astronaut's left shoulder. The ad posits that when in space the future Mercury astronaut will be "as alone as man's ever been," a scary prospect, yet his solitude appears to be relaxing. The view here is like peeking in to see what Dad's

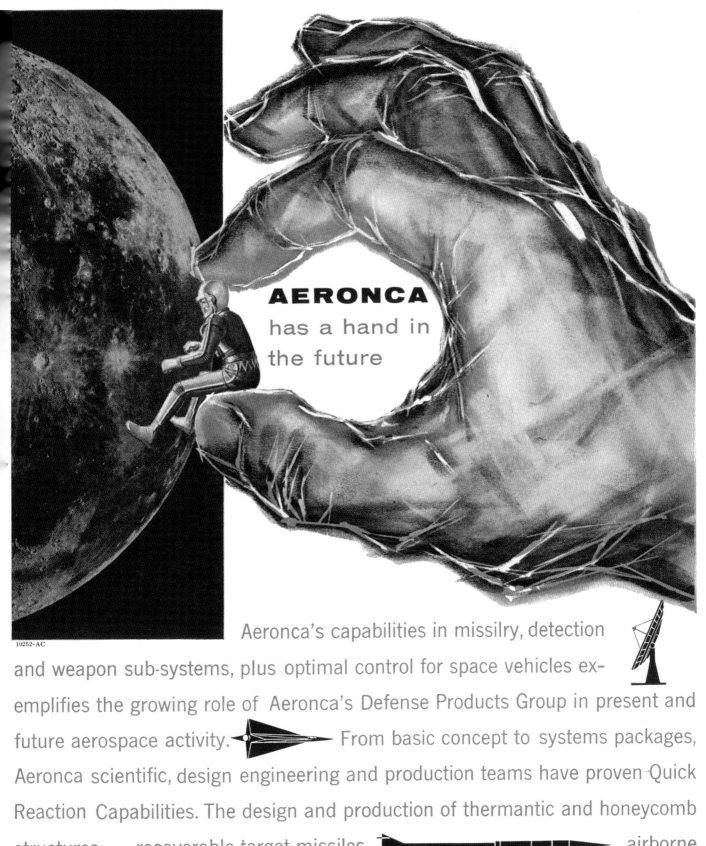

AERONCA
has a hand in
the future

Aeronca's capabilities in missilry, detection and weapon sub-systems, plus optimal control for space vehicles exemplifies the growing role of Aeronca's Defense Products Group in present and future aerospace activity. From basic concept to systems packages, Aeronca scientific, design engineering and production teams have proven Quick Reaction Capabilities. The design and production of thermantic and honeycomb structures ... recoverable target missiles, airborne GSE shelters as well as for the vital B-70 program demonstrate the scope of Aeronca's versatility.

PLANTS AND LABORATORIES FROM COAST TO COAST
Aerospace Division, Baltimore, Maryland
Middletown Division, Middletown, Ohio
Aerocal Division, Torrance, California

AERONCA manufacturing corporation • general offices: germantown road • middletown, ohio

Excellent openings now available for creative R&D Engineers with aerospace experience. Write today to Mr. O. E. Chandler, Manager, Professional Employment.

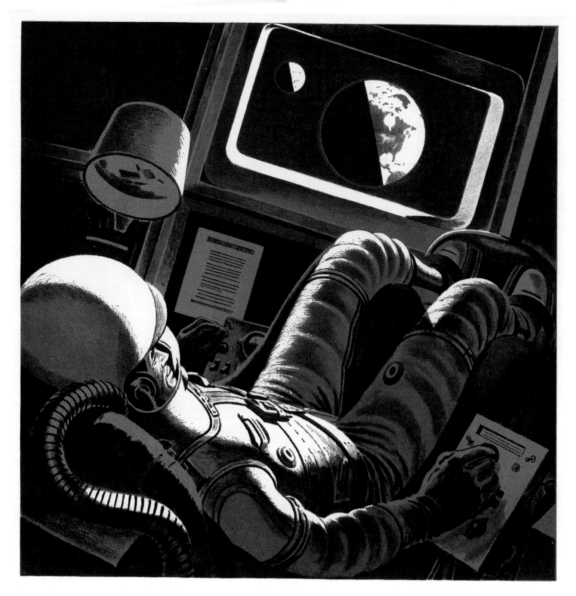

Manned Orbital Flight

When the National Aeronautics and Space Administration's Project Mercury's man is orbiting in space, he will be as alone as man's ever been. His electronic communication from far beyond earth is an essential element of our exploration of space within the solar system. The nation's first manned-satellite fired into orbit will carry microwave antennas conceived, designed, and produced by Melpar, under contract to McDonnell Aircraft Corporation, prime contractor for the Project Mercury Capsule. The electronic creativity in our plants and laboratories is dedicated to world-wide governmental, industrial and space application.

MELPAR INC

A SUBSIDIARY OF WESTINGHOUSE AIR BRAKE COMPANY

For details on provocative job openings in Advanced Scientific Engineering Areas, write to: Professional Employment Supervisor, 3606 Arlington Blvd., Falls Church, Virginia, in historic Fairfax County, 10 miles from Washington, D.C.

ABOVE: This astronaut's seat resembles nothing so much as a La-Z-Boy, and he doesn't seem to need to do any work in space, but just sit back and relax. *Aviation Week,* November 9, 1959

OPPOSITE: The cabin in this ad from Thiokol is so roomy that the "space man" must extend his arms fully to reach the controls. The cramped reality of the early manned capsules bore little resemblance to this vision. *Aviation Week,* March 17, 1958

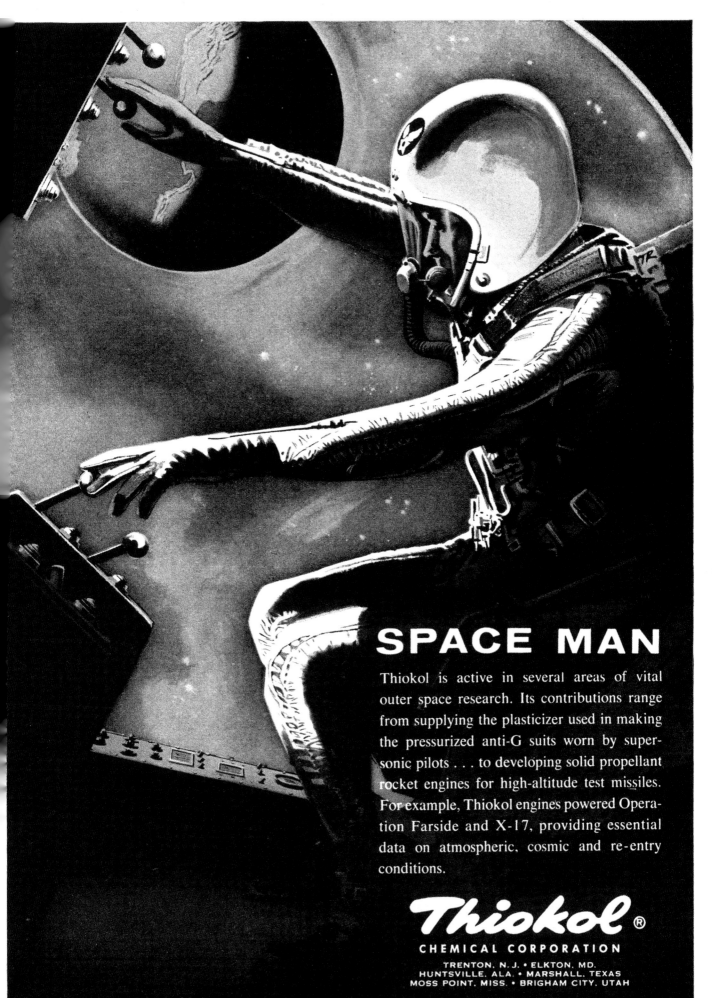

SPACE MAN

Thiokol is active in several areas of vital
outer space research. Its contributions range
from supplying the plasticizer used in making
the pressurized anti-G suits worn by super-
sonic pilots . . . to developing solid propellant
rocket engines for high-altitude test missiles.
For example, Thiokol engines powered Opera-
tion Farside and X-17, providing essential
data on atmospheric, cosmic and re-entry
conditions.

Thiokol ®

CHEMICAL CORPORATION

TRENTON, N.J. • ELKTON, MD.
HUNTSVILLE, ALA. • MARSHALL, TEXAS
MOSS POINT, MISS. • BRIGHAM CITY, UTAH

® Registered trademark of the Thiokol Chemical Corporation for its liquid polymers, rocket propellants, plasticizers and other chemical products.

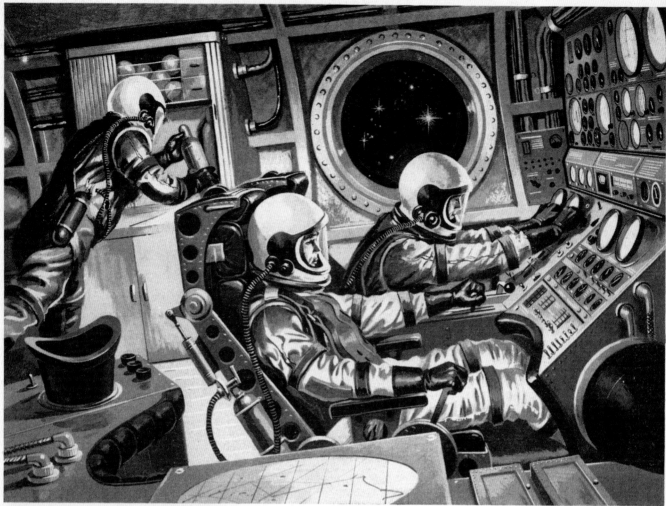

STAFOAM RIGID
1. Thermal insulation
2. Acoustic & vibration dampening
3. Foam core construction
4. Helmets and liners
5. Instrument casing

STAFOAM FLEXIBLE
6. Shock padding (High hysterisis)
7. Seat & backrest cushioning
8. Compartmented containers
9. Pressure suit insulation & liners

POLYPOT
10. Instrument potting
11. Crystal clear windows & canopies
12. Control knobs & accessories

DAYCOLON
13. Gears, roller bearings, O rings
14. Instrument & control knobs
15. Instrument scope boots
16. Applicable hardware

POLYRUBBER
17. Personnel shock padding
18. Instrument shock mounts
19. Window and hatch gasketing
20. Hose and encasements

stafoam *in Space*

DESTINATION...

A new dimension in the application of foamed plastics

STAFOAM, "foamed in place" in its varied and multipurpose densities, is destined to change the manufacturing habits of the nation. More and more airframe and component industries are discovering and using the miraculous polyurethane STAFOAM for its inherent adaptations to modern production demands.

Here, at last, is the versatile and economical material that withstands *all* and more of the manufacturers' requirements. STAFOAM is supplied in unlimited variations of densities, weight, texture, color, strength, insulation and thermal characteristics.

The STAFOAM orbit is infinite! Your investigation may uncover an entirely new dimension. *Write* or *call* today!

The new Freedlander Research and Development Center at Hawthorne, California devoted entirely to the development of STAFOAM applications, invites you to call or write for research and/or manufacturing information.

stafoam

AMERICAN LATEX
PRODUCTS CORPORATION
3341 W. El Segundo Blvd., Hawthorne, Calif.
ORegon 8-5021 • OSborne 6-0141
A Division of The Dayton Rubber Company

BRANCHES
SAN FRANCISCO, 42 Gough St.
SEATTLE, 2231 5th Avenue
DALLAS, 126 Parkhouse St.

watching on TV in the living room. This image also appeared on the back cover of the popular magazine *Space World* in November 1960, next to the query: "What kind of man reads *Space World*?"

Sacred Space

Where an association between space and the sacred is made in envisioning civil space exploration, the astronaut's journey becomes something different from that of the secular public hero. In a recruitment ad for senior-level engineers from Autonetics (page 94), three unmistakably Christian images are juxtaposed behind two astronauts performing a space walk. At front is an unusual craft in the shape of a cross or stylized Star of Bethlehem as might appear atop a Christmas tree. Behind this is the triangular design (suggesting the Trinity) of an unexplained spacecraft. The astronaut in the upper left of the image is haloed by the sun's reflection, completing a three-part invocation of religious iconography. Perhaps these illustrations express the artist's faith-based vision for space stations to come.

Even more dramatically, Northrop's forward-looking ad (pages 92–93) references Michelangelo's iconic Sistine Chapel mural depicting the hand of God giving life to Adam. The relationship between God and man is invoked, but toward what end? Here the hands are both those of gloved space travelers. Does Northrop mean to suggest that we will encounter God out there (and that He will be wearing a spacesuit)? Or that the doings of humans in space will assume aspects of the divine?

These images suggest that the furthest reach of what humankind hoped to find in space was in fact the very essence of infinity. They also express domesticity in their visual language, as churches are second homes to many.

Body Imagery Fades from Aerospace Industry Advertising

As the Mercury and Gemini missions materialized from the drawing board to orbit, fewer and fewer industry advertisements used abstracted representations of the human figure. The shift away from the use of body imagery was the result of a few key changes as spaceflight matured as an industry during the 1960s.

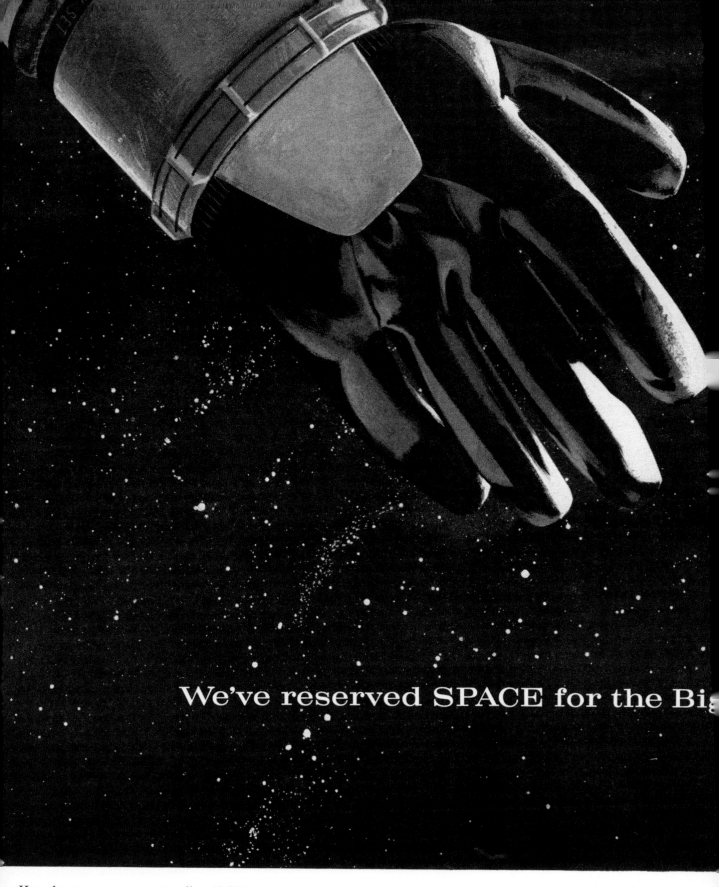

We've reserved SPACE for the Big

How do you meet a man traveling 18,000 miles an hour, 500 miles from earth? Northrop is already preparing for the next big challenge after the first human penetration of space, namely, rendezvous of men in space.

In all its divisions Northrop scientists, physicists, mathematicians, doctors, and engineers are attacking the many formidable problems involved. For example, Northrop projects include techniques for freely altering the course of a vehicle once it has been launched...human factors engineering, environmental stresses, weightlessness...methods of providing food for long-

ranging astronauts by actually growing it aboard their vehicles ...utilization of natural resources of the moon and planets... in-space repair and rescue operations...satellite "filling stations" for supplying additional propulsive energy to orbiting vehicles ...new metallurgical explorations to meet the severe hazards of space environments...recovery systems for returning the astronauts safely to earth.

There is, of course, much to be done before men meet in space. Today, the Northrop Corporation possesses the capabilities and is developing the technologies to help make it possible.

Meeting

NORTHROP

NORTHROP CORPORATION, BEVERLY HILLS, CALIFORNIA

DIVISIONS: NORAIR, NORTRONICS, RADIOPLANE, NORTHROP INTERNATIONAL. SUBSIDIARY: PAGE COMMUNICATIONS ENGINEERS, INC.

solid footing?

Christian iconography is unmistakable in these crafts shaped like a cross or Star of Bethlehem and as a triangle, the symbol of the Trinity. *Missiles and Rockets*, December 15, 1958

As NASA missions became the real-life adventures of a select new group of people called astronauts, there was no longer a need for images of proto-astronauts engaged in hypothetical adventures. The day-to-day lives of the astronauts were followed by millions on TV and in magazines. Humankind's yearning for exploration into new frontiers became part of the larger story of NASA's spaceflight programs. Industry translated all this into the real world of jobs and competition for contracts. As the aerospace industry became well established and the enormous hiring wave of 1958 to 1962 plateaued, personally motivating recruitment advertisements diminished. Industry advertisements shifted away from recruitment and abandoned the direct appeal to identification between the engineers of the future and the astronauts of the future.

Social unrest resulting from racial tension and antiwar sentiments in the 1960s had its effects as well. Profoundly distracted by current events, the public, media, and social thinkers stopped focusing on atomic threat. An atmosphere of destabilization shifted society's concerns from abstract thoughts about space to the concrete, dramatic social problems now facing the United States.

Human Spaceflight Today

With fifty years' hindsight the tone of the popular press stories of the late 1950s criticizing human spaceflight seems cartoonishly overblown. Today's dialogue about its future is practically unrecognizable in the language of those antecedents.[24] Shortly after their publication, articles expressing criticism were forgotten by a starstruck public awed by the spectacle of the Moon landing. Yet the collapse of human spaceflight programs in the years following Apollo proved many critics' points. A big discovery—or even a small one—in any scientific realm could have laid the groundwork for a long-running future of crewed excursions. Instead, once the goal of the lunar landing had been achieved, support for the program ran dry. Many policy makers held the criticisms

The future is coming up fast, and Avion's Display Laboratory is prepared to meet it more than half way.

Total Flight Management Display is fast becoming a reality as Avion Display engineers, with a solid background of experience and capability, are developing hardware *today* to meet the critical demands of orbital missions of *tomorrow*.

If your space project is scheduled to make headlines in 1965, Avion can provide a practical, economical, *demonstrable* answer to your flight management needs.

AVION brings the future up to date...

ACf INDUSTRIES INCORPORATED
AVION DIVISION

MILITARY • INDUSTRIAL
Equipment and Components • *11 Park Place, Paramus, N. J.*

ACf DIVISIONS: AMERICAN CAR AND FOUNDRY, AVION, NUCLEAR PRODUCTS-ERCO, CARTER CARBURETOR, SHIPPERS CAR LINE, W.K.M.

AVION
FOREMOST IN AVIONICS

INVESTIGATE OPENINGS IN DISPLAY AND OTHER AVION PROGRAMS

A developer of hardware and military and industrial equipment, Avion was a brainchild of Jack Northrop, who had founded Northrop aircraft. Here Avion was eager to promise a *demonstrable* answer for flight management to come in 1965. *Aviation Week*, August 24, 1959

to be self-evident. Today's space-station astronauts' adventures are interesting and important, but they are routine enough and close enough to home that they do not capture the sparkling trail of glamour left behind by Apollo.

Sponsor corporations succeeded in creating a proto-astronaut "everyman" who persuaded workers, from technicians to top engineers, to join the industry. They also achieved their overarching goal of building an industry and public opinion about it that would carry them through the 1960s and into the present day. The influence of military interests in orbital space in the past quarter century has drastically outstepped that of civil-scientific concerns. Because consensus about the direction of the civil space program no longer dictates the solvency of major aerospace corporations, the need for astronaut-oriented advertising has vanished.

After the Apollo program was canceled in 1972, human spaceflight lacked an obvious objective. Discussions about the future of spaceflight changed tenor and fractured into specialized arenas. In academic, governmental, and trade publications, the scientists, politicians, and futurists reached no consensus. The most spectacular visionaries seized headlines in the late 1970s with their plans for verdant orbital and lunar space colonies. The progress of this dialogue could not easily be summarized, however, and it largely receded from public view.

Science fiction became more introverted and speculative: classics of the 1970s such as Philip K. Dick's *A Scanner Darkly* and John Brunner's *The Sheep Look Up* reflect the general turn of science fiction toward exploration of contemporary social and technological problems rather than deep outer space.

Today's debate over human versus robotic spaceflight is returning to the public eye, if not to industry advertising. NASA's Constellation project plans and commercial ventures such as the Lunar X Prize and the articulation of the Moon as an "eighth continent"[25] have revived public interest in human spaceflight beyond the routine

orbital journeys of the shuttle system. The Constellation Program, NASA's current human spaceflight project, includes a liaison to the science community[26] and self-consciously positions itself as noncompetitive to robotic research programs. A few critical articles echo, almost phrase for phrase, the objections voiced fifty years ago. Others are more subtle and more logical: an October 2007 *Scientific American* article carrying the unassuming title "Five Essential Things to Do in Space" described the five most important goals for human exploration of space,[27] distilled from several reports by the National Research Council. Unassailably logical and attuned to research and the preservation of all human life, none of the five points called for crewed space missions.

Space historians Roger Launius and Howard E. McCurdy have pointed to an alternate view in their book *Robots in Space*.[28] They argue that humans are the agents of *all* space exploration, even if the off-world work involves only robots. Recognition of the human agency in robotic space exploration can lead toward a resolution of the debate about what consitutes human spaceflight by narrowing the divide between the human and robotic. There will still be astronauts who physically keep the world in touch with the lunar and Martian landscapes. The sense of place is strongly rooted within the human psyche: having once touched the Moon on behalf of all humanity, the astronaut's physical presence in space abides. Yet *Robots in Space* and NASA's growing interactive robotic programs point to telepresence—technology that gives the appearance of being present while being remote—as the future of spaceflight for the greatest number of people. The evolution of robotic technology enabling real-time Earth-based control of distant rovers and explorers has changed the game, and an increasingly wide range of scientists and researchers are able to explore space remotely. Telepresence opens up space exploration far beyond the ability of spaceship propulsion technology that can transport us physically into space. Some day the public should be able to engage space exploration through telepresence at an amateur level. In the meantime, considerable advances in propulsion technology would be required to create spaceships we might all clamber aboard to head to the stars.

NAVIGATING TO VENUS AND BEYOND...

A CHALLENGE TO EXCITE ANY ELECTRONICS ENGINEER WORTH HIS SALT... THE KIND RYAN NEEDS RIGHT NOW

We do not know where Venus is, within 50,000 miles or more. What is needed is a guidance system capable of injecting space vehicles into interplanetary orbits with the accuracy required for advanced space missions.

We are confident that the C-W doppler systems, of which Ryan is the world leader, will meet this challenge of space navigation. This is one reason Ryan is the largest electronics firm in San Diego — *and the fastest growing!* If you are an electronics engineer ambitious to help advance the art, as well as your own career, through vital "frontier work" — we want you *right now* at Ryan Electronics.

Ryan Electronics employs over 2000 people and has over one-third of the company's $149-million backlog of business. Under the leadership of some of America's most prominent scientists and engineers, Ryan is probing beyond the known . . . seeking solutions to vital problems of space navigation.

Expanding facilities of Ryan Electronics at San Diego and Torrance in Southern California are among the most modern in the West. You enjoy living that's envied everywhere, plus facilities for advanced study. Send your resume or write for brochure today: Ryan Electronics, Dept. 1, 5650 Kearny Mesa Road, San Diego 11, Calif.

 DIVISION OF RYAN AERONAUTICAL COMPANY
SAN DIEGO & TORRANCE · CALIFORNIA **RYAN ELECTRONICS**

3. Spacecraft: Form and Function

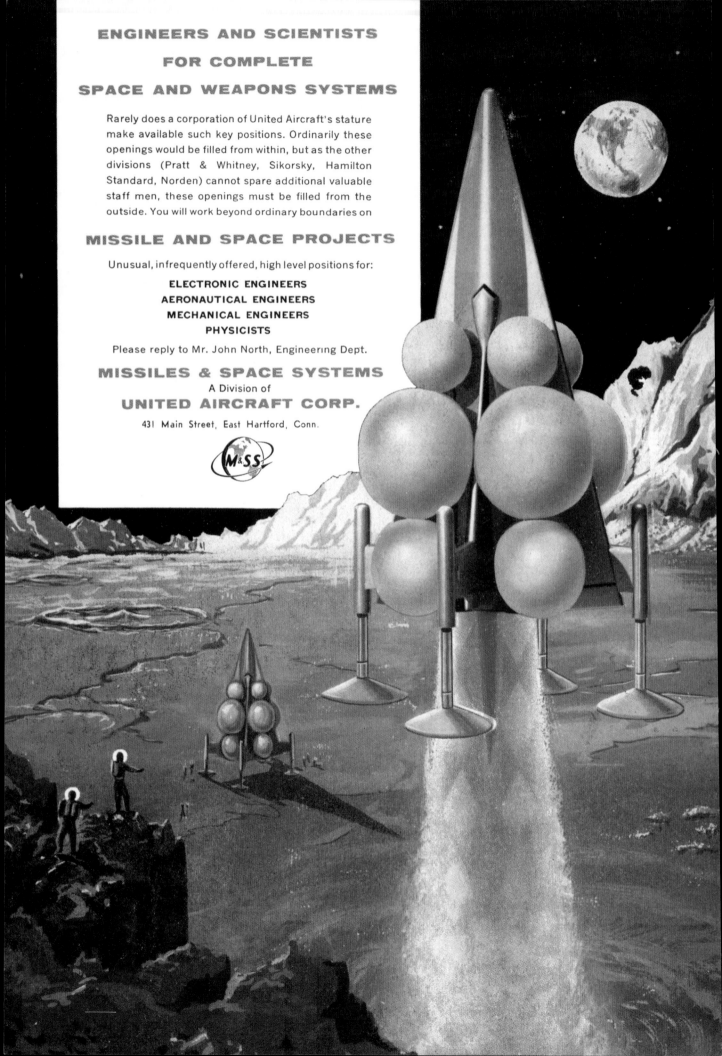

The Astronauts Have Landed

Their journey through space complete and their feet planted on the lunar surface, two astronauts stand high above a steep-ridged valley landing field to greet an approaching ship in Missile & Space Systems' recruitment ad for high-level engineers (opposite). The basin and range landscape of the American West was familiar to many engineers and designers from the rocket test facilities spanning the western states. But the scenario in Missile & Space Systems' ad goes beyond an evocation of the American desert. Two astronauts face the valley before them with a forward-reaching gesture of hope for their dreams of futures yet to be. They could be Moses and Aaron gazing at the promised land. Or, closer to home, they could be Mormon pioneers surveying the new Zion of Utah desert land. In the context of American history, the scene feels colonial, yet the astronauts' halo-like helmets suggest a reference to landscapes of religious significance.

However the story unfurls is left to the viewer's imagination. The scene bristles with potential for tales of near-future human migration as well as echoes of history. The astronauts appear to be greeting the arriving ship—or are they being left behind by one that's departing? Its pulp science fiction vernacular style is reminiscent of a dime novel cover. Could these astronauts be a team of explorers left behind with a second ship to conduct reconnaissance? Does the arriving—or departing—ship carry resources for the first colony development or materials to be transported to Earth? Any number of tales could be spun from this scene: another science fiction.

The astronauts themselves have dropped to the periphery of the image in favor of the enormous spacecraft. The bulbous spheres, like Christmas tree ornaments, adorning the sides of the pyramidal rockets suggest yet another tale: a fictitious means of propulsion. The ad expresses the core message of all aerospace recruitment

OVERLEAF PRECEDING: Detail, pages 132–33.

OPPOSITE: Perched high above the landing field on a rise of rough cliffs reminiscent of the Great Basin, astronauts raise their hands to greet the arriving ship in its landing field, the lunar desert valley.
Missiles and Rockets, February 23, 1959

LEFT: In this *Popular Mechanics* cover an American-made rocket with sphere-shaped fuel canisters chases a near twin Soviet craft, a graphic expression of the space race taking place in the laboratories and test facilities of both countries. August 1959

OPPOSITE: The top image in Lockheed's ad resembles helicopters that 1950s' futurists believed might rescue terrestrial commuters from land-locked traffic jams. The craft at left is indubitably meant for orbital space travel, and the bottom right has more in common with Edsel's Corsair than any known flight craft. *Aviation Week*, January 18, 1960

advertisements of the time: "We *will* reach the Moon, but we don't quite yet know how—and so we need your help."

However, this ship's design is in fact an imaginative visualization based on a true emerging technology. In the late 1950s fuels composed of liquid oxygen and liquid hydrogen were in rapid development for rocket propulsion, and that's what would be in those spherical tanks. Liquid hydrogen, of great propulsive power, in particular is exceptionally difficult to work with in a laboratory or rocket test facility, and fuel tanks grew in size to contain the enormous volume of the ultra-lightweight hydrogen molecules. Both spherical and ultra-wide tubular tanks were used to store and transport liquid hydrogen as it was increasingly relied upon.[1] Early Apollo spacecraft designs featured huge spherical fuel tanks enclosed within the same housing as the crew;[2] later designs separated crew from fuel supply and streamlined the tanks to fit into the oblong shape of a rocket.

Fantastical imagery was, in the early 1950s, applied freely to the very real and gritty processes of mechanical and technological innovation. A wide range of propulsion systems to effect rocket launching and interplanetary transit were under development during this era. Chemical-, nuclear-, electric-, and solar-powered craft were widely hypothesized. Some technologies advertised, such as liquid oxygen, were well established even by 1957 and appeared routinely in advertising as evolving but proven. Other images depict technologies that, in spite of tremendous hype, never launched—nuclear rockets, for example. In between are fantastical designs based on actual evolving propulsive power sources. One technology advertised, ion power, only relatively recently moved beyond design and testing stages to become a late-blooming real-world workhorse.

The zones of possibility between fixed points on the continuum of technological development are depicted in these advertisements for propulsion systems both proven and speculative. All the rockets were meant to reach their destination and go further,

"Limocopter"

Space Transport

NEW FLIGHT FRONTIERS AND SPACE MISSIONS

Mach 6-7 Air Transport

Bold plans revealed in Lockheed's program of total flight technology

beyond what was hoped for them. Along the way, they anticipate what a firsthand look at the solar system would be like.

Behind the drive to build consensus for human spaceflight, the design and construction of launch craft *was* the new aerospace industry. An extension of missile design, rocket design benefited from the Department of Defense's deep cold war pockets, guaranteeing that propulsion engineering would be a boom industry for decades to come. The recruits hired to help launch the proto-astronaut into space would find themselves working mostly in drafting rooms, in machine shops, and on assembly floors—spaces bearing little resemblance to the intriguing interplanetary realms featured in recruitment advertising. Whereas some advertisements drew the recruit to identify with the proto-astronaut of tomorrow, ads focused on propulsion intended him to identify with the machines that his hands would help to draft and build. Only with well-designed and precision-built craft could the fall of Icarus-like spacemen be arrested.

The Garden of the Fantastic

The spherical shapes of liquid fuel storage tanks sparked the imagination of writers and artists interpreting new technology for popular audiences. In the article that accompanies a 1959 *Popular Mechanics* cover image[3] (page 102) diagrams of the spherical hydrogen tanks are annotated with remarks that they could be either discarded in space when emptied or retained and repurposed as living and storage structures on the Moon.[4] The pregnant shape of the spheroid fuel canister once again becomes part of a story, this time for the do-it-yourself public.

Great hopes soon arose for ship morphology to develop considerably beyond the oblong rockets that had launched the Explorer and Vanguard satellites. The designs in Lockheed's flight technology ad (above) nod to automobile and air transport designs

Baby, it's HOT inside

No matter where it comes from . . . ultra-high angular velocities, skin-friction, conduction or radiation from the burners . . . today's airborne bearings spin in temperatures that approach ever closer to the softening point of conventional steels.

Unceasing research work here at Rollway strives for new understanding and control of limiting forces . . . and for practical metallurgical combinations that will enable aerodyne engines to fly faster, higher and further with less mechanical friction drag.

Rollway service extends all the way from down-to-earth estimates of lead time to closely-held schedules of delivery dates. Maybe we have what you want now on test. Costs nothing to find out. Just write or wire Rollway Bearing Co., Inc., 582 Seymour St., Syracuse 4, N. Y.

• TYPICAL OF ROLLWAY R & D WORK IS THIS JET AIRCRAFT HYDRAULIC PUMP BEARING, FEATURING A BROACHED INNER RACE.

ROLLWAY®
BEARINGS

COMPLETE LINE OF RADIAL AND THRUST CYLINDRICAL ROLLER BEARINGS

ENGINEERING OFFICES: Syracuse • Boston • Chicago • Detroit • Toronto • Pittsburgh • Cleveland • Seattle • Houston • Philadelphia • LosAngeles • SanFrancisco

from a time when auto body design borrowed much from the imaginative visualization
of spacecraft and glamorized the automobile. Noted designer Harley Earl incorporated
rocketlike fins into the designs of numerous General Motors cars. The craft in the
lower right of Lockheed's ad resembles the 1959 Edsel Corsair more than it does any
known flight craft, though it's hardly a fair comparison, as this ersatz Corsair is "only"
a Mach 6–7 air transport, not an orbital launch vehicle. It also calls to mind the design
for the Ford Motor Company's 1958 atomic-powered car, the Nucleon.[5] The craft at
left, however, promoted as "space transport," lacks huge launch engines and was likely
intended to be launched from orbit to off-Earth transport destinations unknown.

The varied shapes of the space transport in this chapter demonstrate the underlying
difference between ships that are designed to propel themselves only through the
vacuum of space and those designed to achieve escape velocity, the tremendous
propulsion required to escape Earth's gravity. Rockets and missiles are linked to
sophisticated civil aircraft through their technology, though the momentum of innovation
might render the connection obscure to the casual observer. Technologies now familiar
from the Space Shuttle and Mars Exploration Rover launches were honed during this era.

Chemical Propulsion: A Visual Primer

Hydrogen fuel was just one of the technologies that emerged or saw new life in the
1950s and is one piece in the puzzle of chemical propulsion, the set of technologies
that became space-launch workhorses. The close relationship between propulsion type
and ship morphology evolved rapidly during the early space race. The bulbous hydrogen
fuel tanks eventually shrank to the familiar streamlined pencil-like shape of the rocket
launch vehicle and to the tubular "balloon" tanks that propel routine commercial and
scientific launches today.

The images from this early point in technology could not accurately picture the vehicles
of the Apollo Program that lay a decade ahead. In Rollway's advertisement for airborne
bearings (page 104) interstellar travel is associated with the angular look of the X-15
experimental airplane in a stream of blazing chemical fuels. It was hoped that chemical
propulsion could develop out of missile technology to deliver furiously fast spaceflight.

One of the unchanging objectives of Lockheed Propulsion Company:

advanced propulsion systems for planetary exploration

Lockheed Propulsion has steadily broadened its range of capabilities since it was originally organized to perform research on solid propellants and their applications. In 1959, the company became engaged in research and development of hybrid rocket motors with "start-stop-restart" capability for outerspace use. Other advanced programs include: ultra high-performance solid propellant upper stages and space motors. Whatever the propulsion problem — for defense, commercial use, or peaceful exploration — look to the men and facilities of Lockheed Propulsion.

SCIENTISTS AND ENGINEERS: If you have the talent and training for this work, Lockheed Propulsion has important opportunities for you. The company's location in Southern California's new and rapidly developing aerospace center provides you with the opportunity to work with the industry's best minds. The Lockheed Propulsion Company facility is just minutes from two of California's leading universities. And living in Redlands, you will be halfway between Los Angeles and world-famed mountain and desert recreation areas.

Openings for solid propellants and hybrid rocket motor research and development are immediately available in the following fields: Chemistry — Inorganic, Physical, Analytical and propellant; Physics and Mathematics — Viscoelastics, Mechanics, Engineering Mathematics; Engineering — Design, Stress, Materials, Thermodynamics, Heat Transfer and Ballistics.

Send résumé to: Mr. David Kieselbach, Personnel Manager, Dept. 5211, P. O. Box 111, Redlands, California. An equal opportunity employer.

LOCKHEED PROPULSION COMPANY

A SUBSIDIARY OF LOCKHEED AIRCRAFT CORPORATION

REDLANDS, CALIFORNIA

LEFT: A grasshopper-like lunar craft lands on its target surface. The craft's "head" appears influenced by the look of satellites that bear many antennae. *Missiles and Rockets*, November 26, 1962

OPPOSITE: The incipient techno-future is notably absent from the aesthetic of Bell Aerosystems' ad, and the ad copy does not acknowledge the historical advantage that solid propellants had in the extreme competition between makers of solid versus liquid propellants. *Missiles and Rockets*, May 14, 1962

Liquid and solid chemical propellants have very different histories. Solid chemical propellants, the origin of rocket power, have their earliest antecedent in gunpowder rockets made thousands of years ago in China: explosive black powder was first used to propel airborne weapons during the Han Chinese Song Dynasty period (960–1279). Solid propellants account for most of the history of rocket propellants up to the twentieth-century work of Tsiolkovsky and Goddard, each of whom later experimented with liquid fuels.[6]

Leading manufacturers of solid chemical propellants, such as Thiokol, tended to assume that the storability and portability of solid fuels ensured their enduring market dominance. Lockheed Propulsion's ad (above) only secondarily discusses a hybrid system. Combined uses of solid and liquid fuels ultimately emerged as the long-term solution to competition between the two.

In the early twentieth century the independently developed internal combustion engine leapfrogged existing solid fuel rocket technology and brought airborne propulsion using airplanes into a new dimension of liquid-fueled aircraft flight. Solid fuel rockets ignite hot and then burn out, creating an acute impulse drive that's hard to guide or sustain. Today, solid fuel booster rockets work in tandem with enormous liquid fuel tanks and engines to project satellites, explorers, and manned spacecraft into the sky. But it was liquid fuels (most commonly liquid oxygen, liquid hydrogen, or RP-1 kerosene, singly or in combination) that turned out to be the necessary component to provide the thrust that ultimately best ensured escape velocity as well as optimum steerability.

The physical resemblance to the V-2 missile of the rocket blasting off from the Moon in Rocketdyne's ad (page 108) references the military history of the liquid-fueled V-2. Wernher von Braun's team took liquid propulsion to a new level with the V-2, powered by kerosene and liquid oxygen. The rocket in Marquardt's split-panel ad (page 109) is shown first departing Earth and then landing on the Moon. It depicts a more fully

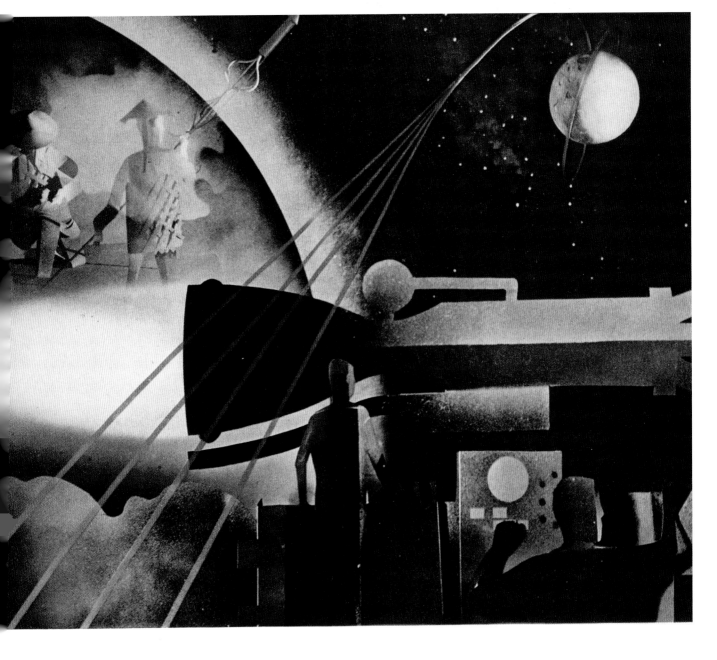

ROCKETRY...FROM KAI-FUNG-FU TO THE MOON

From the first-known use of rockets in the defense of Kai-fung-fu in 13th century China, rocketry has experienced anything but a continuous advance. For many hundreds of years these early fire arrows knew little improvement or new missions. Gradually they were given minor applications as signaling devices, incendiary weapons and lifeline launchers. Suddenly, in the last three decades, rocketry has made its breakthrough as a spectacular source of power.

Since World War II, Bell has been in the forefront of rocket engine application and development, beginning with the design of this country's famed X-1 supersonic research airplane, first to penetrate the sound barrier successfully in 1947. It was followed by the Bell X-1A and X-2, which established even higher speed and altitude frontiers. Next came Bell's own liquid-propellant rocket engine for Rascal, the first operational air-to-surface guided missile.

Today Bell is delivering in quantity the highly-reliable Agena 16,000 pound thrust liquid rocket engine which made aerospace history February 28, 1959, by propelling this country's first polar satellite into orbit. Since then, the Bell Agena engine has put more useful payload into orbit than any other and now is playing a significant role in Air Force satellite programs and NASA's Ranger moon probe. Bell also is providing the rocket reaction control systems for the manned Mercury capsule, Centaur and the X-15 research airplane. Bell engineers continue to develop new uses and new engines for even more powerful rocket propellants to help speed this country's conquest of space.

BELL AEROSYSTEMS COMPANY · *Buffalo 5, N. Y.*
DIVISION OF BELL AEROSPACE CORPORATION

A [textron] COMPANY

COUNT DOWN!

for the conquest of space

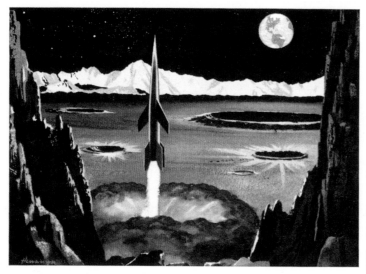

"MISSION ACCOMPLISHED: DEPARTING LUNA 2205 ZEBRA"

This message, flashed across a quarter-million miles to Washington, D.C., will be awaited anxiously by millions.

But even then our first expedition to the moon will still face its most crucial test—the journey home to earth.

The success of that trip will depend in large part on rocket propellants—fuels and oxidizers that will have been stored for days in the tanks of the expeditionary vehicle and yet will respond instantly when needed.

Storable liquid propellants is one of the fields in which Rocketdyne has anticipated the future. For more than ten years, its propellant chemists have been studying, engineering, and testing combinations of storable fuels and oxidizers for greater storability and higher energy.

Storability PLUS high energy

Rocketdyne has tested these combinations in all production and experimental engines. The results prove that today's storable fuels and oxidizers have these important capabilities:

(1) High performance, even after months or years of storage; (2) Stability over a wide temperature range, permitting storage in missile tanks without rigid environmental controls; (3) Dependable performance, predictable even at extremes of heat and cold; (4) Instant readiness for firing at any time during the storage period; (5) Energy yields equal to or higher than those of conventional propellant combinations.

Second-generation missiles

The tests also prove that engines developed for conventional propellants can be converted to storable combinations rapidly and inexpensively—a significant consideration in the develop-ment of second and third generation strategic, tactical, and air defense missiles.

Significant, too, is the *potential* performance of storable combinations. Research points to energy yields as high as 400 seconds of altitude specific impulse—performance 20 percent higher than that of today's combinations. These high-energy yields will offer new capabilities and greater flexibility for America's scientific and military programs.

Stepping stones to Space

Rocketdyne has designed and built much of today's operating hardware in the high-thrust rocket field. Engines by Rocketdyne power most of the military and scientific projects

POWER FOR AMERICA'S MISSILES
Thrust chamber production line for Thor and Jupiter at Rocketdyne's Neosho, Mo., facility moves smoothly.

sponsored by Air Force, Army, and NASA. This experience now becomes the point-of-departure for tomorrow's journeys into the unknown.

FIRST WITH POWER
FOR OUTER SPACE

ROCKETDYNE R

A DIVISION OF NORTH AMERICAN AVIATION, INC.

ABOVE: Relocated to the U.S. following the war, Wernher von Braun and members of his team worked with Rocketdyne, a division of North American Aviation. This recruitment ad ran when Rocketdyne was ramping up for its work on the development of the Saturn rocket engines, the launch powerplant for the Apollo missions. Artist (illustration): Joseph Henninger, *Aviation Week*, July 6, 1959

OPPOSITE: The three parts of this story—liftoff, travel, and lunar landing—are clear enough, but less clear is how this rocket would lift off to return to Earth. *Aviation Week*, April 17, 1961

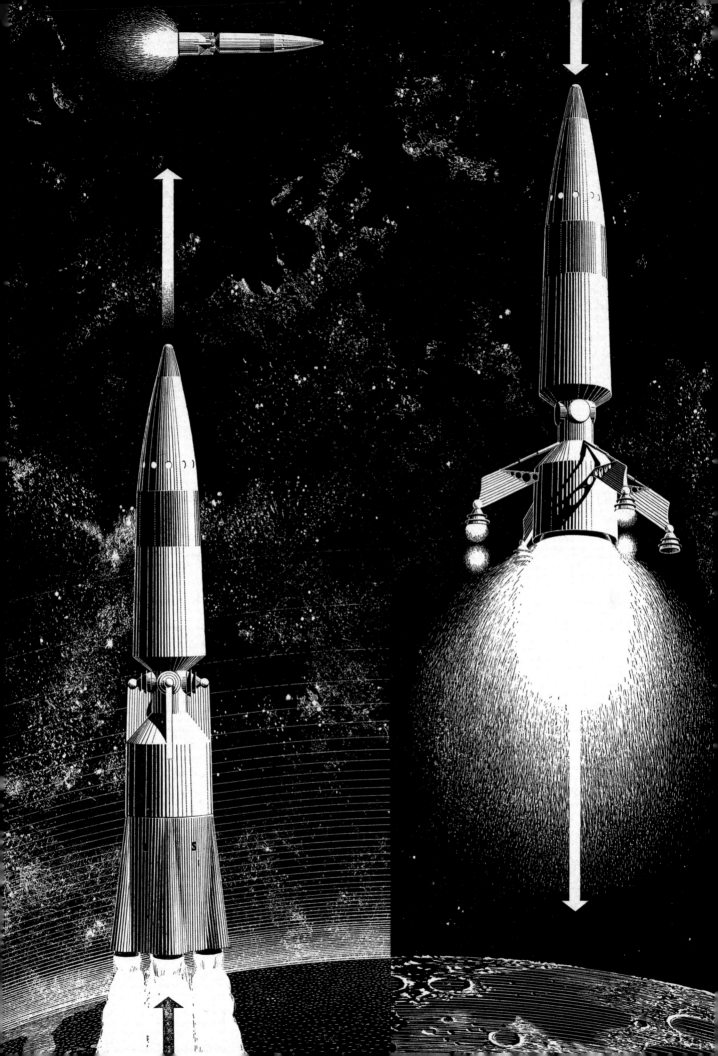

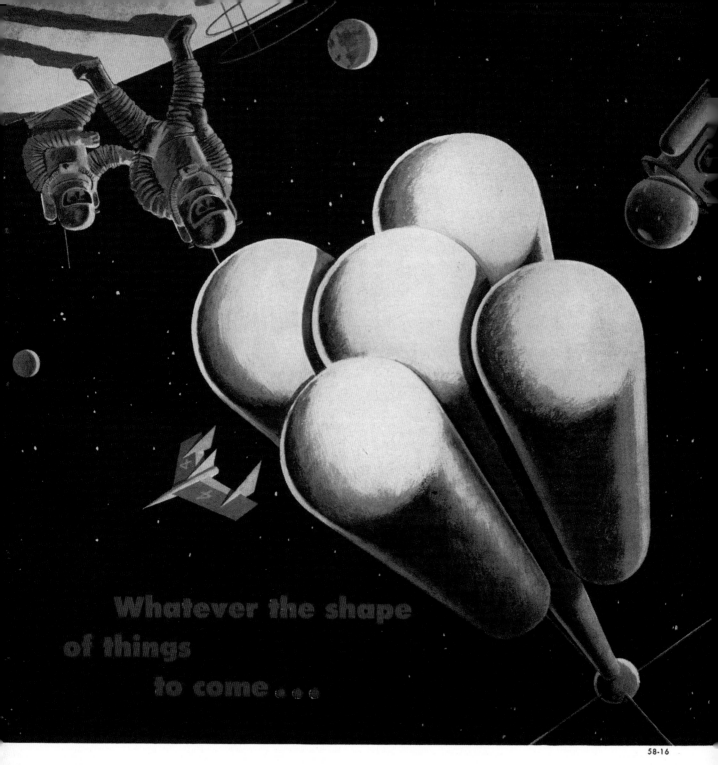

Whatever the shape
of things
to come . . .

58-16

Fantastic shapes for the space vehicles of the future already are on the boards. Even more radical designs are taking form in the minds of engineers. And their parts and components will just as radically differ from those produced today. New standards of precision and new methods of working new materials will be required.

One thing at least is certain: the same design, development and manufacturing experience which made the transition from aircraft piston engines to jets will be needed to produce these shapes of the future. Since the early 1920's, Ex-Cell-O has been among the major suppliers of machines, parts and assemblies to the aircraft industry. In that time it has built a reputation for extending the frontiers of precision.

Today, Ex-Cell-O manufactures such components

as: rotors, blades, fuel nozzles, actuators, valves and fuel controls. Tomorrow? Well, perhaps you yourself have a problem which Ex-Cell-O's long experience in the production of precision controls and assemblies might help you solve. If so, why not contact Ex-Cell-O today?

EX-CELL-O FOR PRECISION (XLO)

EX-CELL-O
CORPORATION
DETROIT 32, MICHIGAN

Aircraft
Division

MAN AND MISSILES FLY HIGHER, FASTER AND SAFER WITH PARTS AND ASSEMBLIES BY EX-CELL-O.

OPPOSITE: As combined liquid oxygen–kerosene engines evolved, engineering requirements demanded that clusters of engines be used (each with attendant fuel tanks) to achieve the velocity needed to hoist large payloads into orbit and beyond. *Aviation Week*, March 3, 1958

RIGHT: This imaginary multiengine Saturn rocket landing on the Moon is a clumpy departure from the streamlined silhouettes of other imagined rocketships, but it is far closer to the reality of the Apollo craft that went to the Moon in 1969. Artist: Alex Schomburg, *Satellite Science Fiction*, October 1958

evolved rocket design with at least three launch engines, rather than one, and the engines have been jettisoned following launch.

The configuration of the tubular balloon fuel tanks featured in Ex-Cell-O's ad (page 110) reflects the rapidly growing trend toward multiengine rocket design, which reached its apogee with the tremendous five-engine Saturn rocket series designed specifically for major missions into space. Saturn rockets eventually supplied the initial rocket stages for the Apollo program, launching all Moon-bound civil spacecraft in a three-stage collaboration with the hydrogen-powered Centaur rocket.[7] The Saturn series played a key role in the evolution of the civil space program even though it was originated as a Department of Defense project. Budgetary, logistical, and international image concerns led to the Saturn rocket program's transference to NASA's control in 1959, and thus the Moon landing initiative became a civil space activity.[8] This watershed event in the balance of power between military and civilian uses of space technology placed the most powerful launch vehicle of the twentieth century firmly in NASA's domain.

The prototypical 1950s engineer pictured in Morse's recruitment ad (page 112) stands before his design reviewing blueprints. The rocket, portrayed with a distinct lack of visible exostructure, bears little resemblance to today's. The exposure of its upper and lower propulsion fuel sections calls to mind Robby the Robot more than it does the gleaming white Saturn launch vehicle. The tank at the top of this rocket perhaps would contain large-moleculed liquid hydrogen; the lower sphere in the guts of the rocket is likely for liquid oxygen, a frequent combination that dominates upper-stage launch vehicles up to the present.

While vast teams of engineers were developing launch propulsion technology, others were cultivating much smaller scale propulsion engines to drive control (steering) systems. As Chandler Evans illustrates with a sprite-possessed fin-design

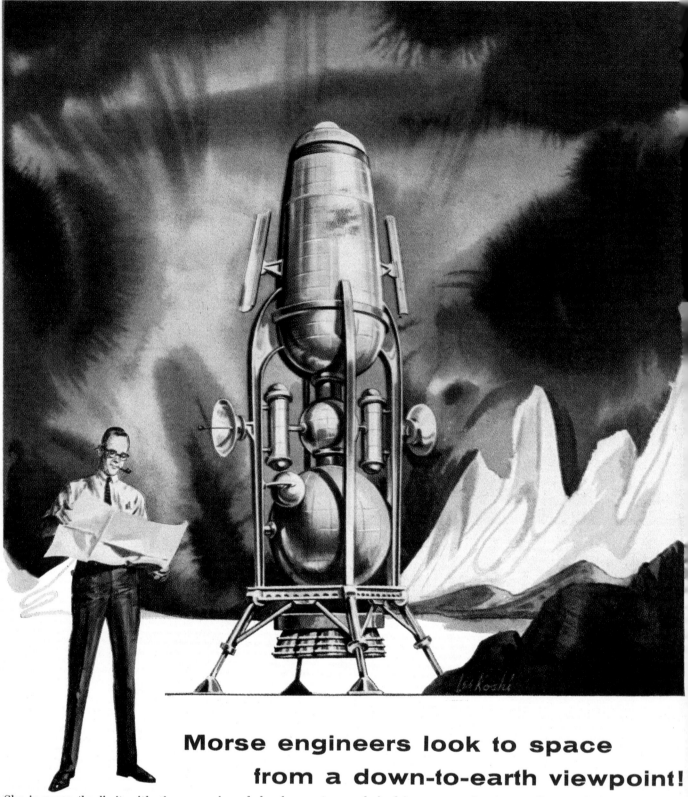

Morse engineers look to space
from a down-to-earth viewpoint!

Sky is never the limit with the research and development staff working with the broad facilities at Morse.

Morse has grown up with the automotive industry. Its specialists have worked with designers and engineers in developing and perfecting the products of their imagination.

For more than 60 years, Morse has specialized in the science of kinematics. Perhaps its best known products are basic chain drives, gear reducers, couplings, and clutches in more major fields than you could count on the fingers of both hands.

Morse engineers, supported by Borg-Warner's ultra-modern research laboratory, can now offer a better way of giving your ideas a boost, and provide down-to-earth solutions to your problems in the race for space. Consult: Morse Chain Company, Dept. 37-30 a Borg-Warner Industry, Ithaca, N.Y. In Canada: Morse Chain of Canada, Ltd., Simcoe, Ontario.

World's largest manufacturer of precision parts

A BORG-WARNER INDUSTRY

Now... Hot Gas to impart force or motion

Today's hot gas servo control systems are attractive to the aerospace industry because of their reliability, simplicity and readiness capability. CECO's extensive development work in the field of high-pressure pneumatics further indicates that such systems can effect dramatic weight and cost savings as well.

Chandler Evans has run hot gas systems on both solid and liquid propellants. Typical applications are: control surface actuation, rocket engine thrust vectoring, reaction steering, and antenna or seeker positioning.

Contact your nearest CECO Field Engineering Office for cooperation in solving your control system problems.

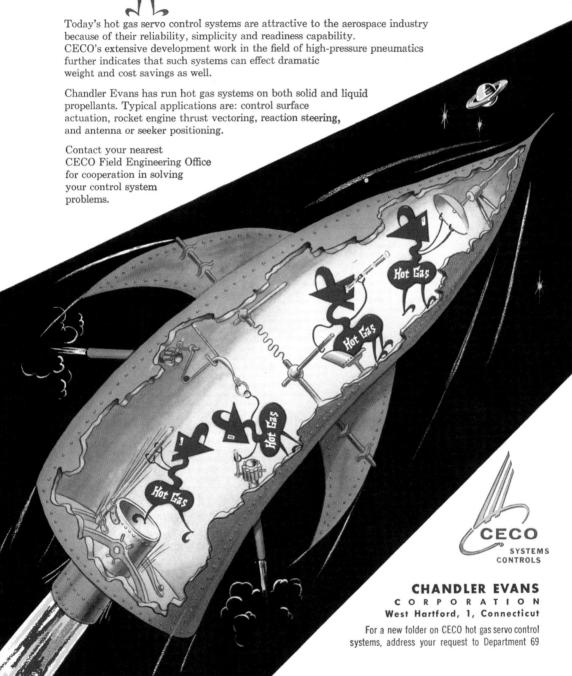

CECO
SYSTEMS
CONTROLS

CHANDLER EVANS
C O R P O R A T I O N
West Hartford, 1, Connecticut

For a new folder on CECO hot gas servo control systems, address your request to Department 69

OPPOSITE: Behind white lunar mountains an unnaturally vivid sky that looks almost like the northern lights is a visual metaphor of the power of the engineer's imagination. Artist: Les Koski, *Aviation Week*, March 7, 1960

ABOVE: Chandler Evans advertised its navigation system with flames of hot gas animated as navigational sprites staffing four navigation stations: sighting; telemetry; steering (with a rudder); and pitch, yaw, and roll control with two side thrusters. Saturn hangs in the backdrop of this star-chasing journey. *Aviation Week*, October 12, 1959

CONCEIVING THE MEANS

*of launching larger payloads in space
is one aspect of a vast new program at
Martin-Denver. If you know creative
persons who should be a part of this
program, urge them to communicate with
N. M. Pagan, Director of Technical and
Scientific Staffing, The Martin Company,
P. O. Box 179 (Dept HH 2),
Denver 1, Colorado*

MARTIN
DENVER DIVISION

OPPOSITE: Willi K. Baum created in oil this image of three elongated tanks of liquid fuel and the cloud of rocket exhaust thrust from them for Martin's ad for its launch systems program, 1960. Courtesy of the author

RIGHT: The delicate pen-and-ink work of Ken Smith promoted the Marquardt Corporation's development of a liquid fuel braking/propulsion "pulse" engine that would rotate an arriving spacecraft from headfirst to feetfirst and then control its landing on the lunar surface. *Aviation Week*, November 6, 1961

rocket (page 113), the propulsive force of the emission of hot gas when chemical fuels ignite is what pushes a spacecraft, or its control and guidance system, toward its objective. Marquardt competed with Chandler Evans in the guidance controls market. The chemical bipropellant system described in Marquardt's pulse rocket ad (above) is hypergolic, meaning that two fuels (hydrazine and nitrogen tetroxide here) automatically combust when mixed. Control of the two fuels' mixture, in short bursts, creates the "pulse" action that allows for controlled cooling and braking. The tight style of artist Ken Smith's illustration for the ad neatly conveys the sense of precision needed to make such a landing.

Two Aerojet-General ads (pages 116 and 117) represent the approaching end of fancifully fictionalized depictions of chemically propelled launch vehicles. Both promote the company's significant achievement with AbleStar, the first start-and-stop rocket engine. AbleStar used a hypergolic fuel system of hydrazine and nitric acid,[9] a formula whose complexity is belied by the charming image of a balloon-shaped spacecraft with little feet.

Although multistage rockets were abundant on launch test pads in that era (as now), there was no more romantic way to depict them than as a landing craft. The spheres visible in the underside of the engine in the AbleStar ad on page 116 are helium tanks that provide pressure to power the engine's chemical propellant feed system.[10] Both ads promote the same Aerojet rocket, but one invites imagination about lunar exploration, while the other is a dead ringer for a documentary photograph of the rocket that it promotes.[11]

In July 1962 NASA came to a decision that would spell the end of fantastical promotional imagery of spacecraft. After "a million man-hours of engineering studies demonstrated that it would be the cheapest method, and would result in the earliest possible accomplishment of a lunar landing,"[12] a lunar orbit rendezvous (LOR) plan

AEROJET'S
AbleStar

RestartABLE

April 13, 1960, marks a dramatic milestone in American propulsion technology—the first successful restart of a rocket engine in outer space. The mission, under Air Force Ballistic Missile Division management—launching of the ARPA-Navy Transit navigational satellite into precise orbit. The propulsion system: Aerojet's AbleStar upper stage.

ReliABLE

AbleStar's spectacular achievement carries to a new pinnacle the unrivaled reliability pattern of Aerojet's ABLE series—15 tries, 15 triumphs—in launchings conducted for the Department of Defense and the National Aeronautics and Space Administration.

AvailABLE

Produced by Aerojet-General, under systems management performed by Space Technology Laboratories, the AbleStar was designed, developed, qualified and flown in less than one year from contract inception. Simple, low-cost AbleStar upper stage engines are available now for immediate contributions to America's space programs.

A product of the
Aerojet Systems Division

Aerojet-General ®

C O R P O R A T I O N
Azusa, California

A
SUBSIDIARY
OF
THE
GENERAL TIRE
AND
RUBBER
COMPANY

FIRST RESTART IN SPACE

Engineers, scientists—investigate outstanding opportunities at Aerojet

ABOVE AND OPPOSITE: Depicted with a shape like a nineteenth-century hot air balloon, the hypergolic AbleStar (opposite) recalls the Montgolfiers' era of flight. The disembodied AbleStar engine (above) is a quasi-realistic picture of the same engine. *Aviation Week,* July 11, 1960; *Missiles and Rockets,* August 28, 1961

for the Apollo program's lunar landing was announced. Chosen for its conservation of resources and design efficiency, the LOR plan brought an end to the romantic vision of a rocket landing on the Moon.

It also resolved the problem of how one rocket, typically illustrated with just one or two fuel tanks, would launch from Earth, turn around, and return home from the Moon. The Apollo LOR program would consist of three separable vehicles: the launch vehicle, the crew module, and the lunar excursion module (LEM), known by the humble nickname "moon bug." The specification of these components marked a significant rift between the evolving technological reality and the pervasive motif of a rocket landing on the Moon. The little LEM was poorly adaptable to the romanticized visions of lunar landings in science fiction literature.[13] As early as autumn 1962 imaginative depictions of rockets began to disappear from trade advertising, to be replaced by realistic representational imagery.

Nuclear Rockets!

In 1960 Wernher von Braun told a congressional committee that "an upper nuclear stage for the Saturn vehicle is planned with a 1968 or 69 launching date."[14] Although chemical propulsion developed so far that it came to define the industry, many competing launch technologies fell by the wayside. Engineers of 1960 sought "answers to the spaceflight challenge"[15] that would enhance chemically propelled rockets, perhaps even ultimately go beyond them: "Ion, nuclear, arc jet and photon engines will surpass chemical rockets,"[16] proclaimed the popular, pulpy *Space World* in 1961. In recent years, some of the ideas set aside fifty years ago have been redeveloped, while others, such as nuclear rockets, remain dormant.

The abrupt birth in 1945 of the atomic era focused the world's scientific consciousness on nuclear power, influencing an array of technological and cultural developments in the 1950s, in particular the hope for future spaceflight. The promise of clean, limitless fuel for civil applications stirred an optimism that contrasted sharply with the anxiety of the threat of nuclear weapons. Nuclear-powered rockets promised to supersede solid and liquid fuel, with cleaner, stronger, faster propulsion—in theory, anyway.

Space wagons
with nuclear horses

Space exploration will really come of age when manned rockets can leave earth, accomplish their missions and return without disposing of parts of themselves en route. This breakthrough depends on the rapid development of both nuclear rocket engines and space vehicles capable of using them. Douglas is putting forth a major research effort in the area of manned nuclear space ships. Every environmental, propulsion, guidance and structural problem is being thoroughly explored. Results are so promising that even if the nuclear engine breakthrough comes within the next five years, Douglas will be ready to produce the vehicles to utilize this tremendous new source of space power! Douglas is seeking qualified scientists and engineers for this and other vital programs. Some of our immediate needs are listed in the column on the facing page.

Elmer Wheaton, Engineering Vice President, Missiles and Space Systems, goes over new space objectives that will be made possible by nuclear propulsion with Arthur E. Raymond, Senior Engineering Vice President of **DOUGLAS**

MISSILE AND SPACE SYSTEMS ■ MILITARY AIRCRAFT ■ DC-8 JETLINERS ■ CARGO TRANSPORTS ■ AIRCOMB ■ GROUND SUPPORT EQUIPMENT

NUCLEAR ROCKET PROPULSION AT AEROJET-GENERAL

Nuclear rockets, with a performance capability nearly twice that of the highest-specific-impulse chemical rockets, have been of major interest to Aerojet-General for several years.

Exploratory studies were initiated by Aerojet in 1955 to ascertain the feasibility of nuclear rockets, and the technical advances required to develop a successful nuclear propulsion system were determined. This work at Aerojet has undergone continuous expansion under government and company sponsored programs. Included are: preliminary design of engines and vehicles, simulated nuclear engine tests, radiation hazards research, analog computer system design (to simulate nuclear rocket operation), nuclear test facility construction, and the design, development, testing, and manufacture of reactors.

These programs have resulted in significant progress toward the development of a practical and reliable nuclear propulsion system. They are based on Aerojet's combined experience in liquid and solid propellant rocketry, nuclear technology, and cryogenics—experience which ensures that the challenge of a new era in propulsion can, and will, be met.

Aerojet-General ®

CORPORATION

THE GENERAL TIRE

A SUBSIDIARY OF THE
GENERAL TIRE AND RUBBER COMPANY

Engineers who had faith in atomic propulsion foresaw a future in which nuclear
rockets would liberate us from the constraints of chemical propulsion, blasting
humanity into space like no other force imaginable. In 1961 the scholarly *Astronautics*
editorialized: "With nuclear rockets, we could be first to the planets."[17] Never mind the
Moon shot—nuclear rocket technology suggested models of solar system exploration
that leapfrogged von Braun's paradigm. Aerojet-General was a lead contractor in the
United States' largest nuclear rocket program, Project Rover, initially a joint project of
the Atomic Energy Commission (AEC) and the Department of Defense. After preliminary
research on nuclear rocket feasibility at Los Alamos National Laboratory from 1955
to 1960, development facilities for the Project Rover rocket were built at the Nevada
Test Site in 1960. On August 31, 1960, a joint AEC-NASA nuclear propulsion office was
established and NASA joined the project.[18]

The establishment of this office marked atomic rocket power's shift from military
to dual military-civil use, and the prospect of nuclear-powered spaceflight had already
generated excitement throughout the industry. Just a year before the joint office had
opened, the navigational computer builder[19] American Bosch ARMA Corporation ran
ads promoting nuclear-powered craft (pages 122, 123, and 125). Classic creations
by the master of the science fiction vernacular Frank Tinsley illustrate these ads and
invite the viewer to imagine the suspenseful action that they depict. Designed to fly
in two directions, nose first and tail first, the proposed nuclear rocket in the ad for
the "Mars Snooper" is an impressive variation on the official AEC-NASA Project Rover
vehicle. Tinsley was a writer and futurist as well as an artist, and he was likely a creative
contributor to this sensational idea.

Project Rover was not, however, the only officially sponsored U.S. nuclear rocket
project. Between 1958 and the mid-1960s a small handful of alternative nuclear rocket
programs were pursued by different engineers. They were commonly based on the
idea of nuclear pulse propulsion, in which blasts from discrete detonations of small
atomic "bombs" propel the spacecraft. At the Martin Company between 1959 and
1961, the engineer Dandridge Cole hypothesized several craft designs using variations
on a propulsion system of this type, including one called "Macrolife" that could have

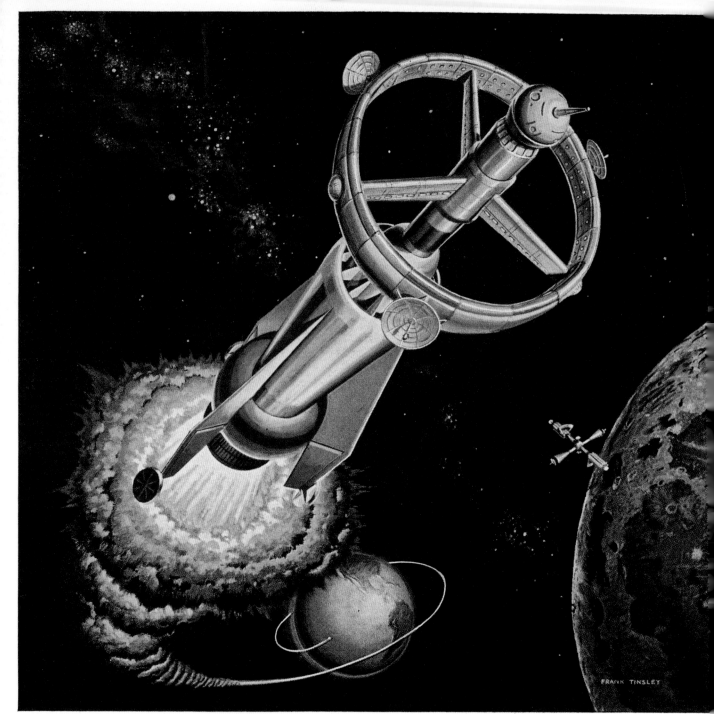

STEPS IN THE RACE TO OUTER SPACE

Atomic Pulse Rocket

This is the Atomic Pulse Rocket, a pot-bellied space ship nearly the size of the Empire State Building, propelled by a series of atomic blasts.

The enormous rocket (weighing 75,000 tons fully loaded) is designed to leave Earth with a thrust of 100,000 tons. Altogether a thousand atomic blasts—each equal to 1,000 tons of TNT—are fired from a low velocity gun into a heavy steel rocket engine at a rate of one per second until the vehicle leaves Earth's atmosphere. Then steam and vaporized steel maintain the thrust. After transit speed is reached, and the propulsion system

shut off, power is provided by solar batteries plating the wing and body surfaces.

Inside the rocket, living quarters are situated in the rim of a pressurized wheel-like cabin which revolves to provide artificial gravity. Radio and radar antennae revolve with it. Tubular hydroponic "gardens" on either side of the rim grow algae to produce oxygen and high protein food.

The Atomic Pulse Rocket could transport payload to the Moon at $6.74 per lb., less than one quarter the prevailing air

freight charges over equivalent distance.

A similar project is past the pilot-study stage in the Defense Department.

ARMA, now providing the inertial guidance system for the ATLAS ICBM and engaged in advanced research and development, is in the vanguard of the race to outer space. For this effort, **ARMA** needs scientists and engineers experienced in astronautics. **ARMA**, Garden City, New York. A Division of American Bosch Arma Corporation.

AMERICAN BOSCH ARMA CORPORATION

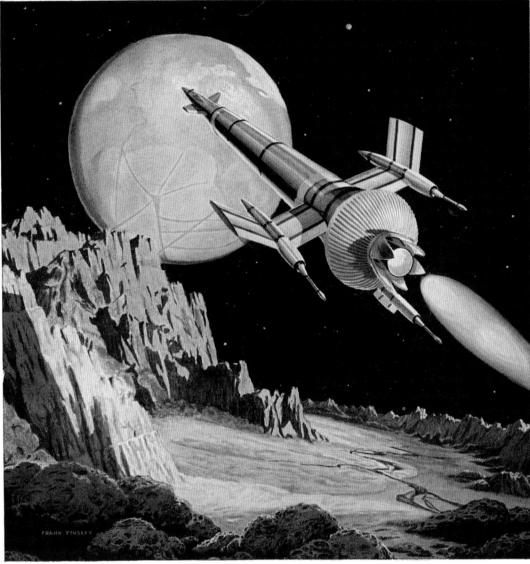

STEPS IN THE RACE TO OUTER SPACE

Mars Snooper

This nuclear-fueled reconnaissance craft is preparing to land on Mars' outermost satellite, Deimos—12,500 miles away from the "red planet" (center) and 35 million miles away from the Earth. Deimos' gravitational pull is so slight that a featherlight landing could be made, and a take-off could be accomplished with little more than a shove of the pilot's foot! (At Deimos' orbital speed, such a push would start the ship back to Earth at 3000 miles per hour.)

Our spaceship is designed to fly in two directions—nose first as a space rocket and tail-first as a ramjet airplane. Propulsion for both is provided by a single atomic heat source, reacting with hydrogen for rocket thrust, and with atmosphere to power the ramjets.

Travel to Mars, braking for landing, take-off and re-entry are accomplished by rocket-thrust. As the ship approaches the Earth's atmosphere, it assumes a tail-first attitude. The "petal doors" enclose the rocket nozzle, and the ship is transformed into a high speed, ramjet airplane with M-shaped wings. Control fins are located in the nose of the craft, near the crew's quarters.

OPPOSITE: This atomic rocket, planned by Manhattan Project physicists, was to have been powered by a series of very small nuclear bombs ejected behind the craft and detonated sequentially, propelling the craft forward. Artist: Frank Tinsley, *Aviation Week*, July 4, 1960

ABOVE: Mars looms large over the horizon, beyond Deimos, its outermost satellite, while the nuclear-powered "Mars Snooper" skates Deimos's surface in preparation for landing. Deimos was proposed here as the best approach for reconnaissance on Mars. Artist: Frank Tinsley, *Missiles and Rockets*, January 26, 1959

A rocket takes off from the remote launchpad of a well-developed lunar base of the classic semisubmerged type, with roads leading out concentrically, dividing the lunar surface into an eight-sliced pie. The roads seem to be populated with vehicles or way stations and the base with outbuildings that likely contain hydroponic gardens. Artist: Frank Tinsley, *Fortune*, July 1959

carried ten thousand or more colonists. Between 1963 and 1965 Lawrence Livermore Laboratory extended Cole's work in Project Helios, a vehicle planned for crewed Mars missions.[20] Neither Cole's nor the Livermore Laboratory's atomic pulse rocket projects progressed beyond conceptual stages.

The largest and most fully executed of the atomic pulse propulsion rockets was Project Orion (1958–65), which started as a Defense Department project. As described by George Dyson in *Project Orion: The True Story of the Atomic Spaceship*,[21] Orion had a short but intense life span. It was conceived in 1958 to carry large numbers of colonists to distant interplanetary destinations. But as the Department of Defense realized that there was little or no military application for the rocket that the physicists were working on, support for the project decreased. What's more, the project originated so far out of NASA's purview that the administration could not easily assimilate it, which ultimately caused Congress to fail to support it. After seven years' work Orion was terminated in 1965.

Frank Tinsley was likely drawing on all these projects in the space engineering community when he formulated the "design" of the atomic pulse rocket in the ad for American Bosch ARMA Corporation (page 122). It was to be nearly the size of the Empire State Building, weigh 75,000 tons, and be propelled by a thousand atomic blasts. Tinsley's rocket features a classic von Braunian wheel-shaped habitation module attached to its nose cone, a feature not present in any sketches for any other nuclear pulse rockets.

Reacting in part to Orion, the Department of Defense attempted to subject its practice of filtering documents to maintain secrecy to all advertisements for classified activity such as nuclear rocket development. The department's directive of 1960 aimed to censor *all* aerospace industry advertisements, placing all military contractor statements and advertising under the overview of a Department of Defense spokesman. A pushback from an industry anxious about its ability to recruit a workforce, however, was effective and the directive was retracted.[22] Had that gag order not been rescinded, ARMA could not have attempted to link its fanciful creation to the existing atomic pulse rocket initiatives with the winking remark that "a similar project is past the pilot-study stage in the Defense Department."

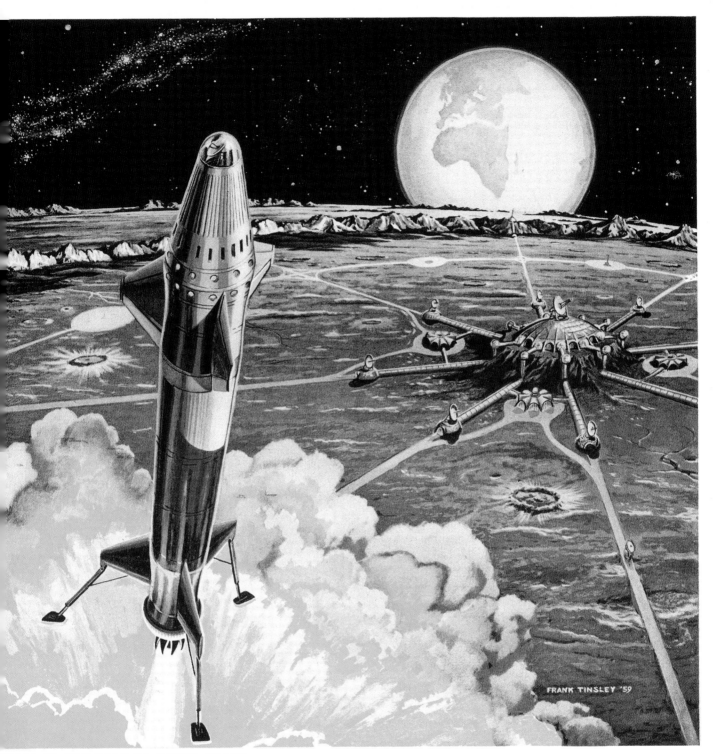

STEPS IN THE RACE TO OUTER SPACE

FRANK TINSLEY '59

Nuclear Rocketship

Despite the sky-high transportation costs, Lunar manufacturing should prove economically viable. With unlimited Solar power, controlled atmospheres and advanced automation, a considerable commerce could be realized in delicate instruments, rare minerals, reactor cores and other items that might be more efficiently processed or produced in the Moon's perfect vacuum.

To supply the Moon colonists, and to carry their production back to Earth, special rocketships will be developed. Nuclear energy is the most promising source of propellant power.

The ship shown here utilizes nuclear fission for heat and hydrogen gas as a working fuel. From pressurized tanks, the gas is fed through a heat exchanger, expanded, and expelled for the motive thrust.

When the craft leaves Earth, it carries only enough gas for a one-way trip. For, by extracting hydrogen and oxygen from Lunar rocks, Moon settlers could refuel the rocketship for

the return voyage. This will permit smaller fuel tanks on the craft and larger payloads.

———

Inertial navigation systems will play an increasing role in the exploration of outer space. **ARMA** is actively supporting the Air Force's program in long range missiles and is in the vanguard of the race to outer space. **ARMA** . . . Garden City, New York. A Division of American Bosch Arma Corporation.

AMERICAN BOSCH ARMA CORPORATION

Project Rover's vehicle came to be known as NERVA (Nuclear Engine for Rocket Vehicle Application). NERVA had a longer life span than Orion but an outcome that was similarly disappointing for those involved. Extensive development on the NERVA rocket was conducted in Nevada throughout the 1960s, even after it was decided that the Apollo missions would be launched solely by chemically propelled rockets. By 1971 NERVA development was complete and waiting for a testing cycle and work assignment. "The year 1970 was marked by the transition from completion of the NERVA technology program to the definition phase...the NERVA engine, as defined, could be used in a variety of missions,"[23] the AEC reported somewhat wistfully of its orphaned project. But history had moved beyond NERVA. The high cost of the Vietnam War and the shrinking economy contributed to the Nixon administration's casting a critical eye on space projects in 1971–72. The reactor program at NASA Lewis Research Center, part of Project Rover, was abruptly closed in January 1972. "Long-range research and development work that cannot be expected to have a real need or application until the 1980s must be terminated at this time,"[24] the director explained to the deflated staff.

Public concern, too, contributed to the cancellation of the nuclear rocket program. *Missiles and Rockets* had pointed out in 1960 that the problem of radiation in the vicinity of the launching site would prohibit launch observation within a mile or two and require concrete shielding for the crew, not to mention that the entire launchpad facility would have to be abandoned long-term in the event of a launch calamity[25]—and launch calamities were all too familiar in the early days of chemical rocket testing.

All of this resulted in the permanent abandonment of nuclear rockets by NASA and the Department of Defense. In spite of NASA administrator Sean O'Keefe's encouraging words about nuclear propulsion in 2002,[26] NASA has no active nuclear rocket projects under way as of 2009. Chemical launch technologies roundly won out, and today's Space Shuttles and Chinese, Russian, and Indian launch vehicles all employ variations of the chemical propulsion technologies.

But nuclear power did have its day in space. Paralleling the early days of Project Rover and NERVA, the AEC was also engaged with Martin, Aerojet-General, and other contractors in a non-NASA nuclear project. Called by its acronym, SNAP developed

NUCLEAR POWER PACKAGES
FOR SPACE

by AEROJET

Long-duration electrical power systems
to supply space vehicle operational
needs, such as communications,
auxiliary power, and sustaining thrust
are under intensive investigation
by our subsidiary, Aerojet-General
Nucleonics, at San Ramon, California.

AGN's background in packaged nuclear
power is being combined with corporate
experience in advanced propulsion
systems, to open a new field of uses for
space vehicles through the availability
of large blocks of power.

Plants at Azusa, Downey, San Ramon
and near Sacramento, California;
Frederick, Md.

Aerojet-General® CORPORATION

A
SUBSIDIARY
OF
THE
GENERAL
TIRE
AND
RUBBER
COMPANY

Engineers, scientists—investigate outstanding opportunities at Aerojet.

FACIN

$E = MC^2$

HE FOURTH DIMENSION IN PROPULSION DEVELOPMENT

Whether the universe has a "saddle shape," or any shape at all, is a matter of interesting conjecture. The matter of space travel, however, is the subject of intense experimentation. A nuclear/thermionic/ionic propulsion system, currently being studied at Lockheed Missiles and Space Division, might well become the power source for space vehicles.

Its design incorporates a nuclear reactor only one foot in diameter, generating heat at a temperature of 1850°K. This is transmitted to banks of thermionic generators, converting the heat directly into electrical energy for the ion beam motor which uses cesium vapor as a fuel. The entire system is designed without any moving parts, minimizing the possibility of failure.

Lockheed's investigation of propulsion covers a number of potential systems. They include: plasma, ionic, nuclear, unique concepts in chemical systems involving high-energy solid and liquid propellents, combined solid-liquid chemical systems. The fundamentals of magnetohydrodynamics, as they might eventually apply to propulsion systems, are also being examined. Just as thoroughly, Lockheed probes all missile and space disciplines in depth. The extensive facilities of the research and development laboratories—together with the opportunity of working with men who are acknowledged leaders in their fields—make association with Lockheed truly rewarding and satisfying.

Lockheed Missiles and Space Division in Sunnyvale and Palo Alto, on the beautiful San Francisco Peninsula, is an exciting and challenging place to work. For further information, write Research and Development Staff, Department M-24D, 962 West El Camino Real, Sunnyvale, California. U.S. citizenship or existing Department of Defense industrial security clearance required. All qualified applicants will receive consideration for employment without regard to race, creed, color or national origin.

Lockheed / MISSILES AND SPACE DIVISION

Systems Manager for the Navy POLARIS FBM and the Air Force AGENA Satellite in the DISCOVERER and MIDAS Programs

SUNNYVALE, PALO ALTO, VAN NUYS, SANTA CRUZ, SANTA MARIA, CALIFORNIA • CAPE CANAVERAL, FLORIDA • HAWAII

"systems for nuclear auxiliary power,"[27] or radioisotope-fueled batteries for spacecraft.
SNAP batteries do not provide propulsive power; rather they power operating systems
aboard spacecraft. On June 29, 1961, the first nuclear battery–reliant satellite was
launched into orbit,[28] and SNAP units subsequently became widely used and now
dominate the systems power of many interplanetary spacecraft. When Apollo 11 landed
on the Moon, one of the sensors that astronauts Armstrong and Aldrin left operating on
the lunar surface was SNAP-powered.[29]

Interplanetary Travel

Once escape velocity has been reached, orbital, interplanetary, and even interstellar
travel can be propelled by much more modest expenditures of force. The early satellites
were the first spacecraft to operate on just small battery packs or to free-orbit with
no propulsive assistance. This was possible because spacecraft abruptly cut loose
from gravity are in a vacuum. A small amount of propulsion accomplishes a lot in
deep space, and small forces sustained over time in a vacuum can propel ships to
tremendous speeds. Many vivid ideas for cheap and clean transit of ships that would
reach beyond orbit into deep space were cultivated during the late 1950s and early
1960s to varying degrees of success.

In several proposed engine types, nuclear power was used on a very small
scale to support an engine that uses another material as its propellant. The suite of
experimental electric propulsion systems being developed in the late 1950s included
magnetohydrodynamics, thermionics, and plasma.

"Electric" propulsion does not mean electricity is the single source of energy in
a propulsion system, but refers to a set of systems that each use some method of
engaging electricity to act on propellants to produce thrust.[30] Propellants are generally
elements and gases, such as cesium, mercury, hydrogen, ammonia, nitrogen, or the
noble gases. By 1964 more than a dozen companies in addition to NASA were engaged
in experiments on a wide range of electric propulsion systems employing different
propellants.[31] None of these systems has corollaries in our familiar world of ground or
air propulsion, making them seem to many even more exotic than nuclear fuels.

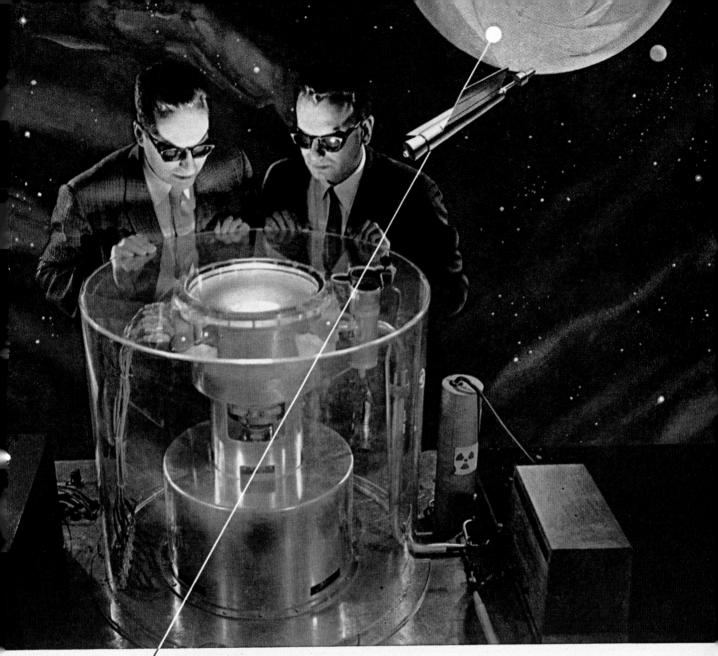

PINCH PLASMA ENGINE
NEW POWER FOR SPACE VEHICLES

"The experimental model of a new concept . . . a magnetic pinch plasma engine for interplanetary space travel is in operation at our laboratories," says Alfred Kunen (R) Project Engineer, Plasma Propulsion Project, shown with Milton Minneman of Republic's Scientific Research Staff, during actual operation of the engine. ➤➤➤ Republic's plasma engine unique in that it utilizes intermingled positively and negatively charged particles in a single jet thrust, can operate on fuels more readily available than required for an ion engine, and attains greater thrust. By compressing these particles in an invisible cylindrical magnetic girdle and shooting plasma out the rear at tremendous velocities, sufficient thrust is generated to push a vehicle through the near-vacuum of outer space. ➤➤➤ Republic is working on advanced plasma engine studies for the U. S. Navy Office of Naval Research and the U. S. Air Force Office of Scientific Research. ➤➤➤ Today's pinch plasma engine is but one of many bold concepts under development at Republic to create for the space world of tomorrow. It is part of Republic's multi-million dollar exploration into the realm of advanced aircraft, missiles and space travel.

REPUBLIC AVIATION
FARMINGDALE, LONG ISLAND, N. Y.

Designers and Builders of the Incomparable **THUNDER-CRAFT**

Republic's new $14,000,000. Research and Development Center, is scheduled for operation early in 1960.

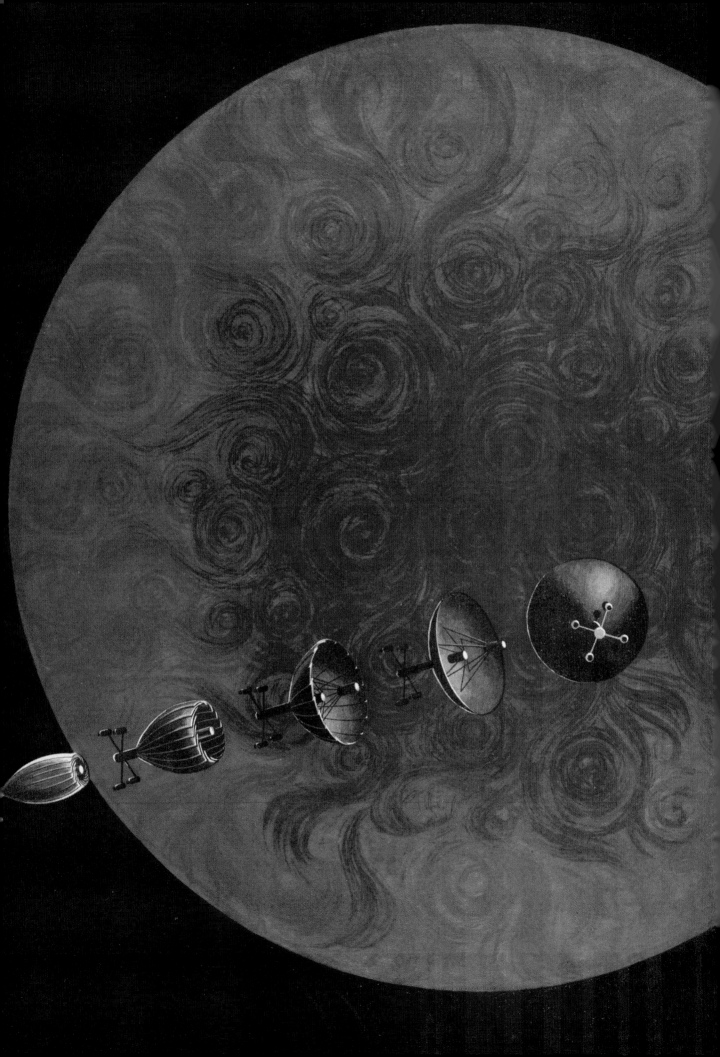

Solar energy conversion: Through recent advances in materials and electronics, we are on the threshold of a new era of energy utilization. By concentrating solar radiation into the cavity of a thermionic converter, electrical power is generated directly from sunlight without moving parts or circulating fluids. This freedom from earthbound energy sources promises far-reaching applications in space exploration. Artist's concept shows the unfolding of a solar collector mirror with its central power package which would be attached to various types of space vehicles. Lockheed's design of a thermionic converter operating model is shown at left. The water wheel depicts one of man's earliest known forms of energy conversion.

THERMIONICS

EXPANDING THE FRONTIERS OF SPACE TECHNOLOGY

The development of new techniques in energy conversion is typical of the broad diversification of work at Lockheed Missiles and Space Division. The Division possesses complete capability in more than 40 areas of science and technology — from concept to operation. Its programs provide a fascinating challenge to creative engineers and scientists.

Exploration into unknown areas such as Thermionics, provides endless stimulation to imaginative scientists and creative engineers. Research at Lockheed's Missiles and Space Division covers the entire spectrum — from pure basic research to development work, in support of current projects. Thermionics is but one phase of Lockheed's complete systems capability in missiles and satellites. To maintain this position of leadership calls for an extensive research and development program — ranging from electrical propulsion research to advanced computer research, design and development. Typical current projects are: Man in space; oceanography; fuel cells; space station; space navigation; solid state electronics.

Engineers and Scientists: If you are experienced in work related to any of the above areas, you are invited to write: Research and Development Staff, Dept. H-29A, 962 W. El Camino Real, Sunnyvale, California. U.S. citizenship or existing Department of Defense industrial security clearance required.

Lockheed / MISSILES AND SPACE DIVISION

Systems Manager for the Navy POLARIS FBM; the Air Force AGENA Satellite in the DISCOVERER, MIDAS and SAMOS Programs; Air Force X-7; and Army KINGFISHER

SUNNYVALE, PALO ALTO, VAN NUYS, SANTA CRUZ, SANTA MARIA, CALIFORNIA
CAPE CANAVERAL, FLORIDA • ALAMOGORDO, NEW MEXICO • HAWAII

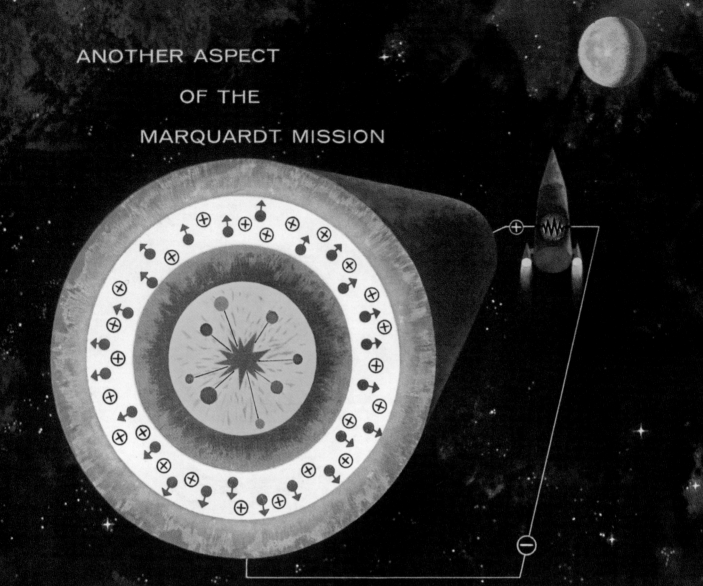

ANOTHER ASPECT OF THE MARQUARDT MISSION

PLASMA THERMIONICS FOR SPACE POWER

The most ideal electric power sources yet devised for the operation of space vehicles are the nuclear and solar heated plasma thermionic systems which are in work in ASTRO, Marquardt's division for research into the space age.

Planned to replace the heavier, and more complex turbo-electric systems, ASTRO's designs employ the plasma diode thermionic converter to transform nuclear or solar energy into electric power without the use of moving parts.

The conversion is extremely simple. Nuclear or solar energy heats a refractory metal plate (a cathode) to a temperature far beyond the melting point of steel. This causes electrons to be boiled off and collected by a cooler plate—thereby creating electrical energy. Cesium plasma is contained between the two plates which form the cell. The positive cesium ions help the electrons along during their movement from the

heated to the cooled elements of the cell, thus, increasing t͟ amount of current that can be made to flow.

ASTRO's plasma thermionic power studies typify but o͟ aspect of The Marquardt Mission.

Creative engineers and scientists are needed.

ASTRO DIVISION

THE *Marquardt* CORPORATIO͟

CORPORATE OFFICES: VAN NUYS, CALIFORNI͟

◆ ASTRO ◆ COOPER DEVELOPMENT DIVISION ◆ OGDEN DIVISION ◆ POMONA DIVISION ◆ POWER SYSTEMS GROU͟

Electric propulsion systems can be divided into three general groups: *electrostatic*, which use fields of static electricity to accelerate an ionized propellant; *electrothermal*, which heat a propellant electrically; and *electromagnetic*, in which magnetic fields interact with electrical currents to accelerate charged particles inside a plasma field.[32] Each system is designed to produce a low level of thrust sustained over a long period of time with an economy of propellant—ideal for interplanetary travel. In Lockheed's thermionics ad (pages 132–33) a solar-collecting satellite is set against the swirling sun to demonstrate the potential of electrothermal systems ("thermionics").

The pinch plasma engine (page 131) was an initiative of Republic Aviation, sponsored in part by the navy and the air force. In pinch plasma propulsion, a neutral mix of ion and electrons is suspended in a gas (ionized gases are referred to as plasmas). Plasma propulsion "utilizes the magnetic acceleration of a plasma to eject particles from a space vehicle."[33] The result is a propulsion with low thrust and high specific impulse. The "pinch" chamber confines the gas as well as the electrical current that is released into the gas by an electrical charge. The charge ionizes and heats the gas, creating a shock wave and pressure buildup inside the "pinch" chamber, which ejects the gas at 1.8 pounds of thrust.[34] An engine with low thrust and high specific impulse could push vehicles for long distances fairly efficiently in the vacuum of space. It will gain such momentum over time that time itself becomes a component of the propulsion system. Engineer Milton Minneman, pictured at left in Republic Aviation's ad (page 131), calculated that a plasma engine could reach Mars from Earth orbit in just over eight months.

Electric propulsion technology generated considerable excitement in the aerospace field at the time. The Republic team undertook a number of studies in the potential usefulness of pinch plasma propulsion in Mars excursions with differing trajectories and carrying different payloads. And Marquardt's plasma thermionics ad was featured on the cover of *Space World*,[35] where it was described more fancifully, as depicting an engine that can "theoretically drive a vehicle at a speed closely approaching the speed of light."[36]

In the "Air-Space Research" center image of Marquardt's celebratory ad (pages 136–37), an ion-powered spacecraft glides between Earth and Moon. Two very small side-positioned propulsion jets and a central propulsive cylinder similar to the craft

New Concepts for the Space Age
Mark 15 Years of Progress by MARQUARDT

When founded in 1944, Marquardt was an organization devoted exclusively to research and development of the ramjet propulsion principle. Today, in its fifteenth year, the Corporation employs more than 5,000 in the crea- tion and exploration of new concepts for the space age. Marquardt is now diversified, operating in five basic areas—all primarily related to the search for earlier and ever more effective solutions to space-age problems.

AIR-SPACE RESEARCH

NEW CONCEPTS IN AIR-SPACE RESEARCH spring from ASTRO—Marquardt's Air-Space Travel Research Or- ganization—where studies of an ionic rocket capable of powering future space vehicles are in progress. Other imaginative ASTRO studies span a broad spectrum in- cluding high-energy fuels, exotic materials, nuclear power- plants, advanced optics, cryogenics, space medicine, communications and guidance.

NEW CONCEPTS IN POWER SYSTEMS are in the making at Marquardt's Power Systems Group. Within the Group, Propulsion Division is engaged in continuing studies of a Hyperjet (rocket-ramjet) configuration capable of lift- ing future satellites from launch pad to upper atmosphere. Controls and Accessories Division is currently developing attitude controls for reconnaissance satellites, while Test Division is capable of ground-testing space-age hardware.

NEW CONCEPTS IN MANUFACTURING are typified by the first-of-its-kind Hufford Spin-Forge at Marquardt's Ogden Division. This 250-ton machine will contribute advances in space-age metal working state-of-the-art, while augmenting the Division's production of supersonic ramjet engines for the Boeing Bomarc IM-99.

NEW CONCEPTS IN SPACE-AGE TRAINING are an important product of Marquardt's Pomona Division—creators of a unique system which realistically simulates a 4,000 mile mission on an 8-foot map. The system will ground-train air and spacemen without risk and at great savings in cost.

NEW CONCEPTS IN RESEARCH ROCKETRY and instrumenta- tion come from Cooper Development Corporation, a Marquardt subsidiary. Cooper has contributed to pro- grams including Explorer and Sunflare projects, and Falling Sphere—is now at work on Project Mercury.

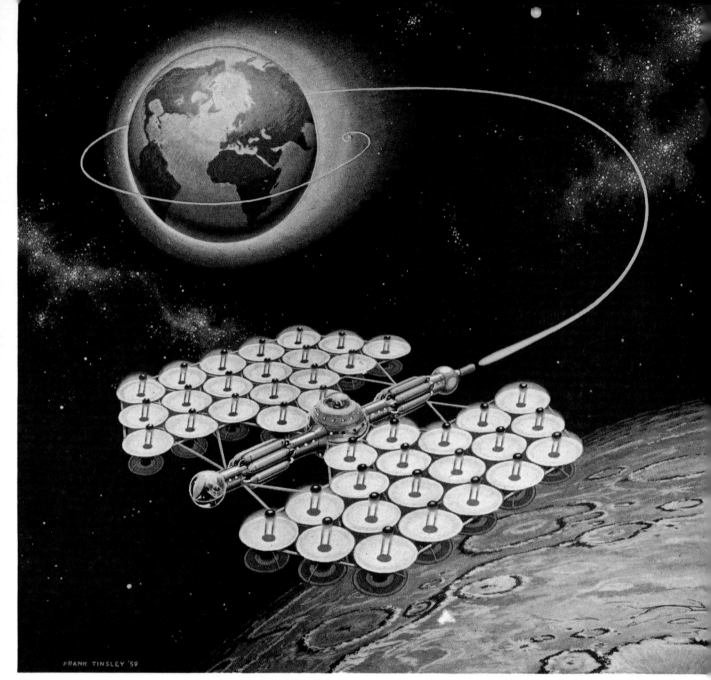

STEPS IN THE RACE TO OUTER SPACE

Cosmic Butterfly

Spreading its wings to absorb the eternal flow of solar energy is the Cosmic Butterfly, a space vehicle of a type first conceived by Dr. Ernst Stuhlinger of Redstone Arsenal.

Each of the fifty-foot parabolic mirrors in the wings concentrates the Sun's rays on a boiler at its focal point. Steam is developed, which drives a 200-kw turbo-generator in the base. Cooled by frigid outer space in heat diffusers, the steam reverts to water and is pumped back to the boiler to be used over and over again.

The current thus generated drives the main propulsion unit, an ion rocket in which powerful electric fields accelerate charged particles, shooting them from the rear of the rocket exactly as the elec-

tron gun in your TV set bombards the screen. Sunlight, then, is the power source, whereas cesium is the propellant.

While the recoil thrust is relatively small, the weightless vehicle is operating in a vacuum and the push is enough to enable the Butterfly to reach interplanetary speeds. Unlike conventional rockets, the Butterfly is under power the entire trip. Half way to its destination it turns around, and the ion thrust is used to slow the craft down to arrival speeds.

Since its thrust is entirely inadequate to cope with the gravity of major planets, the Cosmic Butterfly never lands. It is

assembled in space and shuttles between artificial satellites.

The Cosmic Butterfly could carry ten passengers and 50 tons of cargo from an Earth satellite to a comparable one orbiting around Mars in about one year of continuous travel.

———

Inertial navigation systems will play an increasing role in the exploration of outer space. **ARMA**, now providing such systems for the Air Force ATLAS ICBM, will be in the vanguard of the race to outer space. **ARMA** . . . Garden City, N. Y. A Division of American Bosch Arma Corp.

AMERICAN BOSCH ARMA CORPORATION

pictured on page 134 are very clean looking compared to chemical propulsion.
Marquardt's Air-Space Travel Research Organization (ASTRO) was working to develop an
ionic rocket capable of powering future space vehicles.

Ion technology was extremely complex to develop, and ground tests of engines
outside the laboratory were disappointing. The gases used as fuels tended to
corrode the moving parts of test engines when they were removed from laboratory
environments.[37] Then, in 1964, NASA's budget peaked and then declined through the
1960s.[38] NASA's budget had doubled every year between 1958 and 1964, and this
budget freeze came as a shock to all areas of development. NASA and its contractors
responded by narrowing their focus to ensure that the Apollo Program made launch in
1969. Shrinkage in long-term research and development was widespread throughout
the industry. Research-intensive avant-garde propulsion systems were among the
projects that experienced scattered shutdowns. The air force withdrew support from
Republic Aviation for development of the pinch plasma engine[39] while a narrowing group
of other electric propulsion systems attracted sustained attention.

American Bosch ARMA's ad for a solar ion engine shows a design developed in
the mid-1950s by Ernst Stuhlinger at the U.S. Army's Huntsville, Alabama, Redstone
Research Arsenal. It was based on ideas originally developed in Germany and later
in the United States by Stuhlinger and other members of von Braun's Peenemünde
research team. In this model cesium or rubidium vapor is charged between incandescent
solar-powered plates, ionizing the atoms. The ion stream is accelerated to extremely high
velocity and discharged as electrical jet exhaust, propelling the spacecraft.[40] This craft
was to carry ten passengers plus fifty tons of cargo and would take about one year to
reach Mars from Earth orbit.[41] Tinsley's writing about this ship's possibilities carry a hint
of disdain for those who would reject it. He wrote, "The idea of direct Earth-to-Mars travel
is rejected by many of our outstanding space engineers. These veterans cling to more
conservative, carefully thought-out concepts, developed over the past decade or two."

Despite diminished activity in the mid-1960s, ion propulsion systems continued
to be tested and refined through the 1990s, and forty years of work ultimately paid
off. In 1998 NASA and JPL launched the DS-1 spacecraft, a xenon-fueled ion engine

spacecraft propelled by a static ion thruster. Its design was not unlike a single "cell"
of Stuhlinger's Cosmic Butterfly. The DS-1 completed a three-year mission around the
solar system testing dozens of experimental spacecraft technologies and gathering
data about the solar system and comets. Such ion engines have since become routine.
The European Space Agency and the Japan Aerospace Exploration Agency have also
flown ion-powered spacecraft, and domestically hundreds of commercial ion-power
technology satellites are in orbit.[42]

Farther out in space, literally and conceptually, is the photon engine pictured in a
General Dynamics recruitment ad (page 141) as a four-sphere skewer rather like olives
for a martini. The fantastic imagery of this ad, an "artist's conception of fusion-photon
intergalactic space vehicle," was meant to entice engineers while the work promised
seems less than liberating.

Solar Propulsion

To sail through space, silently, on a whisper of solar wind…to reverse the fall of Icarus
so that the sun's power propels humankind *outward* into the solar system, even the
galaxy: that is the goal of solar sail technology. This delicate and elusive engineering
feat holds the imagination of researchers and fantasists alike in thrall.

A small Dutch caravel-style sail ship floats weightlessly above the galaxy and its
distant star formations in Lockheed's vision for solar sailing (pages 142–43). A similar
caravel ship adorns the logo of the Planetary Society, the space advocacy organization
that sponsors the most promising contemporary initiative to sail solar-powered
spacecraft. The society's logo was inspired by the logo for *Cosmos*, a television series
broadcast in 1980 promoting space that was developed by the physicist and futurist
Carl Sagan, a cofounder of the Planetary Society. A famous statement from Sagan
serves as the society's slogan: "We have lingered long enough on the shores of the
cosmic ocean. We are ready at last to set sail for the stars."[43]

Solar sailing is based on the premise that radiation pressure from sunlight,
known as "solar wind," when falling on a sail creates a minute but ever-compounding
propulsive force. The velocity that results from the accrual of this small force becomes

INDUSTRIAL ENGINEERS

Artist's conception of fusion-photon intergalactic space vehicle

If you are an experienced industrial engineer capable of contributing imaginative solutions to advanced manufacturing problems, you will certainly want to consider carefully one of the immediate positions available at Convair/San Diego.

If you have a degree in industrial engineering and several years of aircraft or missile experience, that is most desirable. However, a degree in a related engineering field and a background in another assembly or fabrication industry will be acceptable.

The men selected will be responsible for methods, plant and product layout, facilities utilization and processes, manpower control, and cost reduction. They must be capable of directing small groups of technical specialists assigned to specific problems in the manufacture of conventional and space vehicles.

A prompt interview will be arranged with qualified respondents. Please direct your resume to Mr. M. C. Curtis, Industrial Relations Administrator-Engineering, Convair/San Diego, 3900 Pacific Highway, San Diego, California. All inquiries will be acknowledged.

CONVAIR / SAN DIEGO

CONVAIR DIVISION OF

GENERAL DYNAMICS

SOLAR SAILING

EXPANDING THE FRONTIERS OF SPACE

SOLAR SAILING: Space travel with the aid of solar radiation pressure—an area of advanced research at Lockheed. Vehicle would employ a sail that would be raised and lowered in flight. The artist has depicted Magellan's ship "Trinidad" to symbolize man's great voyages of discovery.

Lockheed Missile Systems Division is engaged in all fields of missile and space technology—from concept to operation. Advanced research and development programs include—man in space; space communications; electronics; ionic propulsion; nuclear and solar propulsion; magnetohydrodynamics; computer development; oceanography; flight sciences; materials and processes; human engineering; electromagnetic wave propagation and radiation; and operations research and analysis.

The successful completion of programs such as these not only encompasses the sum of man's knowledge in many fields, but requires a bold and imaginative approach in areas where only theory now exists.

The Missile Systems Division programs reach far into the future. It is a rewarding future which men of outstanding talent and inquiring mind are invited to share. Write: Research and Development Staff, Dept. A-29, 962 W. El Camino Real, Sunnyvale, California, or 7701 Woodley Avenue, Van Nuys, California. For the convenience of those living in the East or Midwest, offices are maintained at Suite 745, 405 Lexington Avenue, New York 17, and at Suite 300, 840 N. Michigan Avenue, Chicago 11.

"The organization that contributed most in the past year to the advancement of the art of missiles and astronautics."
NATIONAL MISSILE INDUSTRY CONFERENCE AWARD

Lockheed / MISSILE SYSTEMS DIVISION

SUNNYVALE, PALO ALTO, VAN NUYS, SANTA CRUZ, SANTA MARIA, CALIFORNIA
CAPE CANAVERAL, FLORIDA · ALAMOGORDO, NEW MEXICO

so tremendous that mind-boggling speeds are attained. "A trip to Mars or Venus
can perhaps be made in less time by solar sail than by chemical rocket,"[44] wrote a
Westinghouse Research Laboratories engineer in 1959, just when the pool of "new"
technologies for space travel was brimming. In 2007 Planetary Society chairman Louis
Friedman reaffirmed this estimate, projecting solar sail speeds of up to one-tenth the
speed of light.[45] To achieve such speeds, solar sails would need to be a kilometer in
diameter. The Planetary Society's first serious attempt at solar sailing, the *Cosmos 1*,
was a more modest several yards across. In the ad on page 145, Frank Tinsley depicted
a flotilla of three massive manned "solar wind ships," and the text notes sails must be
several miles in diameter for long trips.

Solar sailing has the longest legacy of all unfulfilled promises for space propulsion
technology. Mathematicians and engineers first began cultivating the idea of solar
sail travel in the seventeenth century. Sails were investigated and discussed in the
technical literature of the hot period of new aerospace research in the 1950s,[46] and
a 1961 *Saturday Review*[47] article by NASA's director of the Office of Space Sciences
Homer Newell is promising if noncommittal. Hard research and testing, however, were
not forthcoming: the technology was too experimental and disconnected from fundable
objectives to be supported by mainstream research.

Sail ships have thrived better in fiction so far than in the skies, in stories such as
Arthur C. Clarke's "Wind from the Sun." In spite of their promise, solar sails remain
frustratingly unrealized. The Planetary Society's long-planned *Cosmos 1* spacecraft
suffered launch vehicle failure in 2005 and was lost, interrupting the most promising
solar sail project to date. In August 2008 NASA too experienced launch failure of its
small solar sail project, NanoSail-D. NASA's project was to test solar pressure as a
means of orbital maneuvering, while *Cosmos 1's* more ambitious plan was to test sailing
as a primary propulsive force: to set loose the first free-flying solar sail in space.

Solar sailing remains "the only practical technology capable of interstellar flight"[48]
according to Louis Friedman of the Planetary Society, and as such is likely to be
proven in the foreseeable future. The loss of the two most important test flights to
such a twentieth-century problem as dud chemical rockets will surely become an

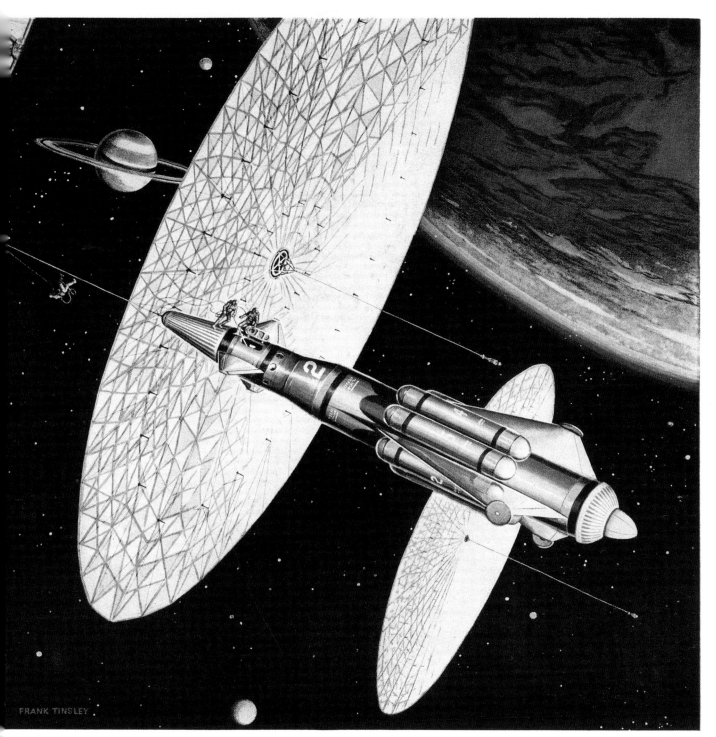

FRANK TINSLEY

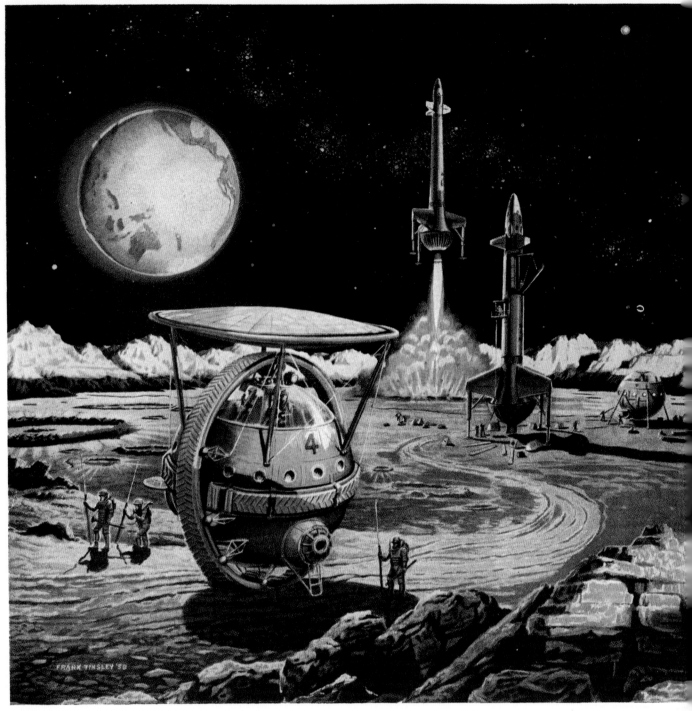

STEPS IN THE RACE TO OUTER SPACE

Lunar Unicycle

This 30-foot high Unicycle is designed for preliminary exploration of the Moon, once a base camp has been established. It's entirely constructed of inflated, rubberized fabric, with the exception of strengthening members, hatches and a few other items of equipment. Gyros stabilize and steer the vehicle; electric motors furnish the driving power.

Electricity for the motors and instrumentation comes from solar batteries mounted in the "parasol". The cleated, rotating wheel upon which the Unicycle travels is made of inflated tubes. A spare wheel, carried around the body, acts as a bumper in traversing narrow defiles. Built in two sections, these wheels are assembled by belt-lacing type fasteners.

The upper level, the navigating and communications deck, is ringed with recording and surveying instruments. Living quarters make up a middle deck and below is the hold with supplies, spacesuits, oxygen equipment and spare apparatus.

In the background, two of the expedition's ferry ships are seen; one landing, one unloading in the bright Earthlight.

Propped by a kickstand while its passengers embark on pedestrian explorations, this imaginary rover is a rubber inflatable with a belt around its middle that serves as a spare tire as well as a bumper. The solar array ''parasol'' suspended above the unicycle rover is fitted with solar batteries to collect and store energy for all the rover's systems. Artist: Frank Tinsley, *Aviation Week*, February 16, 1959

anachronism. The Japan Aerospace Exploration Agency's 2004 test deployment of a suborbital solar sail was the first successful deployment of a solar sail. And the Planetary Society is deep into planning—and fund-raising—for *Cosmos 2*, though a launch date has not yet been set.

Rovers

On the lunar surface, as in space, astronauts encounter lower-gravity environments than on Earth; likewise, lunar rover propulsion is governed by different physical rules than earthbound motor and rail transit. Electric, isotopic, and solar power, all widely adaptable for deep space, are also, in theory, adaptable to lunar and to Martian rovers.

In the landscape of American Bosch ARMA's ad featuring a lunar unicycle (page 146) are two ships identical to the nuclear rocket in the ad on page 123. Here the fantasy goes a step further. The first nuclear rocket has transported lunar explorers, some of whom remain near the launch site with mission supplies. The established lunar base lies either out of view or in the future. As a second rocket arrives, using tall staffs, the exploring astronauts hike away from the lunar rover that has transported them a few miles from the rocket landing site. Their transit vehicle: a low-gravity rover, a solar-powered lunar unicycle. Yes, a solar-powered lunar unicycle. The design of this craft may look absurd to the contemporary eye, yet who can say? Dozens of rover design ideas have been developed and tested in the forty years since the first lunar landing, and eight have conducted missions on the Moon and Mars.[49]

Of the eight that have been realized, the Soviet Lunokhod Rover[50] is the most like the lunar unicycle. An eight-wheeled vehicle with a rotund, if not spherical, profile, the Lunokhod was powered by batteries attached to the inside of a round solar panel roof. The Habot (Habitat Robot), a NASA-sponsored prototype for a solar-powered lunar rover, also bears functional similarity to the unicycle,[51] although with four wheels. And inflatable structures too have been used in other rover prototypes.[52] The only thing unique about the idea of the lunar unicycle is its single wheel design, and the ne'er-to-be nuclear rocket to transport it.

4. The Landscape of Space

Making a Place for Space

The terrific propulsive power of the chemical rockets developed after World War II opened the gateway for human entry into space. Space professionals and enthusiasts saw hope in nuclear rockets that human interplanetary travel would follow the anticipated lunar landing. The promise of solar sails and ion-powered batteries inspired confidence in future human spacefaring well beyond Earth's orbit. In the meantime, orbital space became dotted with robotic craft as new satellites were joined by even newer models. The tangible success and rapid development of the satellite sky after 1957 suggested that a push with life-bearing spacecraft beyond orbit was a natural and attainable next step.

Now touched by human society, through satellites, space became a *real* place. For Americans orbital and interplanetary space became a further frontier. Described in historiography as a "new ocean,"[1] space was as much a new *land*, as in *landscape*, as an ocean. Our cultural approaches toward exploring new lands are rooted in an earthbound sense of place. The images in this chapter explore the remapping of this sense onto the new territory of space.

It was widely expected within the industry that the Apollo Program's target of lunar exploration would be but a stepping-stone to interplanetary travel. Unexamined anthropocentrism dictated that human beings would be at the center of every step of discovery. Correspondingly a distinctly terrestrial sense of space as a new place for human activity emerged during the early satellite era, replete with analogies to preexisting beliefs about landscape and how it is occupied.

Wherever people map, explore, and settle a new landscape, cultural beliefs and assumptions affect their activites. When that landscape became space, projections of human incursion anticipated but then ultimately overreached the unfolding future of human spaceflight. In advertising their wares in *Aviation Week* and *Missiles and Rockets*

OVERLEAF PRECEDING: Detail, page 182.

OPPOSITE: Detail, page 176.

magazines, aerospace industries created an iconography of what this new landscape of
space would look like. The image of space as a place that is familiar dominated, with an
array of conventional ideas about how landscapes are domesticated.

Comparisons between space and earthbound landscapes are abundant in the
historical literature. Former NASA chief historian Steven J. Dick[2] has written about the
analogy between space exploration and the legacy of European ocean exploration (such
as the era of the Spanish and Portuguese caravel ships alluded to on pages 142–43).
Stephen J. Pyne, a historian of the American West and of space, situates space exploration
within a sequence of ages of exploration,[3] while Bruce Mazlish, editor of the book *The
Railroad and the Space Program*,[4] published in 1965, plumbed the depths of historical
analogy with a comparison between the new world of aerospace as an infrastructural
system and the railroads of the nineteenth century. One writer included in that volume,
Leo Marx, discusses the aerospace industry as populating an ideal landscape with a
wave of mechanization just as the railroads had.[5] Marx saw the unfettered starry sky
as analogous to the pastoral ideal of landscape that was compromised by the advent of
railroad-based industrialization. Railroad and aerospace development alike irreversibly
altered the landscape in building a new layer of technological society.

The new landscape of space came to be depicted with propositions for how it should
be built out. In imagery and language the aerospace industry contemplated the next
steps into space enabled by the steep acceleration of technological innovation. A ground-
based sensibility for space with a predictable program of domestication, road building,
regulation, and colonization followed almost automatically. Space was presented as
both familiar and strange, domestic and alien. This attempt to reconcile outer space as
an extension of our known world began where all journeys begin: at home.

Bringing Space Down to Earth

Whereas some aerospace images transformed the astronauts' shipboard environments
into quasi-domestic spaces (as seen in chapter 2), in others domestic space and outer
space are reversed. As popular culture expanded to embrace the new frontier, space-
themed toys, clothing, record albums, and lunch boxes brought space into the American

SOME DOWN-TO-EARTH THOUGHTS ABOUT THE SPACE AGE

Like all those who participate in the progress of aviation, we are awed by the prospect of the conquest of space. But before we rush headlong into the cosmic dust, let's hang up our space helmets for a moment for some sober reflection on what it will take to get there.

In the race toward tomorrow, look to the reliable as well as the swift. Our recent missile successes and "failures" clearly indicate that space conquest will depend not only on technological *breakthroughs*, but equally on the virtual elimination of mechanical *breakdowns*. Good hardware is even more important in the space age.

For over 16 years, Hydro-Aire has built a reputation on building better hardware for airborne vehicles. Today these products function reliably on virtually every type of aircraft. The same ingenuity and dependability that made these products possible is now the key to solving the problems of more hostile environments, more stringent operating conditions.

The men whose space vehicles will be equipped with these products, can don *their* space helmets with confidence.

HYDRO-AIRE
BURBANK, CALIFORNIA
Division of CRANE CO.
Anti-Skid Braking Systems · Fuel System Controls · Pneumatic Controls · Hydraulic Controls
Actuation Systems · Electronic Devices

Producing Controls for Every Basic Airborne System

OUT TO LAUNCH

From concept to countdown...

Pesco creative engineering
meets the challenges
of space!

Imaginative concepts are translated into reality at Pesco . . . where engineering ingenuity combines with production proficiency to create specialized components for the aerospace industry. And Pesco extends its total engineering capabilities through a close working relationship with the Borg-Warner Research Center! Advanced design principles to meet tomorrow's needs are embodied in many Pesco products now specified for an impressive list of operational air vehicles. Current projects include electronic and hydraulic power packages, environmental cooling systems, cryogenic pumps . . . plus research programs in electrical control actuation, thermo-electric infra-red sensor cooling and thermo-electric power generation. Write today for information about Pesco's integrated design-and-build capabilities.

THE 7 HATS OF BORG-WARNER (top) national defense; oil, steel and chemicals; (middle) agriculture; industrial machinery; aviation; (bottom) automotive industry; home equipment.

PESCO PRODUCTS DIVISION
BORG-WARNER CORPORATION
24700 North Miles Road • Bedford, Ohio

EXPORT SALES: Borg-Warner International Corp.
36 South Wabash Avenue • Chicago 3, Illinois

LEFT: The clean metallic gleam of the coatrack here extends into space the ordinary offices where busy engineers specialized in the contracted and subcontracted (and subsubcontracted, etc.) work of designing parts for spacecraft. *Aviation Week*, February 27, 1961

OPPOSITE: This ad, from *Fortune*, like those from the aerospace industry trade journals, brings space out of unknowability and extends its atmosphere of familiarity to the feminine sphere. Whereas the world of the aerospace industry was overwhelmingly masculine, here the image is of a manicured woman mastering an organizational machine. *Fortune*, October 1957

domestic sphere. Likewise, the previously genre-bound literature of science fiction crept into mass culture as episodes of *The Twilight Zone* (1959–1964) and *The Outer Limits* (1963–1965) told stories of people landing on other planets and meeting space aliens, anticipating the eventual adoption of *Star Trek* (1966–1969) into the full-blown media mainstream.

Mid-twentieth-century art too played a role in bringing space into domestic life. In advertisements from Bell Aircraft and *Missiles and Rockets*, the popular form of the mobile, cultivated as a sculptural medium most prominently by Alexander Calder, drew some connections between space and a broader cultural discourse of modernism. As David Crowley and Jane Pavitt commented in *Cold War Modern: Design 1945–1970*, design and technology were close mutual contextualizers during this era.[6]

Even the National Cash Register Company co-opted space imagery in promoting its new electronic machines (opposite)—an expression of how far and wide the motif of space exploration percolated. Here the juxtaposition of a manicured woman with space and new technology positions the future as a gendered, tamed environment. Space again is domesticated as the backdrop to the office of the future, an environment that, like church, is a second home to many and certainly more domesticated than the cold gantries and engineering boards of industry. The image of a working woman juxtaposed with space is rare even among a survey of general-interest advertising of the era. Ads and editorials in *Fortune* and *Life* or most any other American magazine of this period often adapted images of aerospace to the specific work of other industries.[7]

In a self-promotion for *Missiles and Rockets* from 1958 (page 157) the motif of the mobile is used to place missiles and rockets alongside jets and finned automobiles as equal members of essential twentieth-century technological elements. Balanced side by side, they are domesticated by the box of Jets breakfast cereal suspended too in the mobile. This was one of the first advertisements to juxtapose these kinds of visual elements to suggest the familiarity of space.

the miracle of electronics brings...

tomorrow's posting machine today!

National POST-TRONIC*

the first electronic posting machine released for sale!

electronically verifies proper account selection

electronically selects correct posting line

electronically picks up and verifies old balance

electronically determines "good" or "overdraft" balance pickup

electronically picks up and verifies accumulated check count

electronically detects accounts with stop payments and "holds"

electronically picks up, adds and verifies trial balance

electronically picks up, adds and verifies balance transfers

— and what the POST-TRONIC does *electronically,* the operator cannot do wrong!

Up to Now most of the operations in bank posting were subject to the human element, with countless possibilities of error and with time-consuming human effort.

But now — with the National POST-TRONIC, the new bank posting machine — most of the posting functions are performed *electronically.* And what the POST-TRONIC does *electronically* the operator cannot do wrong — because she doesn't do it at all!

Through the miracle of *electronics,* far more of the work is done without any thought or act or effort by the operator than can be done by any previous method. And, therefore, *far faster.*

It posts ledger and statement and journal *simultaneously,* all three in original print (no carbon). It simplifies operator training, and makes the operator's job far easier. And it has many other advantages which, combined with *electronics,* bring the lowest posting cost ever known. It will soon pay for itself with the time-and-effort it saves and the errors it eliminates.

THE NATIONAL CASH REGISTER COMPANY, *DAYTON 9, OHIO*

* *Trade Mark* *989 OFFICES IN 94 COUNTRIES*

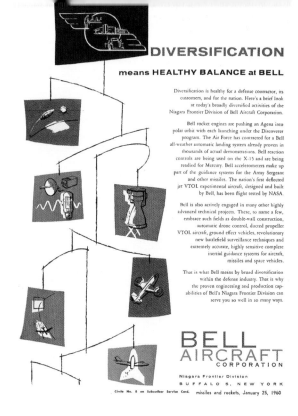

LEFT AND OPPOSITE: Symbols of industry on the mobile's panels
in Bell Aircraft's ad (left) nest references to the industrial sector
within the domestic, creative symbology of the mobile itself. In the
Missiles and Rockets ad (opposite) aerospace industry is linked
with flashbulbs, cars, and even breakfast cereal. *Aviation Week*,
January 25, 1960; *Missiles and Rockets*, October 20, 1958

Convair and Marquardt's unusual promotions on pages 158 and 159 seem to export
"home" into space rather than bringing space to earth. They also pose a complex
expansion of the idea of *domestic* to the broad sense of our shared country, as is
understood by "domestic food production" or "domestic industries." In both images
a chunk of land floats in space. Convair's ad makes a spacecraft out of an industrial
landscape while also suggesting the precariousness of a new industry. The floating slab
of Earth in Marquardt's ad, published three years later, is a liquid fuel plant populated
with balloon tanks for storing the liquid hydrogen and oxygen fuel that will ignite rockets
to travel into space. The ad's promotion of Marquardt's testing facility uses the chain of
balloon tanks to materially link the land to space. In both images a piece of land forms
a visual synecdoche of Earth.

American cultural approaches to new landscapes at the time formed a prescriptive
working ideology of exploration, setting up patterns of behavior even where those
patterns ill applied. Once space was marked as "our" territory, debates about road
building on public lands, public or private (civil-scientific or commercial) uses of
space, and colonization ensued.

The Highway System and the Space Program

The international legal community was already taking steps prior to the launch of
Sputnik to determine how traffic in space would be regulated. Could "roadways" be
designated in space that would prevent one country's satellite from flying over the
airspace of a warring nation? Or should flyovers be permitted? How would space be
regulated? These issues were crucial in the cold war especially given that each of the
two competing superpowers planned to spy on the other once the cooperative niceties
of the International Geophysical Year could be dispensed with. Scholars looked to
Antarctica and the high seas for their chief legal models, the two areas on Earth where

The Mobile Missile Market

MISSILES AND ROCKETS

Like a mobile . . . the missile market is made up of separate parts and different elements. Many industries and thousands of companies compose the mobile missile market. Aircraft companies build missile frames and prime systems. Automobile companies manufacture missile systems . . . a cereal company builds missile subsystems.

And like a mobile . . . there is constant movement and change in the missile market. New developments happen fast. That's why missile men in management, engineering, production and procurement need an undiluted missile book to be posted constantly and accurately. Throughout the complex market missile men look to MISSILES AND ROCKETS as the number one missile book.

AMERICAN AVIATION PUBLICATIONS, INC.
WORLD'S LARGEST AVIATION PUBLISHERS
1001 Vermont Avenue, N.W. • Washington 5, D.C.

CONVAIR-*Astronautics*... springboard into space

CONVAIR-*Astronautics* — producer of the Atlas ICBM — has in its new facility a center for the conquest of space and for the continuance of our freedom. Our future is guarded by the superior talent and experience teamed to create — at **CONVAIR**-*Astronautics* — America's advanced *springboard into space!*

CONVAIR A DIVISION OF GENERAL DYNAMICS CORPORATION

ANOTHER ASPECT OF THE MARQUARDT MISSION

BRINGING SPACE DOWN TO EARTH

Marquardt's successful accomplishments in the aero/space field are supported by unique testing and laboratory facilities, created especially to sustain and extend advanced research and development activities. Reproducing extreme space environments on earth permits testing to be performed economically under rigidly controlled conditions. When applied in conjunction with Marquardt's aero/space research and development programs, these facilities provide a complete capability for producing advanced systems of proven performance and extreme reliability.

Small scale airbreathing engines and rockets can be tested to Mach 11 and 160,000 feet altitude for intervals of 180 seconds using many propellants including liquid hydrogen and liquid air. Aerodynamic models, combustion chambers, and refractory metals and compositions can be tested in the plasma-driven hyperthermal test cells at intervals as long as 30 seconds at 16,000 feet per second and altitudes to 300,000 feet, or above 99.98 percent of the earth's atmosphere. Airbreathing engines up to 6 feet in diameter can be tested continuously to Mach 6 at 145,000 feet. The skillful exploitation, arrangement, and operation of facilities and laboratories for such testing enhance and speed successful completion of Marquardt's projects.

Devoted to finding the most economical solutions to aero/space problems, test facilities typify yet another aspect of the Marquardt Mission.

Creative engineers and scientists are needed.

THE *Marquardt* CORPORATION

CORPORATE OFFICES—VAN NUYS, CALIFORNIA

◆ ASTRO ◆ OGDEN DIVISION ◆ POMONA DIVISION ◆ POWER SYSTEMS GROUP ◆

OPPOSITE: Convair's ad brings to mind the question: Is this slab of Earth with a tidy missile factory a spacecraft? Artist: Kuderna, *Aviation Week*, June 2, 1958

ABOVE: With a chain of propulsion fuel tanks, a section of Earth is linked to space as a physical destination. Artist: Ken Smith, *Missiles and Rockets*, May 1, 1961

Douglas is construction foreman on the longest road in the universe

Revolutionary new "pathway" concept lets the operator "drive down the street" to anywhere — promises major civilian benefits

Six years ago, recognizing that development of advanced vehicles was outpacing man's ability to control them, the Military assigned Douglas the job of doing something basic about simplifying instruments.

This project evolved into ANIP (Army-Navy Instrumentation Program) with Douglas coordinating the efforts of a highly-specialized industry team.

Result has been a remarkable control panel design — a *visual* highway down which the operator drives his aircraft, spaceliner, submarine, tank or ship with perfect confidence, even when visibility is zero. Also provided is a topographical map which gives him *visual* current information on his position and the reach of his fuel supply.

Civilian application of this new concept could well extend to ships, airliners and even trucks and cars which will *drive themselves* down this "electronic road."

ANIP is another demonstration of how Douglas imaginative thinking and practical know-how lead the way in today's technology.

DOUGLAS

MISSILE AND SPACE SYSTEMS •
MILITARY AIRCRAFT • DC-8 JETLINERS •
TRANSPORT AIRCRAFT • AIRCOMB® •
GROUND SUPPORT EQUIPMENT

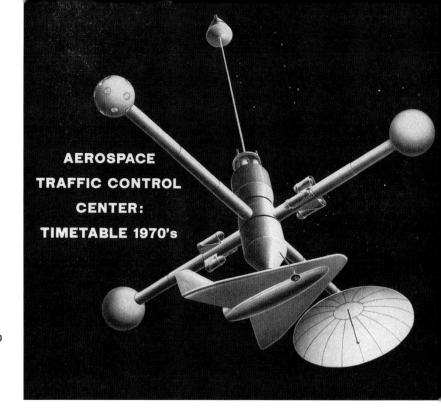

AEROSPACE TRAFFIC CONTROL CENTER: TIMETABLE 1970's

OPPOSITE: Douglas Aircraft compared its work with navigation control for spacecraft to driving down the street. *Aviation Week*, August 22, 1960

RIGHT: Lockheed foresaw manned orbital traffic control stations by the 1970s. *Missiles and Rockets*, March 26, 1962

rights of sovereignty do not apply. Neither, however, possessed the dimensionality and transparency of space. It was unclear how far *up* national sovereignty could extend. The IGY contributed to rapid resolution of the flyover question, as it set a timetable for synchronized satellite development programs. It was decided that the United States, in light of its own aspirations, would register no official objection to Sputnik's flyover, tacitly affirming a doctrine of permissible "innocent passage" with regard to satellites— an idea borrowed from the law of the high seas.[8]

As legal and diplomatic communities debated sovereignty and transit rights through space, the wheels of industry turned. On land, road building may commence even when land rights are not yet determined. Likewise, the rapidly developing network of launch platforms and stores of chemical rockets were being built even though the domestic and international legal communities were still theorizing the boundaries of space. The next step, as framed in aerospace industry ads, after the surveying and mapping activity of the early satellites, was the construction of new roads. The equation is not far-fetched. *The Railroad and the Space Program* compared more than a century of history to the nascent space program, a massive stretch of history, and yet now with a half century of hindsight on the space age a similar analogy can be drawn between the interstate highway system and the space program.

The road in the ad from Douglas on page 160 could be seen as a nod to parallels between nineteenth-century railroad building and twentieth-century road building. Yet its text points to the massive public works project under construction at the time. Financed in 1956 by the Interstate Highway Act,[9] interstate highway building was under way nationwide during the late 1950s and 1960s. The vast scope of the program placed it at the center of popular cultural references of the day.

The widely lauded interstate highway program was subject to a battle that was not unlike the culture war over the validity of human spaceflight: "American commitment

SPACE SYSTEMS

A cloverleaf highway intersection with Earth at its center connects our world with not just the Moon but Mars and Saturn. *Aviation Week*, February 6, 1961

to automobility [was expressed by] the conviction of most that motor vehicles and fast-moving expressways were good in their own right."[10]

Just as the highway system was promoted as a link between distant countryside and farms with urban consumers, a route from farm to market, the Moon and planets were widely seen as potential sources of valuable minerals, and the space program was to provide the route for off-Earth mining. The interstates succeeded in transforming agricultural distribution, but mining outposts in space remain science fiction, their expense and technical difficulty being prohibitive. The busiest infrastructural use of space is orbital rather than interplanetary, for telecommunications.

Highways are emblematic of the difference between domestication and wildness in the American landscape. In much the same way that roadlessness denotes wilderness on public lands, it is the extension of "roads" into cislunar and interplanetary space that delineates and de-wilds a landscape previously wilder than any encountered on Earth.

Legal and diplomatic concerns about sovereignty and flyover rights also brought up questions about how the traffic of spacecraft would be regulated. In 1957 a Martin Company official agitated in *Missiles and Rockets* for a U.N. space police agency to regulate orbital space like a traffic cop.[11] In hindsight, it was a sensible anticipation of the congestion to come, but few at the time comprehended the urgency of coordination of space traffic and the suggestion was largely ignored.

However, as the legal community urged nonpartisan regulation of space, the U.N. did begin the process of exerting some regulatory influence, forming the ad hoc Committee on the Peaceful Uses of Outer Space in December 1958.[12] The committee's purpose was, among other things, to avoid extending national rivalries into space and to facilitate international cooperation within space. The committee's advisers on the law of outer space[13] prepared an analysis in 1960 of the contemporary thinking on questions of space law for NASA and the American Bar Foundation. It declared, "[T]he majority

B. F. Goodrich optimistically depicted free space as real estate for sale. *Missiles and Rockets*, December 14, 1961

of the writers discussing the problem of a law for space have urged that space be regarded as *res communis* or *re extra commercium*, like the high seas...[this] amounts to affirming a community policy of encouraging all non-exclusive, or sharable, uses of space."[14] In other words, it was territory common to all humankind, not bound by land-based discourses of property and property rights.

The principles outlined in 1958 were expanded and succeeded in 1967 by the U.N.'s Outer Space Treaty,[15] which concluded that "the exploration and use of outer space...shall be the province of all mankind." The treaty established a precept that space is indivisible and not subject to claims of sovereignty. Its primary objective was to prohibit weapons of mass destruction in orbit and military installations on the Moon. It did not, however, address regulation of traffic flow among civil spacecraft, which has continued to increase.

The problem of traffic jams caused by disabled vehicles (see page 19) was a more realistic expectation on the new highway of space than was the orderly vision of the cloverleaf highway interchange (page 162). Space junk turned out to be a far greater regulatory problem than traffic coordination of active spacecraft. In 1972 the U.N. created a new treaty, the Convention on International Liability for Damage Caused by Space Objects, commonly known as the Liability Convention.[16] The treaty inspired at least a passive attention to the fate of spacecraft whether actively in use or derelict by stating that nations were fiscally liable for any damage caused by stray craft. The treaty motivates, in theory, the development of technology for space junk remediation. Yet it falls short of advocating for a clutter-free space environment for its own sake apart from the virtue of minimizing damaging collisions.

Public Space, Private Space

While the parameters of national sovereignty in space were being negotiated, the question of whether private property would be allowed remained open. On Earth

NEXT STOP: MARE IMBRIUM

One of the primary needs in the next generation of our space program is for a reliable "space bus"—a vehicle versatile enough to carry a variety of exploratory packages to the moon and possibly to the near planets. Once it is injected into a lunar or planetary trajectory, this bus will have to guide itself to its destination, accomplish a soft landing, release and activate its payload.

The problems involved in the design and fabrication of such a vehicle, as well as the various payloads it might be expected to deliver, are being intensively explored at Norair. These investigations cover guidance, communications and position sensing systems, thermal and environmental conditioning, structural and material development

and a host of other in-house capabilities. Expanded working groups in all essential areas are coordinating their efforts in the search for practical, integrated solutions to these problems.

This determination to research problems as thoroughly as possible, the ability to concentrate such a wide range of technologies toward their solution, and the added ability to translate the results into working hardware are prime assets of Norair in the space age.

NORAIR
A DIVISION OF
NORTHROP

LEFT: The concept of the space bus is portrayed as a public city bus, complete with uniformed driver, fare box, and rearview mirror. *Aviation Week*, May 8, 1961

OPPOSITE: Using a statement from General Thomas S. Power, who assisted General Curtis LeMay and directed the first large-scale fire bomb raid on Tokyo in 1945, Convair advertised its astronautics work as being not in the service of earthly warfare but apparently as exploration for exploration's sake. *Aviation Week*, January 13, 1958

competing interests traditionally seek to stake a claim in new lands that have been opened up. Would space also be a place where territory might be staked out?

The U.N. ruled out ownership of space by national interests, yet commercial interests were another question. As the law has evolved, commercial activity in space has never been prohibited, nor has ownership of property in space as long as ownership of space itself is not being asserted. Commercial activity in space has therefore been relatively unaffected by the provisions of the U.N. treaties.[17] In one ad to promote its product—testing equipment for microwave broadcast technology (page 163)—B. F. Goodrich referred to the "sale" of electromagnetic (EM) spectrum rights, a kind of "property" in space that can be privately owned, regulated by the United Nations' International Telecommunications Union.[18]

Public use of space, on the other hand, is the focus of a promotion of Northrop's contractual involvement with the U.S. Air Force in developing the Dyna-Soar, a "space bus" for transit between Earth and space stations (above). The idea of a space bus was redeveloped from scratch in the civilian Space Shuttle program.

Early concern about human contamination of space was voiced in Jet Propulsion Laboratory's promotion of its sterilization program (page 166). The idea of preventing biocontamination in space had originated in 1956 in an International Astronautical Federation forum[19] and was picked up by scientists worldwide before the first satellite had even been launched. Science fiction had induced widespread belief in the likelihood of life on Mars and Venus, but there were worries that the controlled environment needed for scientific research could be compromised even on the Moon by the presence of biological organisms exported from Earth. Some consideration of the possibility that there might exist biological, *ecological* systems on other planets that needed protection from Earth-borne biological contamination was present even in results-oriented research.

We don't want to put life on other planets

Just one living cell. The discovery of just one living cell in space would be one of man's greatest accomplishments. It would affirm the possibility that man-like civilizations could exist on other worlds.

But what if the life we found in space had been put there by our own spacecraft? What a tragic irony that would be!

To prevent this awesome mistake, Cal Tech's Jet Propulsion Laboratory is designing its spacecraft for the National Aeronautics and Space Administration to be 100% sterile before leaving our atmosphere.

The JPL Sterilization Program began even before the first Ranger shot. Different sterilization techniques are being tested in the JPL Lunar Program: heat soaking internal components at 125° Centigrade for 24 hours; coating all exposed surfaces of the spacecraft with ethylene oxide gas; using liquid sterilants during the spacecraft assembly.

By the time Mariner A makes the first "fly-by" to Venus, these tech-

niques will be perfected. Then, spacecraft will be free of any living organism that might upset our hopes of finding other life on other planets.

Spacecraft sterilization is only a small part of the work on JPL Planetary Program and the job of space exploration as a whole. It's a job that requires the most creative, inventive minds this country has to offer. Minds that will only take know for an answer.

Write to us. Learn first-hand about the fascinating work our scientists and engineers do as America's leaders in space exploration. Learn how you can be part of this work...how your particular talent will be taxed to the limit in this, the greatest experiment of mankind.

JET PROPULSION LABORATORY
4808 Oak Grove Drive, Pasadena, California
Operated by California Institute of Technology for the National Aeronautics and Space Administration

All qualified applicants will receive consideration for employment without regard to race, creed **or national** *origin. / U. S. citizenship or current security clearance required.*

The problem of pollution in recent years in space coupled with concerns about the Earth's environment have inspired a conceptualization of an ecology of space.[20] It took hundreds of years for an environmental ethic to develop in the American West among those for whom the West was new territory. Had the West been explored first, as space was, by research scientists rather than by military, commercial, and colonial interests, it's possible that an environmental sensibility might have arisen sooner. But for the near future of the space environment, the question of regulation remains wide open. Beyond the provisions of the U.N.'s Liability Convention, few regulations have been made to address contamination of space by either junk hardware or biota.

Space Tourism

The researchers in Douglas Aircraft's life sciences division's ad (page 169) are not yet, in 1959, referred to as *astronauts* but as *travelers*, a word that blurs the distinction between astronauts and everymen and suggests the lay public may someday go into space. With artwork by George Akimoto, a Japanese-American staff artist at Douglas Aircraft from 1955 through 1983,[21] Douglas promoted its abilities in space life sciences even as it projected a future in which astronauts would be accompanied, or even replaced, by members of the not yet spacefaring public.

The opportunities to be enjoyed by Douglas's future space traveler were expanded considerably in another ad from Douglas—the company best positioned at the time to turn fiction into reality (page 168). A classically colonial perspective on spacefaring in the ad copy betrays a deep pitfall of the unexamined transference of territorial models of exploration onto the new "land" of outer space. In the late 1950s African societies were beginning to break free of European colonialism. This great global change, occurring simultaneously with the interstate highway project in the United States, went unrecognized by ad writers seeking to apply models of earthly exploration to space. The African safari was a comfortable cultural reference point even amid the political changes of the day.

Douglas's Moon vacation ad also makes reference in its passing mention of its work on a study of "the moon as a military base" to the U.S. Army's 1959 classified Project Horizon, a plan for a lunar military base. In the cold war context, U.S. national security

How much would you spend to vacation on the Moon?

Out of today's space research come unexpected by-products —perhaps even space travel for the average citizen . . .

When only explorers dared cross darkest Africa, few foresaw it as a future vacationland. Outer Space now stands in a similar position.

What will Lunar vacations cost? When rocket development is written off and we have nuclear power, a traveler may go for about the present price of a tiger hunt or African safari!

At Douglas Aircraft, builder of the big DC-8 jets, practical steps to bring this about began 14 years ago when Douglas engineers designed and engineered a feasible space platform. Today, with more than 20,000 rockets under its belt—including the *Nike* series and *Thor*, reliable Space Age workhorse—Douglas is deep in a series of space age studies: the moon as a military base . . . compact space huts . . . how will man react to the space environment . . . what useable natural resources to expect . . . and, always, more efficient rockets for military, scientific, and peaceful needs.

The Douglas concept of a *complete* support system has resulted in space research ranging from nuclear rockets to nutrition for space travelers

DOUGLAS

MISSILE AND SPACE SYSTEMS •
MILITARY AIRCRAFT • DC-8 JETLINERS •
TRANSPORT AIRCRAFT • AIRCOMB® •
GROUND SUPPORT EQUIPMENT

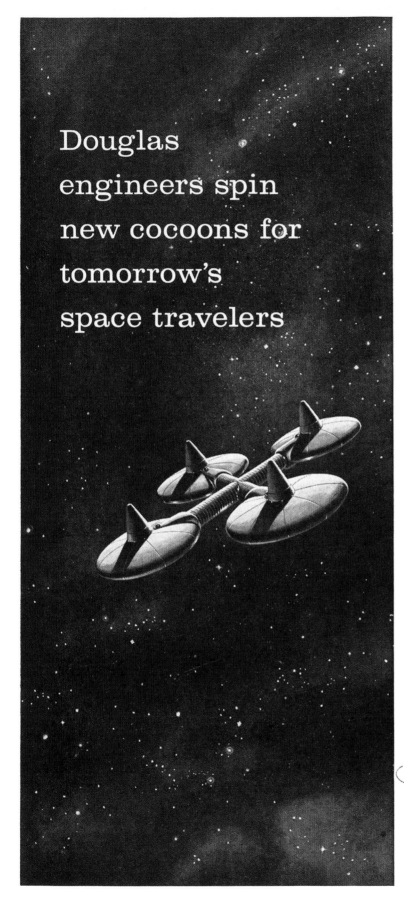

Douglas engineers spin new cocoons for tomorrow's space travelers

Space researchers in human factors engineering utilize latest discoveries of medical science

Each time a space traveler leaves home (earth) he has to be completely wrapped in a special environment. He needs it to survive under alien conditions such as extreme heat and cold, high vacuum, cosmic radiation and tremendous G forces.

At Douglas, life scientist research over the past ten years has explored more than *forty* basic factors relating to human survival in space. Douglas engineers are now completing — at military request — a careful survey of conditions that will be encountered en route to and on other planets. They are also evolving plans for practical space ships, space stations and moon stations in which men can live and work with security thousands of miles from their home planet.

Out of these research activities and those made by companion workers in this field has come new knowledge of great medical importance ... even to those of us who are earthbound.

DOUGLAS

MISSILE AND SPACE SYSTEMS •
MILITARY AIRCRAFT • DC-8 JETLINERS •
TRANSPORT AIRCRAFT • AIRCOMB •
GROUND SUPPORT EQUIPMENT

OPPOSITE: A future Moon tourist peers out the window of this lozenge of a spacecraft as it hovers over a rocket-bedecked lunar landscape, the future equivalent of deepest Africa as vacation destination. *Missiles and Rockets*, August 1, 1960

ABOVE: A unique design for future interplanetary travelers is illustrated by Douglas's staff artist George Akimoto. A model of the space station depicted in this ad eventually ended up on the set of *Star Trek* and later became the K-7 space station in the famous "The Trouble with Tribbles" episode (1967). *Missiles and Rockets*, December 28, 1959

What is the moon made of?

No. Guess again.

Potassium, uranium, thorium? Closer, but still guesswork. And guesses they'll be until man puts scientific instruments on the Moon to gather surface and sub-surface data and transmit these data to Earth.

The right answers will come with unmanned lunar spacecraft projects directed by Caltech's Jet Propulsion Laboratory for the National Aeronautics and Space Administration.

The planned Lunar Exploration Program begins with JPL's Ranger Project that will soon hard-land 50-pound instrument packages on the Moon to measure Moon quakes and temperature and radio their findings back to Earth.

Following the Ranger, the Surveyor will *soft*-land several hundred pounds of sensitive instruments on the Moon. Its objectives are to measure the physical properties of the Moon and

analyze the composition of surface and sub-surface samp[le] Knowledge from these projects is essential to eventual man[ned] landings on the Moon.

Under JPL direction, unmanned spacecraft for these proje[cts] and probes to the planets are being designed. Many discipli[nes] are involved. Physics, electronic engineering, metallurgy ... a long list.

It's a big job. To do it right, JPL must have the best te[ch]nical people in the country. People who want to know ... w[ho] want to be part of the greatest experiment of mankind. If you['re] that kind of people, JPL is your kind of place. Write us to[day].

JET PROPULSION LABORATORY
4808 Oak Grove Drive, Pasadena, California
Operated by California Institute of Technology for the National Aeronautics and Space Administration

All qualified applicants will receive consideration for employment without regard to race, creed or national origin / U.S. citizenship or current security clearance requi[red]

JPL's lunar probe project advertised with this whimsical
photograph was to bring back data needed to be able to support
future human lunar landings and ultimately to establish a lunar
base. *Missiles and Rockets*, October 23, 1961

concern was that the USSR might be first on the Moon and establish sovereignty. It
was assumed there would be a military presence on the Moon in the counterpower's
assertion of lunar goals. Project Horizon, however, never progressed beyond the
planning stages as the space race shifted from military to civil science.[22]

The imagined future of space tourism is, however, beginning to come true. The
trips taken to the International Space Station by the handful of first space travelers
bear little resemblance to the galactic safari envisioned in 1960, but they are just the
beginning. The vast venture capital and technological acumen behind contemporary
private space travel companies all but guarantee their success. Travelers today may
ride Russia's *Soyuz* spacecraft to the International Space Station—at a cost of $20
million—through an arrangement with U.S.-based Space Adventures. Virgin Galactic
expects to offer commercial travel to the edge of orbital space within a few years, and
Bigelow Aerospace plans to sell stays in an orbital habitation module.[23]

Just as the technology for space travel had to be developed, the culture of
spacefaring had to evolve in the decades since 1960. The space tourists of yesterday's
science fiction are today's "spaceflight participants," a term coined by Ansari X Prize
sponsor and space traveler Anousheh Ansari to connote a more serious engagement
with spaceflight than is suggested by the term *space tourist*. More than a mere tourist,
the spaceflight participant must commit to extremely rigorous preflight training. The
price tag of private space travel remains prohibitive today. But should it in the future
be lowered to within the grasp of the space-yearning general public, the phrase *space
tourist* may very well come right back.

Space Colonies?

In the 1950s it was widely assumed in civil and military planning for space that space
stations were necessary for lunar and interplanetary exploration. Space stations had
been a feature of literature since Edward Everett Hale's story "The Brick Moon" and
were a centerpiece of *Collier's* magazine's series on space exploration of 1952–1954.
Wernher von Braun promoted the wheel as the best design principle for space stations,
a version of which is depicted in Don Hinckley's artwork in Thompson's advertisement

**Objective: duplicate the cycle of life so man
can sustain himself in space indefinitely**

To leave the earth at all, man must take his environment with him. But no spaceship could hold all the air, food and water he'll need for any extended trip. His meager supplies will have to be constantly purified and renewed. There can be no waste. Every drop of moisture, every smidgeon of food must be reprocessed and reused.

This means that some substitute will have to be found for the fundamental cycle of life on earth. Northrop's Bioastronautics Laboratory is even now developing new strains of algae as a basic food source. They are investi-

gating biological means of reclaiming waste and purifying air. Studying the effects of hard radiation on living matter unscreened by earth's atmosphere. Learning more about how life is affected by the absence of gravity. Coming to grips with all the interrelated problems of life support.

When men finally move out to occupy space, Northrop's foresight in research will have helped to make their long-term survival possible.

NORTHROP

LEFT: A human hand holds a clod of dirt from which a dandelion shoots up to denote the idea of the cycle of life sustained in space—"indefinitely." *Missiles and Rockets*, November 20, 1961

OPPOSITE: In a multipane panorama of possibility Willi K. Baum's graphic art illustrates the areas of scientific work to be accomplished on a lunar space station. *Missiles and Rockets*, June 13, 1960

for its component parts (page 174). The wheel design became closely associated with von Braun although it had originated in the 1920s with Hermann Noordung.[24] In von Braun's plan, the rotation of a wheel would generate "synthetic gravity" through centrifugal force, and stations could host long-term space living for a great number of people,[25] essentially a space colony.

The space station proposed in the *Collier's* articles would function as a stepping-stone, as one link in a chain making the human journey into space natural and attainable. The sequential Earth to space station to Moon to Mars plan that has come to be known as the "von Braun paradigm" was broadly adopted by the space science community of the 1950s. It was developed at length in 1954 by Arthur C. Clarke in *Going Into Space*, and it is the centerpiece of the influential government document *The Next Ten Years in Space*,[26] quoted in the "time-table" in Republic Aviation's R&D promotion (page 175). The motif of the wheel-shaped space station was so successfully propagated throughout the aerospace industry that representations of space stations deviated from it only occasionally until designs progressed in the 1970s beyond preplanning.[27]

A persistent desire to create a long-term off-Earth home for humans had appeared in science fiction and in technological theory for many decades. Those who first realistically had space travel within reach pushed hard to develop plans to realize this dream,[28] and plans for space stations and lunar colonies were widely discussed among engineers and promoted within industry.

In *Going Into Space* Clarke stated, "When we have had a chance to do some lunar prospecting, we should be able to locate supplies of any material we need. It would then be possible to grow crops on the Moon in pressurized glasshouses, feeding the growing plants on chemicals produced from the Moon itself."[29] The vision of wholly relocating the domestic activity of food production into space offered an extremely affecting goal for space science researchers to pursue.

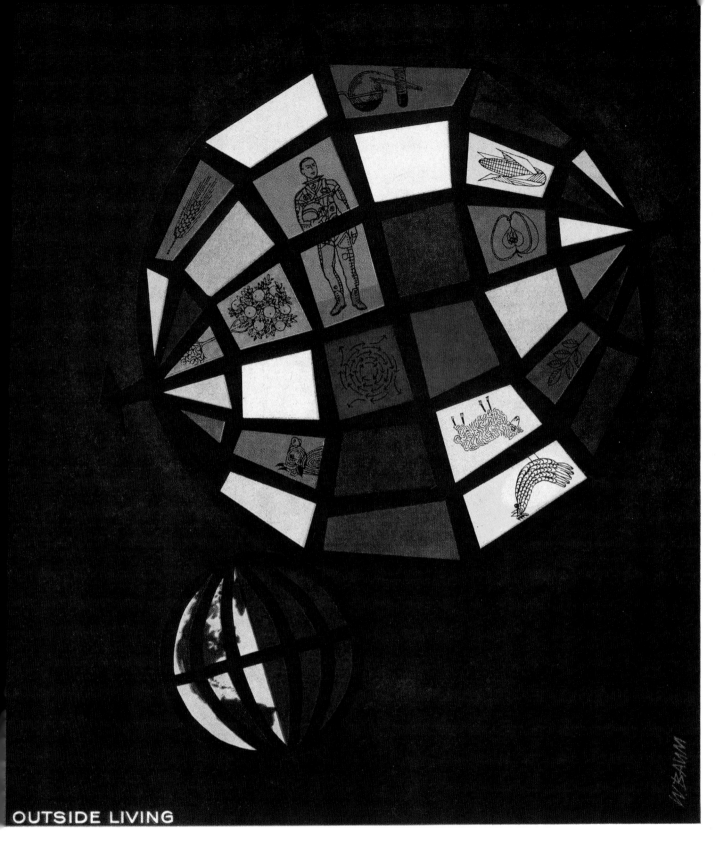

OUTSIDE LIVING

The Lunar Space Station project at Martin is one of astonishing magnitude, for it coordinates practically all areas of scientific thought into one common objective: *sustaining life in outer space.* If you have the scientific or engineering talent required to aid in the fulfillment of this objective, we urge you to write immediately to N. M. Pagan, Dir. of Tech. & Scientific Staffing, The Martin Company, (Dept. 9A), P. O. Box 179, Denver 1, Colo.

MARTIN

DENVER

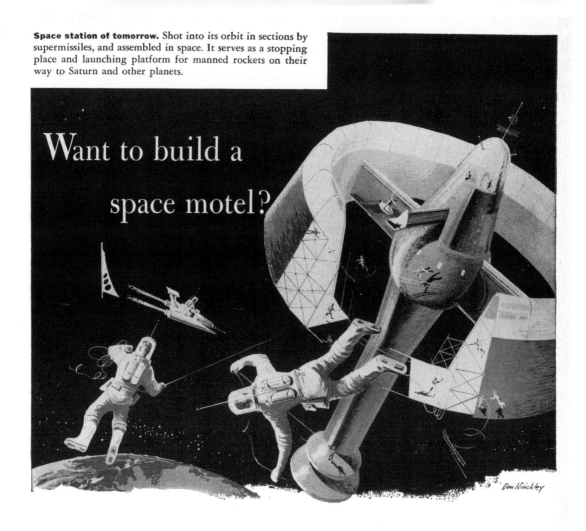

Space station of tomorrow. Shot into its orbit in sections by supermissiles, and assembled in space. It serves as a stopping place and launching platform for manned rockets on their way to Saturn and other planets.

Want to build a space motel?

Thompson Products *can help you handle the job*

IT'S BOUND TO HAPPEN in the not-too-distant future: an American space motel for rockets will be orbiting about the earth!

While the U. S. Government may send it aloft, private enterprise will help build it. And right now, Thompson Products is ready to design and produce important components and assemblies for such a space station of tomorrow.

Fantastically difficult? Perhaps, but so were many aviation challenges when first tackled by Thompson en-gineers and production men. Their success is seen in the fact that today Thompson supplies major precision-made products not only for piston-powered planes, but for most American jets and many of our new guided missiles.

Through the years Thompson Products has contributed many improvements in the automotive, aircraft, electronic and general industrial fields. "Hard-to-make" parts and complex assemblies involving high-temperature metallurgy, the tightest of metal-forming and machining tolerances, and severe stress and corrosion problems are among the tough jobs Thompson people like to take on.

If you're considering the development of an advanced product, let Thompson help get it into production.

You can count on

as a partner in solving the design and production problems of an advancing technology

General Offices, Cleveland 17, Ohio

From Thompson's 21 research centers and 25 manufacturing plants come, each year, important new advances in mechanics, electronics, hydraulics, pneumatics, aerodynamics, thermodynamics and nucleonics.

ABOVE: The idea of space tourism would naturally imply a need for lodging, but in Thompson's ad the "space motel" mentioned refers to a space station that would serve as a "motel" for rockets and as a long-term habitation module for astronauts. Artist: Don Hinckley, *Business Week*, July 12, 1958

OPPOSITE: A von Braunian wheel-shaped space station hovers in orbit around the Moon, a variation on the space station as stepping-stone in the form of an Earth-orbiting workshop for assembly of lunar and interplanetary spacecraft. *Aviation Week*, July 13, 1959

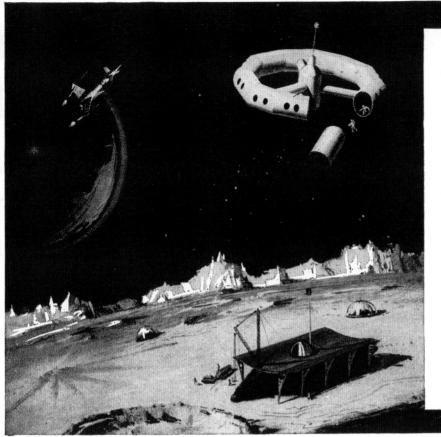

A "TIME-TABLE" FOR SPACE CONQUEST

BY **1963** — INSTRUMENTED PLANETARY SOFT LANDING

BY **1968** — SPACE STATION FOR STAGING TO MOON AND PLANETS

BY **1970-75** — MOON BASE

These predictions were made by Alexander Kartveli, Vice-President for Research & Development at Republic Aviation, and one of the most optimistic of the 56 leading space experts of the world who were consulted by the U.S. House of Representatives Committee on Astronautics & Space Exploration for its report: "The Next 10 Years in Space, 1959-1969."

JOIN REPUBLIC IN AN INTEGRATED ATTACK ON PROBLEM AREAS OF SPACE EXPLORATION

It's the fervent conviction of engineers and scientists at Republic Aviation that the courageous "Space Time-Table" above is entirely feasible — given a tradition-free, integrated approach to the problems. Such an approach is evident at Republic Aviation. Here, groups of specialists from many disciplines are working in close collaboration to solve problems across the entire spectrum of space technologies, which limit today's interplanetary and upper atmosphere flight capabilities.

Expanded by $35,000,000 last year, Republic's integrated Research and Development program has already produced signal advances in space guidance concepts; in new propulsion systems (plasma, nuclear); in radiation physics; in new materials and processing techniques; in unique hypersonic configurations; and in prototype development of hardware (as an example: hydraulic systems that operate reliably up to 1000°F).

Professional men — who can meet new challenges with enthusiasm and dedication — are urged to look into openings with our R&D groups, working in an atmosphere of exhilarating intellectual adventure.

Electronics
Inertial Guidance & Navigation
Digital Computer Development
Systems Engineering
Information Theory
Telemetry-SSB Technique
Doppler Radar • Countermeasures
Radome & Antenna Design
Microwave Circuitry & Components
Receiver & Transmitter Design
Airborne Navigational Systems
Jamming & Anti-Jamming
Miniaturization — Transistorization
Ranging Systems
Propagation Studies
Ground Support Equipment

Thermo, Aerodynamics
Theoretical Gasdynamics
Hyper-Velocity Studies
Astronautics Precision Trajectories
Airplane/Missile Performance
Air Load and Aeroelasticity
Stability and Controls
Flutter & Vibration
Vehicle Dynamics & System Designs.
High Altitude Atmosphere Physics
Re-entry Heat Transfer
Hydromagnetics
Ground Support Equipment

Plasma Propulsion
Plasma Physics
Gaseous Electronics
Hypersonics and Shock Phenomena
Hydromagnetics
Physical Chemistry
Combustion and Detonation
Instrumentation
High Power Pulse Electronics

Nuclear Propulsion and Radiation Phenomena
Nuclear Weapons Effects
Radiation Environment in Space
Nuclear Power & Propulsion Applications
Nuclear Radiation Laboratories

Send resume in complete confidence to: Mr. George R. Hickman, Engineering Employment Manager, Dept. 1G-3

REPUBLIC AVIATION

Farmingdale, Long Island, New York

WANTED: A PIECE OF THE MOON

A century ago, gold dust fired the imagination of the pioneers. Today it's "moon dust", and the pioneers are the United States Army Corps of Engineers. They wanted to simulate a piece of the moon here on earth — an engineering and research facility in which their engineers and scientists could work-to-learn — to solve the problems of constructing facilities on the moon. • We at The Lummus Company salute their imagination, vision and courage as they prepare to perform their hazardous tasks in support of America's Lunar Exploration Programs in the years ahead. We are proud to have been selected by the Corps of Engineers to study the engineering feasibility of the design for such a Lunar Environmental Research facility. • You may not need a piece of the moon in your business but whatever your problem The Lummus Company offers you a complete engineering and construction service backed by an organization with demonstrated skill in handling new and difficult tasks.

LUMMUS

THE LUMMUS COMPANY 385 Madison Avenue, New York 17, New York,

Houston, Washington, D. C., Montreal, London, Paris, The Hague, Madrid; Engineering Development Center: Newark, N. J.

ENGINEERS AND CONSTRUCTORS FOR INDUSTRY

A year later in the novel *Earthlight*, Clarke expanded on the theme with a fictional
tale of a lunar colony, and by 1966 Robert Heinlein's *The Moon Is a Harsh Mistress* had
made the motif of the lunar colony a staple of serious science fiction and a forum to
consider new ideas about human social organization. Kim Stanley Robinson continued
such work, now on Mars, in his Mars Trilogy some thirty years later.[30]

The exciting idea of off-Earth human habitation was presented in industrial
advertising as an inevitable outcome of the wave of technological innovation. The
images were designed to promote belief that lunar habitation modules and greenhouses
would naturally follow combined liquid fuel rockets. Colonization and settlement are
promoted by a clod of soil in the context of space in an ad from Northrop (page 172).
Survival is the subtext in this image meant to stand for the cycle of life, an image that,
though realistic, bears little resemblance to the actual hydroponic laboratory systems[31]
used in research at the time.

"[A lunar base]...would look very much like an Eskimo igloo," Clarke wrote in
1951.[32] And in the inhospitable "land" of the Moon, any residential facility for humans
would have to be mostly submerged in the "soil" to shield its inhabitants from ambient
solar radiation and extremes in temperature variation over a lunar day. An ad from
Lummus, an engineering company, depicts a model of a lunar habitation module
that plays on the question of pioneering property rights (page 176). Its reference
to the Wanted poster and the Gold Rush invokes the mythic West. In a literal sense,
lunar pioneers would need to extract from the Moon resources for life support and
technological development for any colony to sustain itself. Habitation modules like this
one were developed by a number of companies. Titans of industry in the 1960s expressed
interest in planning for lunar bases based on mining potential profiles to be brought
back by the Apollo lunar landing crews,[33] but unfortunately for space enthusiasts those
profiles did not turn out to be promising.

Although the physical resemblance to lunar bases is striking, the igloolike
subterranean domes in Westinghouse's promotion (pages 178–79) of its shockproof
equipment are missile bases. There was a broad overlap in design conventions for
earthbound and space-oriented military infrastructure at the time. The only lunar base

from Westinghouse...equipment

Westinghouse has been building shock-proof electrical, electronic and mechanical equipment since 1940 . . . In fact, Westinghouse makes more types of apparatus for high shock applications than any other manufacturer . . . turbines, gears, generators, switchgear, transformers, motors, control, elevators and electric stairways, lighting, air handling and conditioning equipment, microwave communication systems and many other devices and components.

Whether above ground or below, soft or hardened, defense installations require a great variety of equipment which must operate without fail as individual units *and* as elements of interrelated systems. As a supplier to the Government and to general, electrical and mechanical contractors, Westinghouse provides system-coordinated applications of standard or shock-proof apparatus which assure the most reliable and economical installations.

for hardened missile bases

Take advantage of this Westinghouse experience, product range and application coordination to insure system performance and shortest installation and acceptance times. Contact your Westinghouse sales engineer or write Westinghouse Electric Corporation, 3 Gateway Center, P. O. Box 868, Pittsburgh 30, Pa. Copies of this illustration suitable for framing are available when requested on your letterhead.

J-92023

Artist's conception of a possible hardened missile site, showing in blue some of the shock-proof equipment which Westinghouse can supply.

YOU CAN BE SURE...IF ITS

Westinghouse

WATCH "WESTINGHOUSE LUCILLE BALL-DESI ARNAZ SHOWS" CBS TV MONDAYS

in planning stages as of 1959 was the army's secret Project Horizon, but missile bases following this general design scheme abounded.[34]

Any plans for long-term off-Earth human habitation seemed to be shelved during the time when national attention and industry resources were focused on the Apollo program's goal of human lunar landing. The army set aside Project Horizon and no concrete work emerged from the civil space program to replace it. Von Braun's plans for densely populated space stations, first conceived within a military framework and later transferred to the civil space program, were likewise postponed indefinitely, fantastically out of scope with technological and fiscal realities of the day.

Twenty-five years later, however, after the Apollo program was canceled, professional scientists working primarily outside NASA reformulated ideas for military-oriented space stations into ideas for peaceful space colonies. The wave of resurgent interest in the 1970s was due to a migration of the idea out of industry and into the cultural sphere rather than any official activity. Scientists focused on the subject of space colonies tied their dreams to social interests of the 1970s and became significant cultural figures. The leading proponent of space colonies was Gerard K. O'Neill, a Princeton physicist who wrote the highly influential book *The High Frontier*, in which he portrayed space colonies as an attainable social utopia, places where technological evolution would be harmonized with human society's urgent needs to resolve overpopulation.

O'Neill's ideas were also popularized in 1977 through Stewart Brand's *Space Colonies*, which also promoted O'Neill's vision of space stations as enormous, verdant, permanent solutions to the overcrowding of Earth.[35] Similar ideas were espoused by civil scientists within the Soviet Union, although whereas the optimistic American O'Neill posited space colonies by 2050, the pragmatic Russians estimated a two-hundred-fifty-year development.[36]

The mid- and late 1970s saw the technological idea of space colonies resituated from the dystopia of military one-upmanship into the domain of utopian social thinking. A surge of enthusiasm for space emerged among California futurists and scientists across the spectrum. The astrophysicist and longtime NASA adviser Carl Sagan did more than anyone else to spread excitement about space in the 1970s; his PBS series

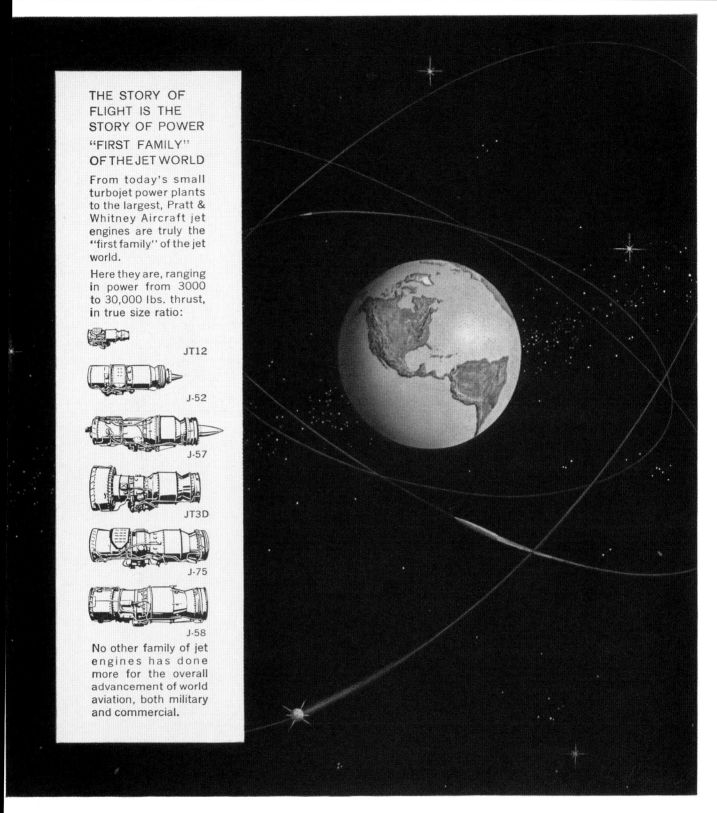

HITCO High Temperature Insulation Materials are helping U.S. to take a

GIANT STEP INTO SPACE

Rockets to the Moon will soon be routine — made possible by brilliant engineering achievements in all phases of Space Technology. One of the most vital of these is High Temperature Materials Research — HITCO's field of activity. *Astrolite*, a remarkable High Temperature Insulation Material by HITCO, resists up to 15,000° F. for short duration uses! Some of the possible applications for *Astrolite* are Missile Nose Cones, Rocket Engine Liners, Nozzles and Heat Shields. Take a Giant Step toward the solution of your High Temperature problem by calling in HITCO Engineers. No obligation, of course!

HITCO capabilities are described in this interesting new brochure. Please request on your business letterhead.

H. I. THOMPSON FIBER GLASS CO. • *1733 Cordova Street* • *Los Angeles 7, California* • *REpublic 3-9161*

WRITE OR CALL YOUR NEAREST HITCO REPRESENTATIVE: EASTERN: Tom Kimberly, 38 Crescent Circle, Cheshire, Conn., BR. 2-6544; Fred W. Muhlenfeld, 6659 Loch Hill Rd., Baltimore 12, Md., VA. 5-3135 • MIDWEST: Burnie Weddle, 3219 W. 29th St., Indianapolis 22, Ind., WA. 5-8685 • SOUTHWEST: Marshall Morris, 2850A W. Berry, Rm. 7, Fort Worth, Tex., WA. 4-8679 NORTHWEST: J. L. Larsen, 5757 Oaklawn Pl., Seattle, Wash., PA. 5-9311 • CANADIAN PLANT: THE H. I. THOMPSON CO. OF CANADA LTD., 60 Johnston St., Guelph, Ont., TA. 2-6630

Circle Number 138 on Reader-Service Card

Earth is positioned here as the home base from which a relationship with our nearest member in the solar system is an essential—and soon to be routine—next step. Artist: George Akimoto, *Aviation Week*, March 9, 1959

Cosmos produced in 1978 and 1979, during the low period in the civil space program after Apollo's cancellation, was seen by millions in the early 1980s. O'Neill's and Sagan's efforts were entirely outside the military infrastructure that had originated ideas of space stations in the public mind. Popularization in the 1970s of O'Neill's vision for space colonies represents the creative peak of an impulse to re-create home—a near replica of Earth itself—in outer space. *The High Frontier* did not yield immediate tangible results but it had an effect on growing minds. Both Peter Diamandis, cofounder of the X Prize, and Robert T. Bigelow, founder of Bigelow Aerospace, cite *The High Frontier* as a book that inspired them to devote their adult lives to redesigning access to space.[37]

Returning Home

As they intersect around the Earth, the fancifully wide ovoid orbital trajectories of the Explorer and Vanguard satellites crisscross in a Pratt & Whitney ad (page 181). The shape created is suggestive of the Rutherford atomic model, the familiar graphic symbol associated with atomic activity. The ad promotes Pratt & Whitney's involvement in projects related to a range of propulsion technologies, including nuclear, solid, and liquid rocket fuels. Its simple depiction of Earth is rather like a common school geography class globe uncomplicated by atmosphere or weather. The continents stand out in sharp relief against flat blue oceans.

George Akimoto's illustration in H. I. Thompson's promotion of its Astrolite insulation (page 182) shows a similar view of Earth, but as a close partner to its natural satellite, the Moon. A rocket launched from Cape Canaveral circles the Earth and continues its journey around the Moon as well as making a threadlike binding around them. The images in both of these ads are exemplary of how it was imagined Earth would look from space, a vision common in aerospace literature prior to photographic evidence of what Earth actually looks like. Political lines may not be drawn on the terrain views presented, but the Americas are unmistakably foregrounded.

As the science historian James Fleming has noted,[38] in 1954, years before the first photographs of Earth from space were taken, the cover image on *Aviation Week*'s

This prephotographic view of Earth from space created in 1954 by an unknown artist introduces weather formations as the other essential feature of Earth besides land and water. *Aviation Week*, February 3, 1958

February 3, 1958, issue (artist unknown) was commissioned by Harry Wexler, director of meteorological research for the U.S. Weather Bureau. It was meant to stir excitement among meteorologists and space scientists about how satellites would transform our understanding of weather.[39] The United States in this view dominates North America.

The satellite TIROS transmitted the first view of the Earth's surface from orbital space on April 1, 1960, confirming the visibility of clouds and other weather patterns anticipated by Wexler. When Earth was photographed by the Apollo 8 astronaut Bill Anders on the December 1968 lunar journey, the image of a marbled, boundaryless, blue-and-white Earth suspended in space's dark vacuum was revealed—humanity's first view of the entire Earth as it appears from distant space. Dubbed *Earthrise*, the photo had a revolutionary effect on our perception of the Earth, a perception that is still being explored and understood.[40] As described by space historian Robert Poole, *Earthrise* was an epiphany that transformed our conception of Earth from landscape to planet.[41] The emerging environmental movement of the late 1960s and early '70s was catalyzed; *Earthrise* was adopted as a symbol for the new Earth Day established in 1970.[42] Used by Stewart Brand as an emblem for the *Whole Earth Catalog*, it became a powerful symbol of thinking beyond boundaries.

In four decades the blue marble of *Earthrise* has become so ubiquitous that its association with avant-garde social thinking has dissipated. *Earthrise* now appears on the startup screen of new iPhones, on ecological-political buttons pinned to backpacks worldwide, and on many Web sites dedicated to space exploration. The evolution in our understanding of our planet through viewing it from space leads our journey in another direction. As Poole explained, "At the very apex of human progress the question was asked, 'Where next?,' and the answer came, 'Home.' "[43]

Not Home Yet

Whenever people have visualized human culture existing in outer space, it has been with a number of assumptions about domestic environments. Returning from the Moon in 1969, the first astronauts brought home to our planet an "alien" gaze that affected how all of humanity perceives Earth. In the dialectic between "home" and outer space, the realm beyond our orbital environment is so alien to our earthly frame of reference as to be almost completely disconnected. Yet that frame of reference is all we have to bring to the attempt to understand it. When space separates us from our frame of reference, we see home as we've never seen it before.

The early aerospace industry was deeply focused on building an ideology of the human presence in space, a prescriptive paradigm reflected in the picture of human occupation of space that cumulatively emerges from the industry's advertisements. Once launch sites and rocket technologies were established, the analogies to road building were largely exhausted, but interest from private enterprise in building new "roads" in space revives the question of how traffic could be controlled. In the meantime more pressing questions about regulating the orbital environment remain largely unanswered.

Commercial interests now look beyond orbital space. With its Google Lunar X Prize,[44] for instance, Google has reignited visions of lunar mining. The Google prize anticipates achievements for small robotic craft, not the thrilling adventure of human spaceflight. Robotic spaceflight has come to have visibility and public interest on par with orbital human spaceflight. Future commercial ventures in space will likely increase and compete with NASA in providing public access to space. While NASA's publicly funded programs continue to pursue large-scale projects that individual companies are ill-suited to coordinate, private industry can assume some of the cost and risk associated with human spaceflight. Collaboration between Google and NASA Ames Research Center in California is one indication of the future direction of industry and civil-scientific space programs: public-private partnerships.

Tension between civilian and military uses of space was only provisionally addressed by the Outer Space Treaty, formulated to impose a moratorium on transforming space

into a grand new battlefield in the cold war. The treaty banned nuclear or any weapons of mass destruction in space. It did not, however, prohibit other military technologies, and since the treaty's ratification in 1967 the military has settled into a pattern of deploying advanced satellites. The present surreptitious military battlefield of space, dominated by the United States, is vast and unregulated by international oversight, and it is largely unseen by the public. At least for the time being that battlefield is limited to the orbital environment; the proposals of fifty years ago for military operations on the Moon are hemmed in not only by the treaty but also by the same fiscal and logistical constraints that have kept astronauts restricted to orbital space since the 1970s.

The paradigm of space envisioned in the aerospace industry's advertisements has failed. There is no traffic control in space; there are no roads. Space is *not* an extension of home; it is an environment like no other. Ground-based models are inadequate to comprehend space or our relationship to it. Although international law has stated that space is *res communis*—that it belongs to all people—a lack of international or even multinational oversight has allowed wasteful and abusive activity to prevail. Notions of territory versus the reality of a global public commons have directed the behavior of all spacefaring nations. The Outer Space Treaty established basic international regulatory protocols, but it was mute, for one thing, on the subject of trash collection in space. In February 2009 two satellites, one a retired piece of space junk, accidentally collided in orbit, smashing into more than two thousand pieces. Weeks later, astronauts aboard the International Space Station took refuge within their escape capsule to weather a threat to the station from the resulting cloud of new junk. This satellite collision was only the most spectacular demonstration so far of the problems posed by conflicting paradigms of commercial versus public use of space.

The barriers to launch resulting from the problem of space junk have narrowed our access to orbital and interplanetary space and are the tangible expression of failure among spacefaring nations to regulate their activities. Maintenance of a global public commons in space requires responsible international coordination, law, oversight,

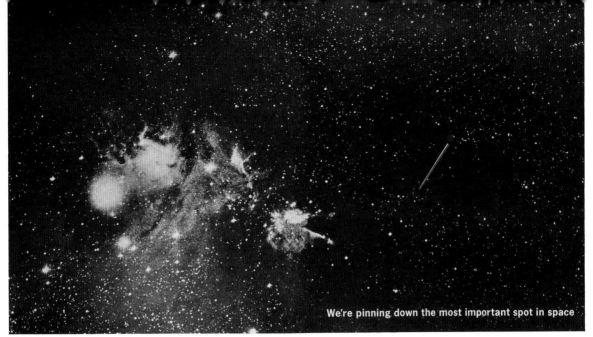

We're pinning down the most important spot in space

and enforcement. The problems today are the result of only fifty years' use of orbital space by a handful of nations. What of the next century? The Outer Space Treaty leaves open questions about how those early to arrive in space, such as the United States and Russia, are to adjust their occupancy of orbital environment as the number of spacefaring nations and private parties grows.

The paradigm of space foreseen in the industry ads also failed to anticipate the disparity between plans and their fiscal feasibility. Advances in technology turned out to be almost as fantastic as planned, but at a cost that was staggeringly higher than expected fifty years ago. Who can afford to build and operate a space junk–busting supersatellite of the kind that Frank Tinsley had imagined we would have by 1970 (page 19)? The cost as well as the physics for launch technology to travel to the alien environment of space require thinking that reaches outside the conventions of ground-based planning.

The misapplication of land-based models of territory in space demonstrates the importance of protection of access and entitlement to space on behalf of all future spacefarers. History has shown that when civil science leads exploration, ecological awareness may follow, but this is less likely to be the case when commercial or military interests blaze the trail. As commerce reaches beyond orbit and to the Moon, a shared—and enforced—international ethos of conservation must be articulated to inhibit further abuse, to protect space for the future.

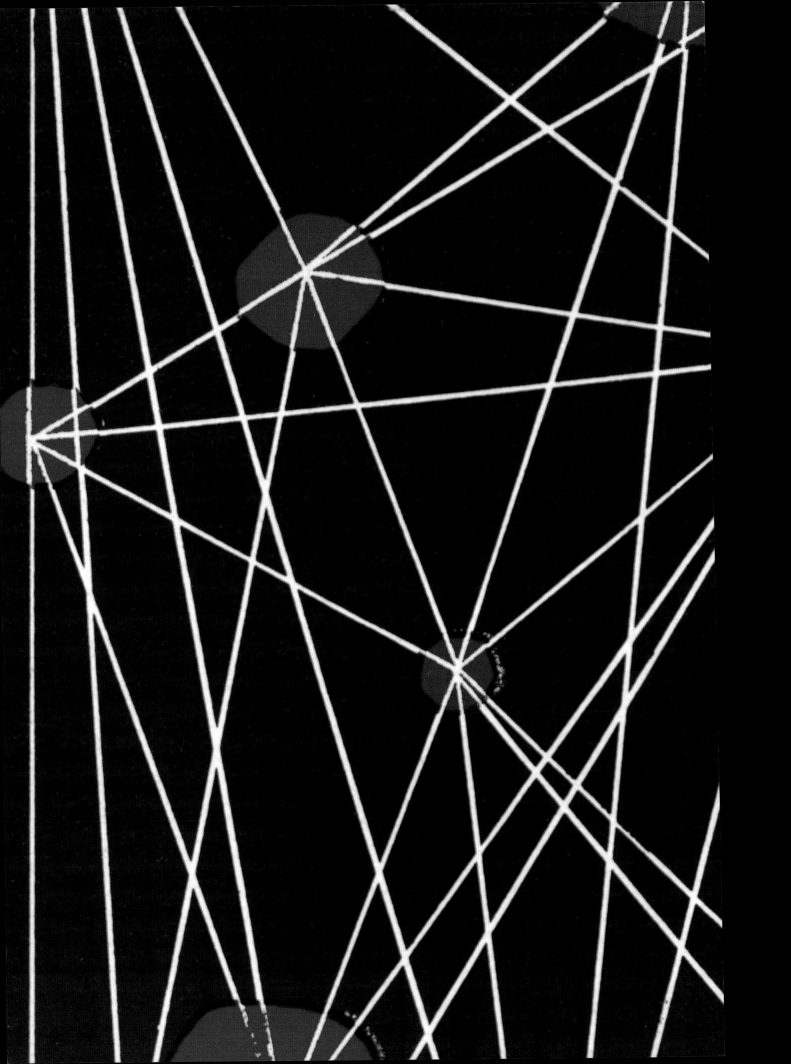

5. Mid-Century Modern Space

Graphic Art for Industry

> With the advent of the Space Age, horizons that have seemed far off have now
> become attainable, and many new revelations are still to come. As in science,
> an obvious parallel exists here for most of the creative arts of our time. Although
> in painting and drawing for industry our meanings may not be as profound
> as those of science, the orbiting search is similarly exciting because we, the
> graphic artists, also seek the unexplored.[1]

The space age was a pervasive motif in the arts and culture of 1959 and the
relationship between artist and industry was close. And yet the *Annual of American
Illustration* in which Bernard D'Andrea underscored that relationship, as noted above,
paid relatively little attention to industrial advertising. D'Andrea was a graphic artist
who created advertising for space contractors General Motors and General Electric. Of
the fifty-three illustrations featured in the advertising art section of the first *Annual*, only
two were commissioned by aerospace industries, both from the series created by the
renowned graphic artist Erik Nitsche for leading military contractor General Dynamics.
The General Dynamics series achieved a very high profile in the world of graphic art
and brought Nitsche fame beyond the norm in graphic arts and industry.

Most graphic artists working for industry remain anonymous or virtually so;
the works they create are the property of the ad agencies or sponsor corporations.
Exceptions are rare. The artists in this book were absent from the *Annual of American
Illustration* and from the even larger similar sections of the *Annual of Advertising and
Editorial Art and Design* of the 1950s and '60s. Both journals tended to restrict their
selections to works aimed at the general public, and the smaller category of industrial,
or trade, advertising was largely overlooked. Of more than five hundred advertisements

OVERLEAF PRECEDING: Detail, page 208.

OPPOSITE: Detail, page 215.

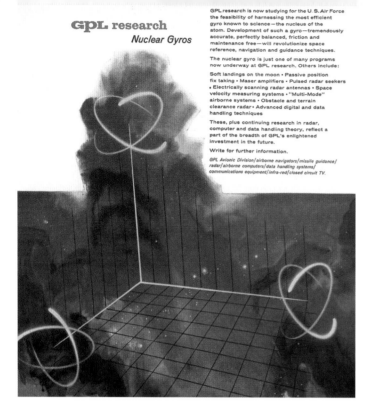

LEFT: Gyroscopes frame the "corners" of a new spatial geometry in General Precision Laboratory's recruitment ad. *Aviation Week*, May 4, 1959

OPPOSITE: Douglas Aircraft boasted of its 1957 Thor missile, the first U.S. ICBM and the forerunner of fifty years of space launch vehicles, the Delta family of rockets. *Aviation Week*, November 2, 1959

considered for inclusion in this book, only two, on pages 8 and 63 (left), both by Willi K. Baum, appear in any of the six contemporary annuals. This omission reflects the division in the historical understanding of advertising art between fine art (art for art's sake) and graphic art (art made for reproduction). Fine art, in contrast to graphic art, is meant to be irreproducible. Advertising was "the mother of almost all graphic design enterprises,"[2] writes design historian Steven Heller. Advertising art and fine art began a flirtation in the early twentieth century that blossomed by the mid-twentieth century into a relationship that commanded public attention with some high-profile ad campaigns that emphasized the status of fine artists. The visual language of modernism came to dominate in all of the arts disciplines by mid-century.

Within the field of graphic arts was another division as well, between advertising to the general public and trade/industrial advertising. As purveyors of industrial advertising, *Missiles and Rockets* and *Aviation Week* targeted primarily a technical audience preinvested in the ideas, if not yet the products, advertised. They promoted industry for industry. The most prominent ad campaign of the twentieth century that engaged fine artists was that of the Container Corporation of America (CCA), initiated in 1937. Led by the Paepcke family, the CCA (through the J. Walter Thompson advertising agency) engaged some of the most accomplished Bauhaus and other European émigré modern artists as well as American fine artists in three successive campaigns spanning the mid-century. The ad campaign peaked in the 1940s in its variety and sophistication. Although it was technically a trade advertising campaign (the purchasing audience for cardboard boxes was predominantly industry), the ads ran in *Fortune* and other popular national magazines and became conversation pieces that strongly affected the general discourse in advertising art.[3] General Dynamics later replicated this exposure in its work with Nitsche.

In the channel between the worlds of graphic art and trade advertising in the 1950s and '60s, aerospace advertising represented a niche industry with a very short

Space veteran at the age of two

history. The complex promises of its products did not fit into conventional marketing categories but constituted their own new category. The industry therefore entered the world of trade advertising with the latitude and the imperative to invent itself. In doing so, the aerospace industry incorporated works of fine art by well-known artists as well as works by anonymous and little-known graphic artists who employed a wide range of modernist techniques to reach into the realms of abstraction and visual metaphor.

The high degree of modernist graphic literacy that informs the work of the artists in this chapter exceeds the complexity of images presenting the technology of the satellite age, or of spacecraft, or of the geography of space, all of which tended toward more literal visual vernaculars. Ads depicting the human body's journey into space introduced the use of abstracted images in aerospace promotion, but the images in this chapter take the relationship between art and persuasion to a height mediated by the motifs of modern art and design. Traditions of the Bauhaus school, Russian constructivism, minimalism, and abstract expressionism are all in evidence. These reference points unmistakably reflect the mid-century modern context of the birth of the space age. Other images employ the contrastingly dense illustrative style of the era and even integrate it with the predominantly spare trends in modernism.

Seeking to persuade on many levels, the modernist aerospace advertisements, like so many others, recruit staff to industry and/or to convene belief in the future of the space industry. Much of the imagery is inspired by the tasks of those working in industry and portrays the technological innovations of the human inquiry into orbit and beyond as facets of modernism. The objectives and the essence of the engineering work that propelled us into space are conveyed as geometric shapes, trajectory lines, and numerical formulas. Vaunted interplanetary goals become the raw material for works of graphic art that break the bounds of the representational and vernacular just as surely as Sputnik and Explorer broke free of Earth's gravity.

Early Modern: Looking at Russia

In Russian constructivism, which emerged in the 1910s, utilitarian form became a pure artistic form.[4] The artist's role was now that of a catalyst for social change, first as a "worker," comparable to the proletarian worker, and eventually as a "constructor" or "engineer."[5] Constructivism's thick bold lines and stark color palettes well complemented the industrial interests of aerospace recruitment advertisements.

In two ads from the Electro-Tec Corporation, photographs of people working become graphic elements within linear illustrations. The constructivist El Lissitzky was, in 1924, among the earliest artists to integrate photography with nonphotographic elements to create such composite images. The textual reference to "skilled hands" and the depiction of a woman at a microscope in Electro-Tec's manufacturing ad (page 195, right) suggest an influence from social realism, an artistic tradition that commonly depicts workers at their jobs in large-scale social or industrial projects.

While the photographic elements suggest social realism, the graphic elements of these two ads recall Russian constructivism in general and the work of one artist in particular: Vladimir Tatlin's 1919 design for a tower, *The Monument to the Third International*, as the monument of the Comintern Communist International, founded in 1919. Tatlin's tower was never built; only the plans and pictures of models remain. It was to be an inclined spiral axis in the shape of an inverted cone with angled struts for vertical supports. Both of Electro-Tec's ads call to mind Tatlin's tower, viewed from the ground and above. What a regret that the identity of the graphic artist of these works has been "swallowed…by the system of production."[6]

At the same time that Russian constructivism was flourishing in the USSR, the Bauhaus school in Germany too was rethinking the relationship between design and industry. Both of these modern schools of thought influenced the growing international abstract expressionist and minimalist movements. Constructivism and later minimalism prominently foregrounded geometric forms, and the rectangular and polygonal fragments and lines of the Barry Controls ads for remedies for vibration reference this graphic leaning toward the geometric form, an orientation that crossed all boundaries between genres of visual art. The genre of "visual music," in which abstract animation

ENGINEERING IS PART OF THE RELIABILITY PATTERN AT ELECTRO-TEC

Highly creative, but infinitely profound engineering is basic to the reliability pattern at Electro-Tec. A product is designed with built-in reliability. It doesn't stop with basic design...all phases of engineering proceed with a comprehension of the natural laws that ensure reliability—the spark that extends product capability and performance beyond the expected. **ELECTRO-TEC CORP.,** South Hackensack, N. J.—Blacksburg, Va.—Ormond Beach, Fla.

MANUFACTURING IS PART OF THE RELIABILITY PATTERN AT ELECTRO-TEC

Skilled hands, close attention to manufacturing techniques, quality control and a deep pride in a product well made...all are intrinsic to the reliability pattern at Electro-Tec. In the many stages between design and finished product, these factors are so balanced that desired component reliability becomes a reality every time. This mix of fine craftsmanship and unexcelled manufacturing capability is one of our most valued assets. **ELECTRO-TEC CORP.** South Hackensack, N. J. — Blacksburg, Va. — Ormond Beach, Fla.

SHOCK AND VIBRATION PROBLEMS?

CONTACT THE SPECIALISTS:

BARRY CONTROLS

Division of Barry Wright Corporation ——————— BW

700 PLEASANT ST., WATERTOWN 72, MASS. 1400 FLOWER ST., GLENDALE, CALIF.

SHOCK AND VIBRATION PROBLEMS?

SOLUTIONS . . . SUBMARINES TO SATELLITES

ANALYSIS • ENGINEERING • MANUFACTURING

BARRY CONTROLS

Division of Barry Wright Corporation ——————— BW

700 PLEASANT ST., WATERTOWN 72, MASS. 1400 FLOWER ST., GLENDALE, CALIF.

ABOVE AND OPPOSITE: The engineering challenge of preventing
shock and vibration is represented here with fragmented
lines and scattered shapes conveying motion. *Aviation Week*,
October 23, 1961; November 27, 1961; December 18, 1961

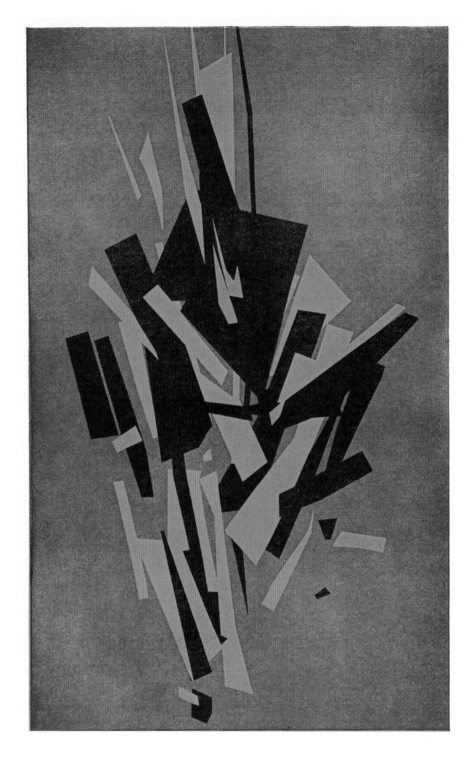

STOP SHOCK AND VIBRATION FAILURES!

Take advantage of our experience in the development and application of isolators . . . custom designs . . . structural damping.

BARRY CONTROLS

Division of Barry Wright Corporation —————————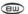

700 PLEASANT ST., WATERTOWN 72, MASS. • 1400 FLOWER ST., GLENDALE, CALIF.

ANALYSIS • DESIGN · TESTING • MANUFACTURING

expresses musical ideas, comes to mind, especially the work of pioneering animator Oskar Fischinger. In a sequence titled "Intermission/Meet the Soundtrack"[7] in the 1940 Disney film *Fantasia*, which was influenced by Fischinger, the "shock" (of percussion) and "vibration" (of string and wind instruments) are depicted as abstract lines and waves. In mimicking the use of stylized lines to convey sound in an animated format, these illustrations well convey the relationship between noise and vibration. The illustration in the Barry Controls ad on page 197 carries this association even further and even recalls Duchamp's 1912 modernist touchstone *Nude Descending a Staircase*.

Modernism in Space

Between the two world wars, a fine-arts tradition was established and came to flourish in Taos, New Mexico. Although the artists of this community were thousands of miles from other early modernist painters, their work was consistent with the dominant themes of modernism. Their sense of place, shape, light, and color was strongly influenced by the spare and minimal landscape in which they were situated, radically different from the density and complexity of New York or Paris, or verdant rural France, or Russia. Everywhere that modernist painting flourished a common set of themes arose seeking to express an integration between the artist's inner ideas and the outer appearance of places and objects. In New Mexico the modernist movement tended to find its form in an emphasis on a spare, sun-dominated landscape.

The eminent Taos painter Emil Bisttram began making paintings in a series titled *Space Images* as early as 1954.[8] Bisttram's works depict in an abstract expressionist mode the interplanetary and interstellar landscape of space that the vast New Mexico sky seemed to bring close to the high desert. Around 1959 Los Alamos Scientific Laboratory (LASL), now Los Alamos National Laboratory, decided to incorporate the works of regional modern artists into its recruitment campaign. Eighteen ads (four of which are shown here, on pages 20, 199, 201, and 202) resulted from this initiative, spearheaded by LASL recruiter Robert Meier. Bisttram's painting *Ascending*, used in the ad on page 199, combines an abstraction of space and the mechanical engineering processes that will get us there. Dominating the center right of the painting, with

Scientific objectivity characterizes the examination of natural forces in the experimental laboratories at Los Alamos.

Original painting by Emil Bisttram, Taos, N.M.

los alamos
scientific laboratory
OF THE UNIVERSITY OF CALIFORNIA
LOS ALAMOS, NEW MEXICO

lines that attach all the forms to one another, is a form suggestive of engineering diagrams—internal rocket structure. Or perhaps it is meant to convey the process of forming connections between ideas; or might the shapes be abstracted systems/bodies representing planets and orbits?

The relationship between LASL and the contemporary artists of Taos is similar to the Container Corporation of America's model of industry advertising. The LASL campaign was developed late in this tradition in advertising, blossoming in 1959 and 1960 after its mid-century peak.[9] A neighborly relationship arose between the LASL research station and the Taos artists who took their inspiration from the desert lands. The foreword of *Art and the Atom*, a catalog prepared for an exhibition of the artwork used in LASL's advertisements, states that the works were not commissioned for the ads but that the ads were created by Robert Meier and the LASL personnel department using existing artworks. The "profound dialogic relationship with environment"[10] that the artists explored was an independent parallel to LASL's functionally dialogic relationship with the same desert environment. As gallery director Leone Kahl observed in *Art and the Atom*:

> The artist is aware of space, mass, motion and energy. He is cognizant of our world in conjunction with outer space and is abreast of the development in the world of science. He searches intuitively rather than theoretically. The scientist is equally involved with the same observations. He explores the potentials; he is the discoverer: the man of research. Both artist and scientist are involved with the mysteries of the Universe.[11]

Nuclear weapons development was then, as it is now, the dominant activity of LASL. Seared into public memory as the site of the development of the first atomic bomb, since the end of the civil nuclear rocket programs LASL has engaged mostly in weapons research. However, the laboratory's program also included civil space work as a strong secondary area of research and development during the eras of Project Rover and the NERVA rocket and in its development of small nuclear batteries for lunar exploration. In the foreword to *Art and the Atom*, Reginald Fisher, then director of the El Paso

At Los Alamos, the mysteries of the universe provide the dynamics for projects ranging from space propulsion to nuclear research.

Original painting by Emil Bisttram, Taos, N. M.

For employment information write: Personnel Director Division 60-34

los alamos
scientific laboratory
OF THE UNIVERSITY OF CALIFORNIA
LOS ALAMOS, NEW MEXICO

Experimentation in nuclear particle motion and energy—one of our many probes into the future.

Original painting by Oli Sihvonen, Taos, N. M.

For employment
information write:
Personnel Director
Division 59-94

los alamos
scientific laboratory
OF THE UNIVERSITY OF CALIFORNIA
LOS ALAMOS, NEW MEXICO

Museum of Art, stated that "the semantics of this exhibition revolve around such terms as: space, energy, motion, dynamics, thrust, propulsion, acceleration, curiosity, probe, experiment, empirical, technology, mystery, experience," and he noted that the paintings were selected "on the basis of the capacity of the particular piece to portray symbolically the essence of the research field under consideration [for recruitment]."

Taos artist Oli Sihvonen too employed a visual language to connect atomics research and space themes to the regional landscape. Sihvonen was an alumnus of Black Mountain College in North Carolina, where he studied design and color under the eminent artist Josef Albers and architecture under Buckminster Fuller. In his work *Blue Spot* (opposite), Sihvonen seems to nod to constructivist El Lissitzky's 1919 graphic composition *Beat the Whites with the Red Wedge*, in which a juxtaposed triangle and circle stand for political conflict. Here, however, Sihvonen represents nuclear particle motion, a component of a possible future probe into space through the LASL's NERVA rockets.

Minimalism

In 1943 the minimalist painters Adolph Gottlieb and Mark Rothko declared:

> We favor the simple expression of the complex thought. We are for the large shape because it has the impact of the unequivocal. We wish to reassert the picture plane. We are for flat forms because they destroy illusion and reveal truth.[12]

The simple expression of complex thoughts when brought to bear on the contemplation of space demonstrates the synchronicity between minimalism's emphasis on geometric forms and the irreducible perfection of the circle to denote the Moon or any solar or planetary body. The circle not only anchors the images on pages 204 and 205 in the tradition of minimalism but works as a representation of space itself.

In the artwork on page 204, the Moon is reduced to its circular shape, light, and shadow within a square frame. Expressing Rothko and Gottlieb's notion of the impact

Aluminum works so many ways for a strong and lasting peace

Reaching for the moon?

Alcoa goes to work immediately on defense projects

Lunar, interplanetary or orbital project—Alcoa is pre-eminently qualified to be part of it. No other light-metals company has more experience. Or has invested more money or man-hours in research. Or has more modern equipment, in more plants—more savvy in developing and manufacturing new aluminum alloys. Alcoa's research and development facilities are integrated with its nationwide manufacturing complex. Regardless of how many operations are involved, each project is produced by one, individual, over-all effort. For more information, write: Aluminum Company of America, 2026-F Alcoa Building, Pittsburgh 19, Pa.

ALCOA ALUMINUM

ALUMINUM COMPANY OF AMERICA

THERE IS NO ROOM FOR SMALL MINDS where men fathom the laws and create the vehicles of space. Nor is there any limit to what these minds can accomplish in a total celestial climate like Martin-Denver. If you seek the stimulation of projects, associates, tools, accomplishments far beyond the ordinary, write: N. M. Pagan, Director of Technical and Scientific Staffing, Martin-Denver, P.O. Box 179H, Denver, Colorado.

MARTIN
DENVER DIVISION

OPPOSITE: The purple background behind this Moon suggests mystery and infinity; space here becomes a vacuum, the non-zone between astral and planetary bodies. *Aviation Week*, June 13, 1960

ABOVE: In the ad designed by Aldcroftt for Martin the sun is the central, minimal figure. Parallelograms are the gateways to space, and a lavender square representing space hangs behind. The head, neck, and shoulders of a human form are created by the alignment of the three shapes, linking human imagination and the journey to space. *Aviation Week*, August 15, 1960

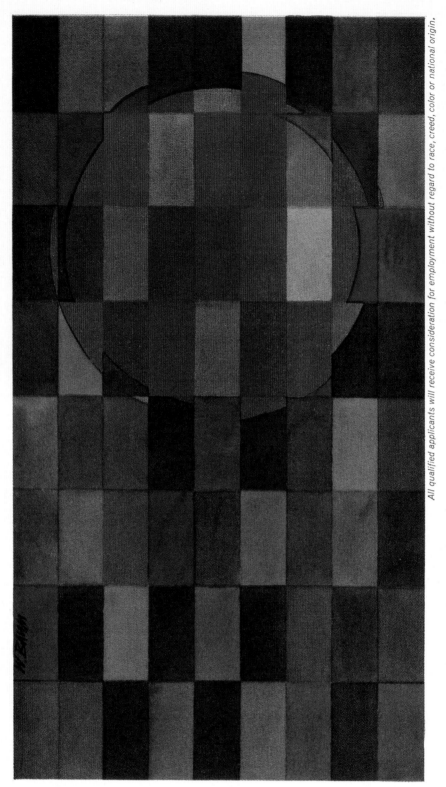

SOLAR ORIENTED SPACE PLATFORMS DEVELOPED FOR *NASA* BY BALL RESEARCH WILL PERMIT INTENSIVE STUDY OF THE ELECTROMAGNETIC SPECTRUM — FROM ULTRAVIOLET THROUGH ENERGETIC GAMMA. FROM THESE INVESTIGATIONS, KNOWLEDGE OF THE SUN'S COMPOSITION, EARTH-SUN RELATIONSHIPS, AND CELESTIAL PHENOMENA WILL BE EXTENDED. SCIENTISTS AND ENGINEERS INTERESTED IN SATELLITE SYSTEMS DESIGN, DIGITAL TELEMETRY, OR DIGITAL TELEVISION ARE INVITED TO JOIN OUR RESEARCH LABORATORIES AND PARTICIPATE IN THESE AND OTHER AD-VANCED PROGRAMS. DIRECT YOUR RESUME TO DR. DAVID STACEY.

BALL BROTHERS RESEARCH CORP.

INDUSTRIAL PARK, BOULDER, COLO. A SUBSIDIARY OF BALL BROTHERS CO., INC.

Circle Number 274 on Reader-Service Card

OPPOSITE: Artwork by Willi K. Baum depicting the sun refracted through multiple panes promotes Ball Brothers' work on solar arrays for NASA. *Aviation Week*, September 25, 1961

RIGHT: Satellite technology is presented here as radio signals bounced to receiving dishes via the burst of an exploding meteor in the ionosphere that looks like a radiant sun. *Aviation Week*, November 25, 1957

of the unequivocal, this Moon becomes a looming objective. The utter flatness of its representation is overridden by a sliver of light to suggest three-dimensionality; the minimalist impulse is at once invoked and denied.

The text superimposed onto the image, "Aluminum works so many ways for a strong and lasting peace," is classic Orwellian doublespeak: whereas aluminum is a material useful in military weapons, here the text refers to the dialogue between the international community that wished to ban weapons of mass destruction in space and national governments that preferred to keep their options open. In 1960, when Alcoa ran this ad, the United States had not yet ratified the outer space treaty that would delineate the theoretically exclusively peaceful use of space.

Artist Willi K. Baum's painting in Ball Brothers Research Corp's ad bears the classic marks of mid-century minimalism. A circle and multiple rectangles express the interplay between sun and space. Ball Brothers went on to contribute to the design and operation of Skylab, the first U.S. manned civil research space station.

Design and Illustration

Modernist artwork of the late 1950s and the 1960s was fairly widely varied; in addition to minimalism's geometric shapes, organic shapes too were prevalent, and photography was often used in combination with graphic illustrations.

Manufacturing giant Avco Crosley advertised early that it had a role in developing the (pre-NASA, U.S. Navy–run) space communications program. At the time that it ran the ad above, the company was also conducting early research and development on the adaptation of a missile nose cone to a manned rocket capsule that would become the Mercury spacecraft, as well as navigation monitoring technology.[13] The lighthearted style of a spiral in this illustration was popular in the era.

control

ABOVE: Integrated as a design element in the art for Honeywell's ad for its space control system is the word *control*. *Aviation Week*, October 5, 1959

RIGHT: The volume ovoid shape here perhaps stands for space, while the chevron is a rocket poised to launch into the warped fabric of the space-time continuum. The chevron mimicks the NASA logo of the time; it also resembles the iconic Starfleet insignia of *Star Trek* to come six years later. *Aviation Week*, October 3, 1960

OPPOSITE: A complex composition of photographic, technical representational, and abstract images makes up Hydro-Aire's ad featuring an isolated draftsman at his drawing board at the apex of a corridor of possibility. *Aviation Week*, May 16, 1960

patterns for **tomorrow**

for holders of advanced degrees now exist in Boeing Wichita's tremendously expanded long-range research and development program for **PHYSICISTS** or **ELECTRICAL RESEARCH ENGINEERS** to conduct acoustics and noise control research supporting advanced designs; to analyze survival properties of advanced vehicles in present and future environments; and evaluate the potential of vehicle defense proposals . . **ANTENNA DESIGN ENGINEERS** to conduct research and development leading to miniaturization of antennas by use of loading dielectrics and/or ferrites . . . **CONFIGURATION DESIGNERS** to create military and civilian vehicle designs based on general missions parameters . . . **DYNAMIC LOADS ENGINEERS** to conduct research in existing and future air/space loads . . . **OPERATIONS AND WEAPONS SYSTEM ANALYSTS** to estimate operational utilities of various devices under study by Advanced Design and recommended optimum design parameters, using advanced (IBM-709) computer aids. Qualified engineers should communicate their interest in any of these top positions to Employment Manager, Mr. Melvin Vobach, Boeing Airplane Co., Department N16, Wichita 1, Kans.

BOEING WICHITA

Solid State Components from Hydro-Aire
may Solve Your Electronic Systems Problem

Today, Hydro-Aire offers you special skills in the development of solid state components to help you solve your systems problems. The Hydro-Aire Electronics Division has been created, staffed and tooled to provide flexibility in design, on-time delivery and reliable performance. These capabilities are now producing precise answers for project engineers at Martin, Boeing, Space Technology Laboratories, General Electric, Litton Industries, Magnavox, Autonetics, and many others.

For a prompt answer to your inquiry, write Electronics Division, Hydro-Aire, 3000 Winona Avenue, Burbank. A note on your letterhead brings your copy of our new Electronics Brochure.

Qualified Electronics Engineers are invited to investigate opportunities at Hydro-Aire by contacting Mr. Harold Giesecke.

With an unusual illustration style using the diorama (page 211), Bell presented a
dramatic story of its high-accuracy navigation system, adaptable to multiple uses and
environments. In this symbolic diorama graphic design meets the art of craft.

The paired abstract shapes in Boeing's ad on page 208, right—one volumetric, one
two-dimensional—call to mind the organic forms that dominated mid-century modern
furniture design. Honeywell's ad for flight control instruments (page 208, left) recalls
a minimalist sketch with its depiction of navigational controls as a series of precise
lines connecting a network of circular shapes. An impression is created of a system of
planetary bodies regulated from a single point.

In the late 1950s photography began to dominate mainstream commercial
advertising, and Hydro-Aire's ad (page 209) with its photographs of people at work in
the electronics industry follows suit, integrating photographs with other visual elements
relevant to the space industry. Electronics diagrams form a dot-and-line pattern in this
tunneling corridor at the end of which sits an isolated draughtsman echoing, perhaps,
shipless astronauts seen in other ads.

The noted illustrator and graphic designer Raul Mina Mora created for Budd, a
defense contractor, a scenario (page 212) in which Earth sits deep in the center of
a swath of color and texture. Here Earth is positioned as a destination, framed by
layers of shape and color that suggest the warp and weave of spacetime, and as a
point of departure from which a rocket has launched and is traveling through Earth's
atmosphere into interstellar space. Mina Mora went on to illustrate many children's
books about science and space in the 1960s and '70s.

As illustrations of untold stories, the artworks incorporated in these ads aim to
present a departure point for new narratives. The storytelling here engages a special
kind of persuasion—the suggestion of bridging the gap between reality and possibility.

Missiles and Rockets I: Titan

The Titan missile, planned in the mid-1950s by the Department of Defense (DOD) as an
intercontinental ballistic missile system to supplement the existing Atlas system,[14] was
originally conceived to function for worldwide nuclear warhead delivery, which was why

Bell's HIgh PERformance NAvigation System — symbolized.

HIPERNAS!

It can pinpoint a long-range missile on target. Guide a satellite or space ship to any point in the universe. Regulate the predetermined course of a surface vessel or submarine to any spot on the seven seas — by any route, however circuitous.

In manned vehicles, it will give exact position — even without an atmosphere — independent of gravity, sea, wind, and weather conditions — without fixes on horizon or stars — after days and weeks of travel.

This is **Hipernas,** a self-compensating, pure inertial guidance system developed by Bell's Avionics Division. Designed for the U.S. Air Force, **Hipernas** is so versa-

tile that a whole family of related systems has been engineered for application in any environment — sea, sky, or space.

The system introduces new Bell BRIG gyros. Its accelerometers and digital velocity meters are already operational in missile and space guidance systems.

Hipernas — and many other systems such as the Air Force GSN-5 and the Navy's SPN-10 All-Weather Automatic Landing Systems — typify Bell's capabilities in the broad field of electronics. This diversity of activities offers an interesting personal future to qualified engineers and scientists.

BELL AEROSYSTEMS COMPANY

BUFFALO 5, N. Y.

DIVISION OF BELL AEROSPACE CORPORATION

A TEXTRON COMPANY

NEW WORLD SYMPHONY

Never has the pace of scientific progress been so rapid. New exploration, successful discovery, throughout the entire scientific spectrum, come at dramatic speed.

Budd is active in many of these fields, with emphasis on practical application of ideas to definite tasks. This includes development of new systems for testing and environmental measurement . . . plastics in new forms . . . machines that employ nuclear radiation . . . the design of structures to cope with the savage thermal thicket encountered in hyper-sonic flight. Budd research aims to make things work . . . for the benefit of people. The Budd Company, Philadelphia 32.

DEFENSE

Budd has long been associated with this country's defense programs. Among its current activities are developments in atomics, the creation and fabrication of structures for missiles and aircraft, and the production of precision components for jet engines.

The numerous graphic elements here—constellations, planets, Moon, an encompassing warp of space that resembles a cradling hand—present a gaze toward an Earth that is both the start and end point of an exciting story. Artist: Raul Mina Mora, *Business Week*, April 26, 1958

its thrust and range were great enough to achieve orbital launch. In 1957 the Martin Company signed a contract with the air force to develop the missile, and the first Titan was test launched on February 6, 1959. Martin created its Denver division specifically to house the Titan project, and its complex in Littleton, Colorado, became a major manufacturing and research and development site for both military and civil projects.[15] After the Titan's initial test, the hiring of a workforce to develop a full complement of ready missiles commenced with fervor. A parallel smaller hiring wave occurred simultaneously in Milwaukee, where GM's AC Spark Plug division, its electronics department, was commissioned by the DOD in April 1959.[16] Ad campaigns sponsored by Martin and GM employed sophisticated graphic artistry in their recruitment objectives: General Motors' "AC Questmanship" campaign of 1959–60 recruited a workforce to design, build, and manufacture the missile's navigation system, while the Martin Company's "Serendipity" campaign recruited workers to build the missile itself.

The Titan program, like the development of early satellite technology, demonstrates the contradictions inherent in the close relationship between military and civilian space programs. Paramount to the DOD was Titan's function as a passive backup to the U.S. military presence around the world, a job it performed from its inception to its decommission in 1987. Its civil application was always secondary to its funders at DOD. To NASA, however, Titan was a launch vehicle—a rocket, not a missile. With NASA's inception in 1958, its engineers began a dialogue with the DOD toward the development of a warhead-free Titan to power space launches. In the complex relationship between NASA and the DOD, divergent objectives, cultures, and histories were counterbalanced by their shared technological resources. Brand-new, NASA admittedly based much of its first few years of organization and operations on what it learned from watching Titan being built.[17] Just as the Atlas rocket had launched the Mercury missions, the Titan was put to work for the civil space program. All ten Gemini missions were launched into orbit by the Titan, and the Titan served robotic missions as well. The air force also sponsored a "hitchhikers" program for civilian and military research scientists to load atmospheric and other experiments aboard Titan-Gemini test flights.[18] The engineering adjustments that made it possible for a large

The first in GM's AC Spark Plug series shows two rockets on the right, an exhaust array at lower left, overlaid with printer's tonal dots, and a horizon line over which appears a shape suggesting a portal into space. *Missiles and Rockets*, June 13, 1960

rocket to be "ridden" by human beings in these significant milestones in the history of the human spaceflight program were later applicable to the engineering of the Apollo missions. The hopes of interplanetary-oriented rocket enthusiasts whose backyard rocket clubs dated to the 1920s were answered by Titan's civil space use.

Graphic design provided an interpretive layer connecting these elements, both complicating and beautifying the picture. The aestheticization of civil space exploration is a storied tradition, but in the case of Titan, as with all liquid- and solid-fueled rockets, recruitment ads brought in people who would find themselves working on a project whose primary application was in the DOD weapons program and whose secondary civil application was little regarded by its designers.

Missiles and Rockets II: The General Motors Series

The concurrent appearance of the Martin and GM images between January 1959 and September 1960 is a reflection of this twenty-month period as a temporal epicenter in the intersection of graphic art and aerospace that peaked during the early development of Titan. The GM series here is found evidence of the era when GM was a world leader in designing for industry.

The graphic designer Will Burtin cultivated a lifelong career in representations of scientific research for industry and formulated a resulting theory of design:

> Science is not restricted to engineering, chemistry, medicine, and energy-matter alone. The impact of scientific thinking and procedure is felt increasingly...in every area of human activity, not excluding that of art.
>
> The designer stands between these concepts, at the center, because of his unique role as communicator, link, interpreter, and inspirer.[19]

With its "AC Questmanship" campaign GM built a relationship between art and engineering consistent with Burtin's thoughts. GM's pledge in this campaign was for *questmanship*, the company's neologism, which assigns an absolute value to the process of technological inquiry.

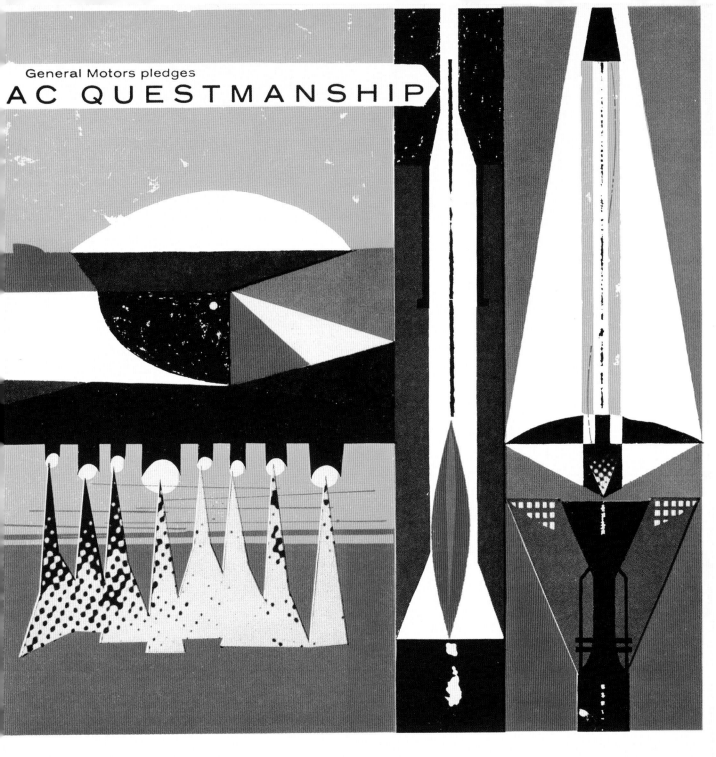

General Motors pledges

AC QUESTMANSHIP

AC Seeks and Solves the Significant—AC has earned an enviable reputation for scientific accomplishment with national defense projects such as AChiever inertial guidance systems. But AC is not limiting its goal to leadership in the international technological race. Utilizing scientific "fallout," AC is also increasing its development of significant new commercial products. / This, too, is AC QUESTMANSHIP: the scientific quest for new ideas, methods, components and systems . . . to promote AC's many projects in guidance, navigation, control, detection and communication. / In the commercial field, AC is already producing communications systems, automotive controls and fuel controls for gas turbine engines. Some day they may even add such advanced projects as systems controls for "ground effect vehicles." According to Mr. B. H. Schwarze, AC Director of Commercial Engineering, "the proper application of scientific 'fallout' to commercial products leads to diversified career opportunities." / You may qualify for our specially selected staff . . . if you have a B.S., M.S. or Ph.D. in the electronics, scientific, electrical or mechanical fields, plus related experience. If you are a "seeker and solver," write the Director of Scientific and Professional Employment, Mr. Robert Allen, Oak Creek Plant, 7929 So. Howell Ave., Milwaukee, Wisc.

GUIDANCE /NAVIGATION /CONTROL /DETECTION /COMMUNICATIONS / **AC SPARK PLUG** ⚛ *The Electronics Division of General Motors*

General Motors pledges

AC QUESTMANSHIP

AC Seeks and Solves the Significant—AC Design and Development is moving far ahead in new technology—the result of GM's commitment to make ever larger contributions to the defense establishment. AC plans to resolve problems even more advanced than AChiever inertial guidance for Titan / This is AC QUESTMANSHIP. It's a scientific quest for the development of significant new components and systems ... to advance AC's many projects in guidance, navigation, control and detection / Dr. James H. Bell, AC's Director of Navigation and Guidance, sees this as a "creative challenge". His group takes new concepts and designs them into producible hardware having performance, reliability and long life. He strongly supports the fact that an AC future offers scientists and engineers "a great opportunity to progress with a successful and aggressive organization" / If you have a B.S., M.S., or Ph.D. in the electronics, scientific, electrical or mechanical fields, plus related experience, you may qualify for our specially selected staff. If you are a "Seeker and Solver", write the Director of Scientific and Professional Employment, Mr. Robert Allen, Oak Creek Plant, Box 746, South Milwaukee, Wisconsin.

GUIDANCE / NAVIGATION / CONTROL / DETECTION / AC SPARK PLUG ⚛ *The Electronics Division of General Motors*

For Further Information Cover 4 Circle No. 4 on Subscriber Service Card. ⟶

C QUESTMANSHIP

ABOVE, OPPOSITE, AND PAGES 218–219: As a set GM's "AC Questmanship" series was a vibrant example of the power of graphic arts to convey a message and feeling about the work of engineers. Although some of these graphics were most likely created by the same artist, it's equally possible they are from the hand of more than one—with its dense tangle of directional arrows, the last ad in this series, on page 219, has a different artistic style in its communication of the complexity of guidance and navigational control. *Aviation Week*, December 21, 1959; February 1, 1960; April 25, 1960; February 29, 1960; March 28, 1960; *Missiles and Rockets*, December 28, 1959

The art of the "AC Questmanship" series, with its emphasis on geometric form and integration of engineering diagram elements, brings to mind techniques of composition and collage practiced by artists as diverse as Kurt Schwitters, Francis Picabia, and, later, Robert Rauschenberg. At their core the works serve the purpose of graphic design: the visual representation of a message, in this case the application of emerging technologies to aerospace systems. The tasks and objectives related to rocket navigation engineering are communicated with compositional elements that create a visual language unto themselves: the engineering process is visualized as abstractions of diagrams, numbers, geometric shapes, and electronic systems symbols. These component motifs are assembled to form a whole greater than the sum of their parts—like a rocket.

The integration of the term *questmanship* into the graphic representation of engineering as a process serves as a persuasive device to promote a type of desk work that could be thought of as fairly passive, as work being done for the greater glory of adventure and discovery.

Missiles and Rockets III: Pattern Language and Serendipity

In 1959 "there was talk of nothing *but* space at Martin," artist Willi K. Baum related.[20] Martin was already working on air force–funded but civil-applicable space research such as space medicine and off-Earth hydroponic food-growing schemes,[21] making it easy for Martin to present civil applicability as the leading face of the Titan project. Indeed, the role that Titan would come to play as supplier of thrust to NASA's Gemini program was already being touted. It was for these civil space projects that Baum was brought in to create the advertisements for Martin that included the "Serendipity" series (pages 220–225) and many more. Baum's agency chief, Earl Halvorson, successfully pitched Baum's work to Martin, and Halvorson and Baum collaborated on the "Serendipity" campaign, with Halvorson writing the copy (including the word

serendipity). Baum acted as both art director and artist, which enabled him to avoid the anonymizing tendency of advertising. Baum saw that Erik Nitsche had signed his work and had built a name for himself, so Baum too signed his work and prevented obscurity.

Swiss-born and Swiss-educated in graphic design, Baum had spent his youth in Dresden, whose destruction by Allied forces in 1945 he witnessed at the age of fourteen. The experience left him a lifelong pacifist, and he described being "horrified" when he learned of Titan's primary military application after becoming professionally engaged by Martin, at $400 per artwork. The primary identity and purpose of Titan was veiled in the boardrooms of Martin—or at least in the personnel department—behind that talk of "nothing but space," says Baum.

Whereas science fiction literature relies principally on verbal language to tell stories about technology and the future, in the other science fiction of aerospace industry advertising, visual language conveyed the idea that technology would lead us into the future and into space. Sometimes this visual language became increasingly metaphorical as planetary and solar shapes became more expressively abstracted from identifiable reference points, as with Baum's illustrations for the second in the series on page 224.

Classically mid-century modern, the four illustrations by Baum in this series are informed by minimalism and expressionism, but their core purpose is that of graphic art to communicate a broadly accessible, inviting, and fantastic view of the dreamscape that Martin's technological future would supposedly allow us to reach. In choosing *serendipity* as the catchword for the recruitment campaign, Halvorson captured the zeitgeist. Like *questmanship*, *serendipity* distills into a single word the flavor of possibility and discovery that drove recruitment.

Two final "Serendipity" ads for Martin (page 225) were illustrated by a freelancer Earl Halvorson hired when Baum was unavailable for work. These last two contrast markedly in style with Baum's work and are closer in style to pop art.

transcending present knowledge ... *creating new concepts in space science . . . a unique challenge for persons who seek intellectual stimulation and association, and are able to recognize and use the serendipity which awaits scientific discovery. At MARTIN-DENVER, post-Titan space programs now in progress offer the professional mind an opportunity for great personal advancement. Inquire immediately of N. M. Pagan, Director of Technical and Scientific Staffing, The Martin Company, P. O. Box 179 (FF-4), Denver 1, Colorado*

MARTIN
DENVER DIVISION

serendipity

exploring the fascinations of space *and applying the knowledge gained therefrom is one aspect of serendipital intellectuality which the truly creative talent finds at Martin-Denver. If you are seeking such an experience, and desire to participate in the most advanced thinking in space science, communicate immediately with N. M. Pagan, Dept. CC-5, The Martin Company, P.O. Box 179, Denver, Colorado.*

MARTIN
DENVER DIVISION

PAGES 220, 221, 223, AND 224: Willi K. Baum's "Serendipity"
ads for Martin. *Missiles and Rockets*, August 24, 1959;
Aviation Week, September 14, 1959, March 9, 1959,
November 16, 1959

The End of an Era

Even at the outset of the years covered in this book, a dense collection of such
graphically rich advertisements was unusual in any magazine, national or trade. On
neighboring pages to those on which the ads in this book appeared in *Aviation Week*
and *Missiles and Rockets*, photographic ads increased until by the mid-1960s they
dominated, although the professional aerospace engineering magazine *Astronautics
and Aeronautics* still featured space-themed modernist artworks on its cover into the
mid-1960s.

The end of the era of graphic art illustration in the aerospace industry coincided
with the end of the boom in aerospace engineering and finance. Once the design for
the Apollo mission was established, the role of imagination in picturing our future
in space was considerably diminished and advertising became grounded in realistic
representation. Pie-in-the-sky start-up budgets allocated to NASA plateaued in 1962
and 1963, as did the sweeping hiring waves that had begun in 1958. Once Martin had
obtained the key contracts with the DOD, the company lost interest in spending money
on visually rich advertising, Baum explained. The ads had achieved their objective
anyway: more than half a million people had been hired into aerospace since 1958.

The role of graphic design in the development of belief systems is powerfully
demonstrated in the aerospace industry ads that conflate the romance of the civil space
program with the well-funded reality of the U.S. cold war arsenal. From the cloudy early
differentiation between civil and military space programs to recruitment into military
technologies through an aestheticized ideology of the human future in a peaceful space
environment, graphic arts provided the means of persuasion. Willi Baum's experience
creating graphic art for the Titan missile exemplifies the split between open and veiled
objectives. These advertisements show how much aerospace industry advertising relied
on aestheticization and visual euphemisms to project a socially palatable identity for
military projects. The romance of space and promise of civil space exploration most
often worked to obscure less utopian military plans.

An inadvertent aesthetics of war resulted, which among other effects compromised
the legitimacy of the civil space program by positioning it as a cover for military

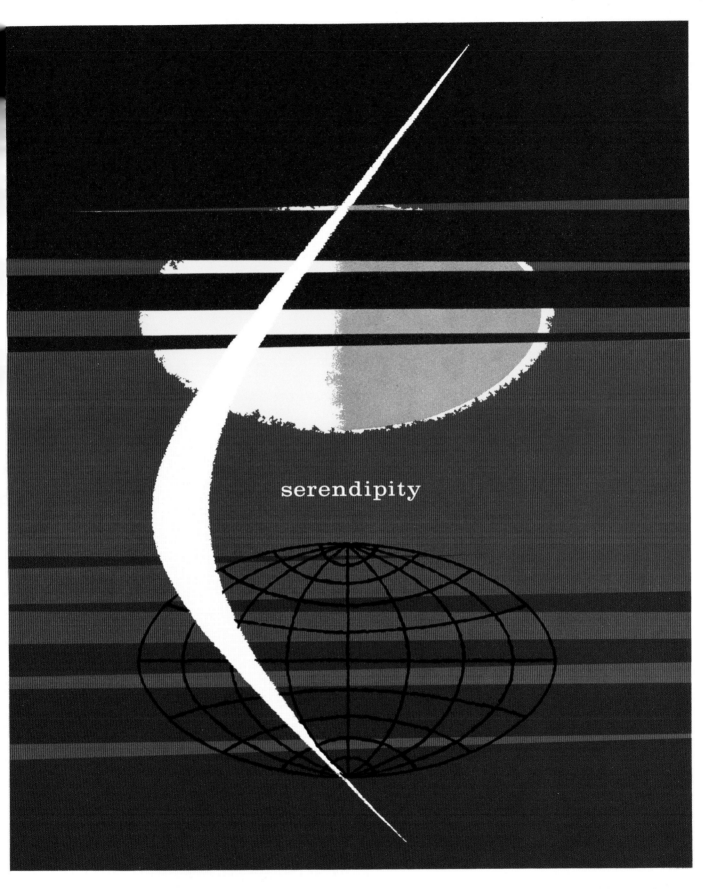

serendipity

probing beyond present knowledge ... *seeking to improve the*
bases for tomorrow's space concepts ... It is this exciting opportunity for
serendipity that confronts the professional minds at Martin-Denver. Possibly
you, too, would enjoy this stimulus for greater personal and scientific recognition.
If so, we invite you to write or call N. M. Pagan, Director of Technical and
Scientific Staffing, The Martin Co., P. O. Box 179, (G-1), Denver 1, Colorado.

MARTIN
DENVER DIVISION

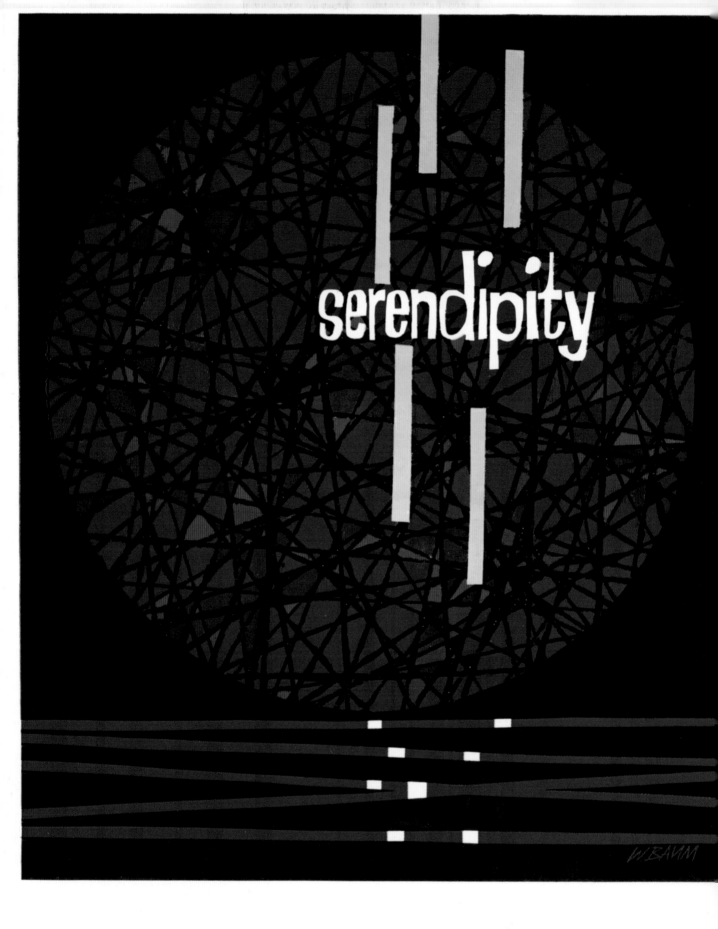

creating new engineering concepts *and discovering solutions to those problems which serendipity has revealed . . . is the task of the professional minds at Martin-Denver. To individuals who possess this creative talent and who seek this stimulation, there is offered an opportunity for outstanding recognition. To participate in this program, inquire immediately of N. M. Pagan, Director of Technical and Scientific Staffing, The Martin Company, P. O. Box 179, (Dept. G-5), Denver 1, Colorado.*

MARTIN
DENVER DIVISION

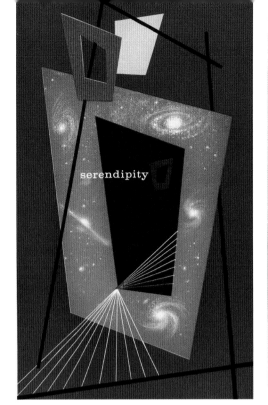

look for the professional challenge ... *available only to those who possess the creative initiative to explore, in thought, beyond what is known about space travel, and return with the serendipity that only the few would recognize. If you are one of those exceptional individuals who is seeking a challenge such as this, communicate with N. M. Pagan, Director of Technical and Scientific Staffing. Martin-Denver, P. O. Box 179, (F-3), Denver 1, Colorado.*

MARTIN
DENVER DIVISION

RIGHT: Two early advertisements in the "Serendipity" series, artist unknown. *Missiles and Rockets*, **February 23, 1959, June 15, 1959**

activity. Not only artists like Baum but workers too would have experienced a bait-and-switch effect. Believing in the visual and verbal messages in these ads, a recruit would have been rather shocked to enter the distinctly militarized environment of missile production. Although a great many jobs did contribute to civil space activity, the proportion of research-and-development jobs offered by aerospace corporations was nearly always small relative to DOD work.

Like science fiction writers, the artists in this book used technological change as a starting point for a host of imagined possibilities. Their images testify to the power that art has to interpret technology and the range of potential futures it may bring.

The images that advertised the space race were sometimes appropriated into a dystopian scenario in which distinctions between military operations and peaceful exploration were obscured. Yet they also brought to life technology's most positive promises, depicting scenes that still dare us to imagine exciting, even utopian, futures. That humankind might be freed from existing physical, geographic, and technological limits invites speculation about not only what technology can be but what society can be.

Many spectacles of near-future possibility that surround us today were, as this book has shown, first anticipated and visualized a half century ago. Many of the same hurdles, technological and otherwise, are yet before us, awaiting answers. Knowing this, we can reconsider the present and the near future: *we are still in the early space age.* The role of art today in mediating the social life of technology is also pressing. Photographic images of space brought back by satellites and probes have overtaken our need and our ability to invent what space looks like. Time is another matter; art remains a force with tremendous power to shape our unfolding shared future.

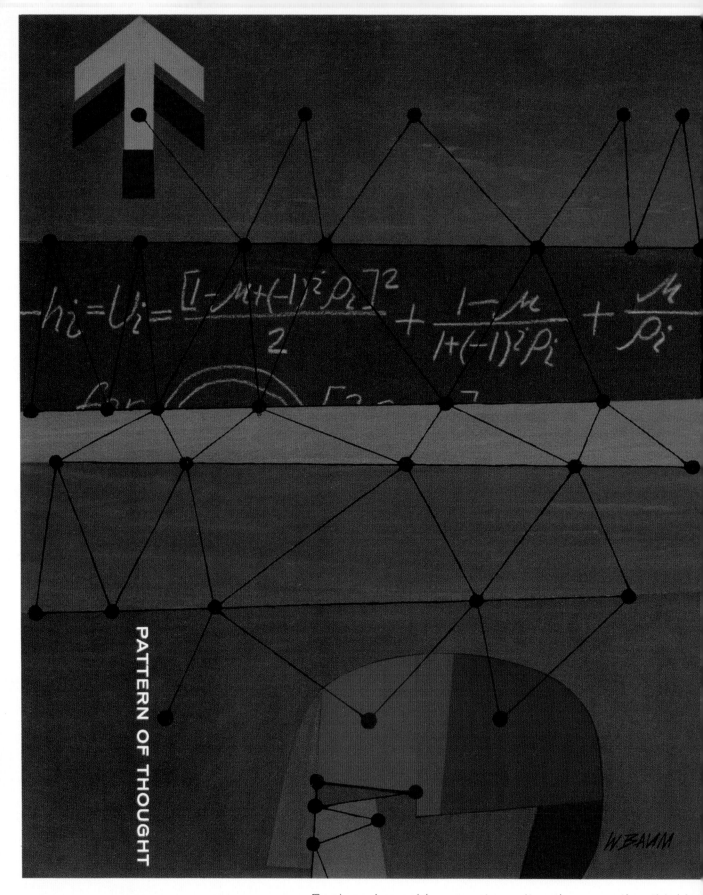

$$-h_i = U_i^2 = \frac{\left[1 - M + (-1)^2 \rho_i\right]^2}{2} + \frac{1 - M}{1 + (-1)^2 \rho_i} + \frac{M}{\rho_i}$$

W.BAUM

PATTERN OF THOUGHT

MARTIN
DENVER

NOTES

INTRODUCTION

1. Robert Rosholt, *An Administrative History of NASA, 1958–1963*, NASA SP-4101 (Washington, DC: Government Printing Office, 1966), 58. See also "Pentagon Gets Some First Aid." *Business Week*, August 2, 1958, 21.
2. Ibid., 137. See also, "Space: Special Report," *Business Week*, August 19, 1961, 77.
3. Rosholt, *Administrative History of NASA*, 175.
4. Marquardt Corporate Information Services, *Remarqs*, Annual Report, November 1964: 17.
5. Johanna Drucker and Emily McVarish, *Graphic Design History: A Critical Guide* (Upper Saddle River, NJ: Pearson Prentice Hall, 2009), 158.

1. SATELLITES IN THE SKY

1. Leo Margulies, "No. 2 Satellite Away!" *Satellite Science Fiction*, October 1956, 2. See also Rosholt, *Administrative History of NASA*, 58; "Pentagon Gets Some First Aid," 21.
2. Arthur C. Clarke, "Extra-Terrestrial Relays," *Wireless World*, October 1945, 305–309.
3. Arthur C. Clarke, in House Select Committee on Astronautics and Space Exploration, *The Next Ten Years in Space 1959–1969*, 86th Cong., 1st sess., 1959, 32.
4. Michael J. Neufeld, *The Rocket and the Reich: Peenemünde and the Coming of the Ballistic Missile Era* (New York: Free Press, 1995).
5. Philip Taubman, *Secret Empire: Eisenhower, the CIA, and the Hidden Story of America's Space Espionage* (New York: Simon & Schuster, 2003), 69. RCA made the first cameras that were intended for television monitoring from space in the early 1950s before plans for satellites were even on a solid development track.
6. For a discussion of the evolution of the Corona Project in RAND Corporation, see *Project Air Force: 1946–1996* (Santa Monica: RAND Corporation, 1996), 20–21.
7. Wesley S. Griswold, "TV Satellite to Watch the World," *Popular Science*, February 1958, 105–109.
8. "Work on Pied Piper Accelerated; Satellite Has Clamshell Nose Cone," *Aviation Week* 68, no. 25 (1958): 18–19.
9. Richard M. Bissell (CIA director) memorandum to James A. Cunningham Jr. (CIA director of administration), June 26, 1958, "Article appearing in *Aviation Week* (23 June issue)," in *Secrecy and U.S. Satellite Reconnaissance, 1958–1976*, Jeffrey Richelson, ed. (Washington, DC: National Security Archive Electronic Briefing Book No. 225, 2007). Accessed October 2008 at http://www.gwu.edu/~nsarchiv/NSAEBB/NSAEBB225/.
10. James A. Cunningham Jr. memorandum to special assistant to the director for planning and administration, June 27, 1958, "Evaluation of *Aviation Week* article on accelerated Pied Piper Program," in Richelson.
11. "Defense Plans Satellite Launches Once-a-Month Basis in 1959," *Aviation Week* 69, no. 23 (1958): 31.
12. A full history of Corona can be found in Taubman, *Secret Empire*, 212–97.
13. Esso Standard Oil Company, *The Story of IGY: International Geophysical Year and Earth Satellites*, promotional booklet, 1957: 14.
14. "Satellite Magnetometer to Measure Earth's Field," *Radio & TV News*, September 1957, 158.
15. *Story of IGY*, 15.
16. Senate Committee on Aeronautical and Space Sciences, *National Aeronautics and Space Act of 1958 as Amended through the End of the 87th Congress*, October 13, 1962, 87th Cong., 2nd sess., 1962, 5.
17. "Satellite in Orbit Relays Ike's Voice," *Broadcasting*, August 15, 1960, 9.
18. Eugene J. McNeely, "A Down-to-Earth Look at Space Communications," *Bell Telephone Magazine*, Spring 1962, 44–45.
19. Taubman, *Secret Empire*, 356–70.
20. U.S. Air Force, ["Above All," satellite edition] television commercial. Airdate May 9, 2008, SciFi Channel. Accessed July and August 2008 at http://www.youtube.com/watch?v=Uk7DVpCkgwQ.
21. Capital One [satire of "Above All," U.S. Air Force commercial] television commercial. Airdate June 13, 2008, USA Network.

Martin Company recruitment ad by Willi K. Baum. Courtesy of the author

2. THE HUMAN BODY IN SPACE

1. "Space: Special Report," *Business Week*, August 19, 1961, 87.
2. The full text of Kennedy's May 25, 1961, speech is available from the John F. Kennedy Library. Accessed January 2008 at http://www.jfklibrary.org/Historical+Resources/Archives/Reference+Desk/Speeches/JFK/003POF03NationalNeeds05251961.htm.
3. Rosholt, *Administrative History of NASA*, 186–87.
4. Ibid., 195.
5. See E. McKnight Kauffer cover illustration on Museum of Modern Art 1941 exhibition catalogue for *Organic Design in Home Furnishings* (silhouetted hand) and Ray Eames cover of *Arts & Architecture*, January 1944 (footprint and handprint), in *Vital Forms: American Art and Design in the Atomic Age, 1940–1960*, ed. Brooke Kamin Rapaport and Kevin L. Stayton (New York: Brooklyn Museum of Art in association with Harry N. Abrams, 2001), 170, 168.
6. Rapaport and Stayton, *Vital Forms*, 27. See also Rapaport, "The Greater Mystery of Things: Aspects of Vital Forms in American Art," in *Vital Forms*, 78–119.
7. See, for example, David Lasser, *The Conquest of Space* (New York: Penguin, 1931); Willy Ley and Chesley Bonestell, *The Conquest of Space* (New York: Viking, 1949); Arthur C. Clarke, *The Exploration of Space* (New York: Harper & Brothers, 1951); Jack Coggins and Fletcher Pratt, *Rockets, Jets, Guided Missiles and Space Ships* (New York: Random House, 1951).
8. Wernher von Braun, "Crossing the Last Frontier," *Collier's*, March 22, 1952, 26.
9. Ibid.
10. Wernher von Braun's three episodes of *Tomorrowland* (Los Angeles: Walt Disney Corp.), aired March 9, 1955 ("Man in Space"); December 28, 1955 ("Man and the Moon"); and December 4, 1957 ("Mars and Beyond").
11. "Take Off That Space Suit," *Time*, March 31, 1958, 50.
12. "Killian Cautions Against Excessive Stress on Man-in-Space Program," *Aviation Week* 73, no. 7 (1960): 29.
13. "Space Exploration as Propaganda," *Science*, March 19, 1960, 799.
14. Ralph E. Lapp, "Do We Need a Man on the Moon?" *Science Digest*, May 1961, 12–17. (Condensed from *Think*, January 1961.)
15. John Kay Adams, "Is This Trip Necessary?" *The Nation*, April 29, 1961, 367–69.
16. Robert Hotz, "Gathering Storm Over Space," *Aviation Week* 73, no. 19 (1960): 21; "The U.S. in Space: Anybody Happy?" *Newsweek*, November 2, 1959, 26; "Man in Space Program Wastes Money and Effort," *Science News Letter*, December 3, 1960, 361; Carl Dreher, "Pie in the Sky: Scramble for the Space Dollar," *The Nation*, February 18, 1960, 131–38.
17. Linda Billings, "Overview: Ideology, Advocacy, and Spaceflight—Evolution of a Cultural Narrative," in *Societal Impact of Spaceflight*, ed. Steven J. Dick and Roger D. Launius, NASA SP-2007-4801 (Washington, DC: Government Printing Office, 2007), 483–99.
18. I. M. Levitt, "Timetable to the Moon," *Popular Science*, May 1958, 105.
19. Image reprinted and interpreted in Jane Pavitt, "The Bomb in the Brain," in *Cold War Modern: Design 1945–1970*, ed. David Crowley and Jane Pavitt, 100–101 (London: V&A Publishing, 2008).
20. See, for example, the series of NASA budgets published in Rosholt, *Administrative History of NASA*. For a sensitive discussion of this conflict see Richard Paul, *Washington Goes to the Moon: A Documentary About Apollo 11* (Public Radio Exchange, 1999). Accessed August 2007 at http://www.audible.com.
21. Martin Heidegger, trans. John Macquarrie and Edward Robinson, *Being and Time* (New York: SCM Press, 1962).
22. Clare F. Farley, "Appendix B to the statement of Clare F. Farley, Deputy Assistant Administrator for Technology Utilization, examples of transfer to the public sector," in Senate Committee on Aeronautical and Space Sciences, *Toward a Better Tomorrow with Aeronautical and Space Technology*, 93rd Cong., 1st sess., 1973, Committee Print, 113 –27.
23. Charles A. Berry, "The Medical Support of Manned Spaceflight," in NASA, *Fourth National Conference on the Peaceful Uses of Space*, NASA SP-51 (Washington, DC: Government Printing Office, 1964), 177.
24. See, for example, Stephen J. Dubner, "Is Space Exploration Worth the Cost? A Freakonomics Quorum," in *New York Times* online edition, January 11, 2008. Accessed January 14, 2008, at http://freakonomics.blogs.nytimes.com/2008/01/11/is-space-exploration-worth-the-cost-a-freakonomics-quorum/.
25. Google, "History Making Moon Mission Unveiled," press release, December 6, 2007. Accessed January 7, 2008, at www.googlelunarxprize.org/lunar/press-release/history-making-moon-mission-unveiled.
26. Wendell Mendell, "Science and the Constellation Systems Program Office," paper presented at the 9th International Lunar Exploration Working Group, *International Conference on Exploration and Utilisation of the Moon* (October 2007, Sorrento, Italy). Abstract online at http://ntrs.nasa.gov.
27. George Musser, "Five Essential Things to Do in Space," *Scientific American*, October 2007, 69–75. As listed in Musser, the five essential things for people to do in space are: 1. Monitor Earth's climate. 2. Prepare an asteroid defense. 3. Seek out new life. 4. Explain the genesis of the planets. 5. Break out of the solar system.
28. Roger D. Launius and Howard E. McCurdy, *Robots in Space: Technology, Evolution, and Interplanetary Travel* (Baltimore: Johns Hopkins University Press, 2008).

3. SPACECRAFT: FORM AND FUNCTION

1. See "Work Begun on Liquid H2 Complex at Nevada Test Site," *Missiles and Rockets* 6, no. 22 (1960): 76–77. See also "The Centaur Drags Its Feet," *Business Week*, April 21, 1962, 58–62, which details the development problems associated with the use of liquid hydrogen as

rocket fuel. For technical detail, see Donald L. Nored and Edward W. Otto, "Fluid Physics of Liquid Propellants," in *Proceedings of the NASA–University Conference on the Science and Technology of Space Exploration* 2 (November 1962, Chicago), NASA SP-11 (Washington, DC: Government Printing Office, 1962).

2. General Electric Corporation, Missile and Space Vehicle Department, *Project Apollo: A Feasibility Study of an Advanced Manned Spacecraft and System, Final Report, vol. I: Summary and Conclusions*, fig. III-2-2 (recommended Apollo configuration). NASA Contract NAS 5-302, May 1961.

3. Dan Q. Posin, "Race to the Moon," *Popular Mechanics*, August 1959, 64–66, 78–84, 219–222. The author was a professor of physics at DePaul University and a professional interpreter of science for the public as a scientific consultant to CBS.

4. Wernher von Braun proposed a similar pattern of disposable use for a set of seven cylindrical fuel tanks carrying hydrazine and nitric acid that fueled the lunar observation rocket *Lunar Reconn Ship RM-1*. This ship design was proposed on television in 1955 in the episode "Man and the Moon" on Disney's *Tomorrowland* television program, broadcast December 28, 1955.

5. Stephen L. DeSesto, "Wasn't the Future of Nuclear Energy Wonderful?" in *Imagining Tomorrow: History, Technology, and the American Future*, ed. Joseph J. Corn (Cambridge, MA: MIT Press, 1986), 58–76.

6. Wernher von Braun and Frederick I. Ordway III, *History of Rocketry and Space Travel* (New York, Thomas Y. Crowell, 1966), 22–35.

7. Jay Holmes, "Rocket Fuel Development Accelerates," *Missiles and Rockets* 6, no. 22 (1960): 74.

8. Rosholt, *Administrative History of NASA*, 107. Rosholt writes: "The transfer to NASA of the Saturn project and the Army installation associated with it was the most significant event in NASA's history between its establishment in October 1958 and the Kennedy announcement of May 1961 to greatly accelerate NASA's space program."

9. Jay Holmes, "Able-Star Makes Technological First," *Missiles and Rockets* 6, no. 14 (1960): 44–47.

10. Ibid., 44.

11. Ibid.

12. Rosholt, *Administrative History of NASA*, 246. For more detail see David H. Hoffman, "Apollo to Use Lunar Orbit Rendezvous," *Aviation Week and Space Technology* 77, no. 2 (1962): 25.

13. One notable exception is a striking advertisement that appeared in September 1963 in *Astronautics and Aeronautics* (p. 42) issuing a call for the opportunity to contribute to the LEM.

14. "Nuclear Stage for Saturn by '68–'69," *Missiles and Rockets* 6, no. 16 (1960): 13.

15. This phrase reflects the title of Frank Tinsley's *Answers to the Space Flight Challenge: Six Steps to Outer Space* (Louisville, KY: Whitestone Books, 1958).

16. Max Hunter and Edward Bonnet, "Power for Interplanetary Travel," *Space World*, October 1961, 32.

17. Harold B. Finger, "Nuclear Rockets and the Space Challenge," *Astronautics* 6, no. 7 (1961): 3. The phrase quoted is from the issue's table of contents editorial summary of the article.

18. Atomic Energy Commission, *Annual Report to Congress, 1960* (Washington, DC: Government Printing Office, 1961), 69–71.

19. "Package small...guidance true," American Bosch ARMA Corporation print advertisement. *Missiles and Rockets* 6, no. 25 (1960): 3. This is one of the few American Bosch ARMA advertisements that made direct reference to the company's actual work in aerospace. Most of its advertisements referenced extremely grand ventures as a means to recruit talent for smaller projects. "Classic bait and switch," said nuclear engineer and 1959 industry recruit Steve Massey referring to ARMA's advertising strategy (interview with author, July 2008).

20. Scott Lowther, "The Helios Concept," *Aerospace Projects Review* 1, no. 3 (2007): 13–22. Information also drawn from Anthony R. Martin and Alan Bond, "Nuclear Pulse Propulsion: An Historical Review of an Advanced Propulsion Concept," *Journal of the British Interplanetary Society* 32, no. 8 (1979): 283–310.

21. George Dyson, *Project Orion: The True Story of the Atomic Spaceship* (New York: Henry Holt, 2002).

22. "DOD Is Killing Proposed Gag on Ads," *Missiles and Rockets* 6, no. 18 (1960): 16–17. Includes reprint of entire proposed directive.

23. Atomic Energy Commission, *Annual Report to Congress, 1970* (Washington, DC: Government Printing Office, 1971), 173.

24. Bruce Lundin, "Plum Brook Shut Down Speech," January 5, 1973, reprinted in Mark D. Bowles and Robert S. Arrighi, *NASA's Nuclear Frontier: The Plum Brook Reactor Facility 1941–2002*, NASA SP-2004-4533 (Washington, DC: Government Printing Office, 2004), 131–33.

25. Adapted from remarks made by Harold B. Finger, NASA chief of nuclear engines, in "Nuclear Stage for Saturn by '68–'69."

26. Sean O'Keefe, "Pioneering the Future" (lecture, University of Syracuse, April 12, 2002). Reprinted in Bowles and Arrighi, *NASA's Nuclear Frontier*, 155.

27. Atomic Energy Commission, *Annual Report to Congress, 1961* (Washington, DC: Government Printing Office, 1962), 65.

28. Ibid., text p. 23; pictures pp. 2 and 64.

29. Atomic Energy Commission, *Annual Report to Congress, 1971* (Washington, DC: Government Printing Office, 1972), 143.

30. Macon C. Ellis Jr., "Survey of Plasma Accelerator Research," in *Proceedings of the NASA–University Conference on the Science and Technology of Space Exploration* 2, 361–81.

31. Summarized from "Breakdown of Electric Propulsion Programs for Space Applications," *Aviation Week* 80, no. 4 (1964): 76–78.

32. Ibid., 78.

33. Milton Minneman, "An Experimental Plasma Propulsion System," in Institute of Radio Engineers, Professional Group on Military Electronics, *Third National Convention on Military Electronics*, conference proceedings reprint (1959), 167.

34. Ibid., 168.

35. *Space World*, November 1960.

36. Ibid., "About the cover" editor's remark, 3.

37. "Ion Propulsion Now a Practical Reality," *New Scientist*, August 16, 2003, 46.

38. Edward H. Kolcum, "Funding Forces One-Year Apollo Delay," *Aviation Week* 80, no. 2 (1964): 26.

39. Michael L. Yaffee, "Electromagnetic Engine Research Grows," *Aviation Week* 80, no. 7 (1964): 80.

40. Frank Tinsley, "Flight to the Stars on Sun Power," *Mechanix Illustrated*, January 1956, 74, 75.

41. Ibid., 76.

42. My understanding of ion-powered spacecraft and their development and use since the mid-1990s owes a considerable debt to Michael Patterson, senior scientist in space propulsion at NASA Glenn Research Center; author interview September 15, 2008.

43. Charlene Anderson (Planetary Society staff), e-mails to author, October 20 and 21, 2008.

44. T.C. Tsu, "Interplanetary Travel by Solar Sail," *American Rocket Society Journal* 29, no. 6 (1959): 422–29.

45. Louis D. Friedman, "Making Light Work," *Professional Pilot*, June 2007, 2–5.

46. Tsu, "Interplanetary Travel."

47. Homer Newell, "The Research Frontier: Where Is Science Taking Us?" *Saturday Review*, December 2, 1961, 72–73.

48. Louis D. Friedman, "Cosmos 2: A Letter from the Executive Director," article posted on the Planetary Society Web site, accessed September 15, 2008, at www.planetary.org/programs/projects/solar_sailing/20071116_letter.html.

49. James J. Zakrajsek et al., "Exploration Rover Concepts and Development Challenges," paper prepared for the American Institute of Aeronautics and Astronautics, *First Space Exploration Conference: Continuing the Voyage of Discovery*, January and February, 2005, NASA/TM—2005-213555, 2. Accessed January 2008 at http://gltrs.grc.nasa.gov/reports/2005/TM-2005-213555.pdf.

50. Ibid., 3.

51. Ibid., 9.

52. Ibid., 7.

4. THE LANDSCAPE OF SPACE

1. The phrase "this new ocean" originated with the speech given by President John F. Kennedy at Rice University, Houston, on September 12, 1962. It entered the language as a powerful metaphor for space and was utilized frequently thereafter, most notably in book titles, such as William E. Burrows's *This New Ocean: The Story of the First Space Age* (New York: The Modern Library, 1998). See also the discussion of this history in Steven J. Dick's "Why We Explore" essay in NASA's *Why We Explore* essay series. Accessed July 2008 at http://www.nasa.gov/exploration/whyweexplore/Why_We_06_prt.htm.

2. See the essay series *Why We Explore* at http://www.nasa.gov/exploration/home/index.html.

3. Stephen J. Pyne, "Seeking Newer Worlds: An Historical Context for Space Exploration," in *Critical Issues in the History of Spaceflight*, ed. Steven J. Dick and Roger D. Launius, NASA SP-2006-4702, (Washington, DC: Government Printing Office, 2006), 7–36.

4. Bruce Mazlish, ed., *The Railroad and the Space Program: An Exploration in Historical Analogy* (Cambridge, MA: MIT Press, 1965).

5. Leo Marx, "The Impact of the Railroad on the American Imagination, as a Possible Comparison for the Space Impact," in ibid., 202–16.

6. David Crowley and Jane Pavitt, eds., *Cold War Modern*.

7. Most absurd of all the ads surveyed for this book, a lollipop floats in space mimicking the view of Earth from the orbit of the Moon (the *Earthrise* photograph), published in a promotion for Norda on the back cover of *Candy and Snack Industry*, August 1973.

8. See the discussion in Leon Lipson and Nicholas deB. Katzenbach, eds., *Report to the National Aeronautics and Space Administration on the Law of Outer Space* (Chicago: American Bar Foundation, 1961), 7–8.

9. Mark H. Rose, *Interstate* (Lawrence: Regents Press of Kansas, 1979), 85–94.

10. Ibid., 93.

11. Donald W. Cox, "International Control of Outer Space," *Missiles and Rockets* 1, no. 6 (1957): 68–71.

12. UN General Assembly Resolution 1348 (XIII), *Question of the Peaceful Use of Outer Space*, adopted December 13, 1958. Accessed August 2008 at http://www.unoosa.org/oosa/en/SpaceLaw/gares/html/gares_13_1348.html. The UN's Committee on the Peaceful Uses of Outer Space was convened specifically, among several other reasons, to create a framework for the permanent continuation of research associated with the International Geophysical Year.

13. Lipson and Katzenbach, *Report to the National Aeronautics and Space Administration*.

14. Ibid., 22.

15. UN General Assembly Resolution 2222 (XXI), *Treaty on Principles Governing the Activities of States in the Exploration and Use of Outer Space, Including the Moon and Other Celestial Bodies*, entered into force October 10, 1967. Accessed August 2008 at http://www.unoosa.org/oosa/en/SpaceLaw/treaties.html.

16. UN General Assembly Resolution 2345 (XII), *Convention on International Liability for Damage Caused by Space Objects*, entered into force September 1, 1972. Accessed August 2008 at http://www.unoosa.org/oosa/en/SpaceLaw/treaties.html.

17. This discussion draws on the paper by Henry R. Hertzfeld and Frans G. von der Dunk, "Bringing Space Law into the Commercial World: Property Rights Without Sovereignty," *Chicago Journal of International Law* 81, no. 6 (2005). Accessed August 2008 at the Space Policy Institute Web site www.gwu.edu/~spi. It draws as well on the summary discussion of contemporary issues for commercial interests regarding space law in Lewis D. Solomon, *The Privatization of Space Exploration: Business, Technology, Law and Policy* (New Brunswick, NJ: Transaction Publishers, 2008), 95–112.

18. As described by Hertzfeld and von der Dunk, "Commercial space today is dominated by communications satellites owned by private companies or national governments. These national governments and the International Telecommunications Union…allocate the right to use spectrum to these communications satellites. Although this right to use the spectrum is not exactly a traditional property right, it does grant the use of a limited resource in space for business purposes for the lifetime of the particular satellite proposed to be used" ("Bringing Space Law into the Commercial World," 2).

19. See the discussion of this history in Andrew G. Haley, *Space Law and Government* (New York: Meredith Publishing, 1963), 280–94. See also Charles R. Phillips, *The Planetary Quarantine Program, Origins and Achievements*, NASA SP-4902 (Washington, DC: Government Printing Office, 1974). Accessed August 2008 at http://history.nasa.gov/SP-4902/sp4902.htm.

20. See, for example, Mark Williamson, *Space: The Fragile Frontier* (Reston, VA: American Institute of Aeronautics and Astronautics, 2006).

21. Information provided by Mike Machat, editor in chief, *Wings and Airpower* magazine, and a professional air and space illustrator, e-mails to author, July 2007 and January 2009. Machat had been inspired to become an air and space illustrator by having seen as a young person George Akimoto's work. He worked closely with Mr. Akimoto as a staff artist at Douglas from 1977 to 1983.

22. The first chapter of *A U.S. Army Study for the Establishment of a Lunar Outpost* is posted at http://astronautix.com/articles/prorizon.htm. Military installations on the Moon were proscribed by the United Nations' Outer Space Treaty of 1967.

23. A detailed profile of 2008-era commercial space projects is the substance of Solomon's *Privatization of Space Exploration*. See also the Web sites for the referenced companies, i.e., www.virgingalactic.com; www.bigelowaerospace.com; www.spaceadventures.com. Space X is another aerospace company that is making incredible leaps toward affordable private launch services, but its business is aimed at servicing industry rather than the public.

24. Hermann Noordung, *The Problem of Space Travel: The Rocket Motor*, trans. and ed. Ernst Stuhlinger and J. D. Hunley, with Jennifer Garland, NASA SP-4026 (Washington, DC: Government Printing Office, 1995). Published originally in German in 1929.

25. The early articles from *Collier's* were expanded and collected in the book *Conquest of the Moon* by Wernher von Braun, Fred L. Whipple, and Willy Ley, and edited by Cornelius Ryan (New York: Viking, 1953). The space station and the phrase "synthetic gravity" appear on page 11.

26. House Committee on Astronautics and Space Exploration, *The Next Ten Years in Space 1959–1969*, 86th Cong., 1st sess., 1959.

27. The story of how the wheel design was developed, established, and set aside, and the design history of the space stations that replaced it, is well told by Howard E. McCurdy in *The Space Station Decision: Incremental Politics and Technological Choice* (Baltimore: Johns Hopkins University Press, 1990). A complete cultural, visual, and technological history of space stations is told by Roger Launius in *Space Stations: Base Camps to the Stars* (Washington, DC: Smithsonian Books, 2003).

28. See RAND Corporation, *Proceedings of the Manned Space Stations Symposium* (Santa Monica: RAND Corporation, 1960).

29. Arthur C. Clarke, *Going Into Space* (New York: Harper & Brothers, 1954).

30. Kim Stanley Robinson, *Red Mars* (New York: Bantam Books, 1993); *Green Mars* (New York: Bantam Books, 1994); *Blue Mars* (New York: Bantam Books, 1996).

31. Fred A. Muckler, "Living in Space" (lecture, the Martin Company, March 2, 1960). An illustration of a lunar habitation module in the lecture strongly resembles the module shown on page 176 in this book.

32. Arthur C. Clarke, *The Exploration of Space* (New York: Harper & Brothers, 1951), 113.

33. Douglas Aircraft Company statement to U.S. Congress, October 15, 1965, in House Committee on Science and Astronautics, Subcommittee on NASA Oversight, *Future National Space Objectives*, 89th Cong., 2nd sess., 1965, 237–38.

34. See, for example, the illustration of a cutaway view of the underground facilities at a Titan II launch complex in David K. Stumpf, *Titan II: History of a Cold War Missile Program* (Fayetteville: University of Arkansas Press, 2000), 104.

35. Gerard K. O'Neill, *The High Frontier: Human Colonies in Space* (New York: William Morrow, 1977). Stewart Brand, *Space Colonies* (New York: Penguin, 1977).

36. "Biosphere for 10 Billion People Predicted," *Los Angeles Times*, May 28, 1978, Part 1-A, 7.

37. Solomon, *Privatization of Space Exploration*, 36, 81.

38. James Fleming, "A 1954 Color Painting of Weather Systems as Viewed from a Future Satellite," *Bulletin of the American Meteorological Society* 88, no. 10 (2007): 1525–527.

39. The first photographs of Earth as seen from orbital space were taken by the *Explorer 1* satellite in 1958.

40. See Robert Poole, *Earthrise: How Man First Saw the Earth* (New Haven and London: Yale University Press, 2008).

41. Ibid., 56.

42. Ibid., 152.

43. Ibid., 13.

44. Brad Stone, "A Google Competition, with a Robotic Moon Landing as a Goal," *New York Times*, February 22, 2008, B-1.

5. MID-CENTURY MODERN SPACE

1. Arthur Hawkins, ed., *Illustrators '59: The First Annual of American Illustration* (New York: Hastings House, for the Society of Illustrators, 1959), 99.

2. Steven Heller, "Advertising: The Mother of Graphic Design," in *Graphic Design History*, ed. Steven Heller and Georgette Balance (New York: Allworth Press, 2001), 295.

3. The CCA ad campaign is analyzed in Michele Helene Bogart, *Artists, Advertising, and the Borders of Art* (Chicago: University of Chicago Press, 1995).

4. Larissa Alekseevna Zhadova, ed., *Tatlin* (New York: Rizzoli, 1988), 345.

5. Margit Rowell, "Constructivist Book Design: Shaping the Proletarian Conscience," in *The Russian Avant-Garde Book 1910–1934*, ed. Rowell and Deborah Wye (New York: Museum of Modern Art, 2002), 51.

6. Drucker and McVarish, *Graphic Design History*, 158.

7. *Fantasia*, feature film produced by Walt Disney Studios (1940). The "Intermission/Meet the Soundtrack" sequence was animated by Joshua Meador and directed by Ben Sharpsteen and David D. Hand.

8. Warren Hanford and Barbara G. Bell, *Modernist Themes in New Mexico: Works by Early Modernist Painters* (Taos, NM: Gerald Peters Gallery, 1989).

9. Bogart, *Artists, Advertising, and the Borders of Art*, 291.

10. *Art and the Atom: An Exhibition of Contemporary Art Used in Scientific Advertisements*, catalogue for an exhibition of paintings selected by Robert Meier of Los Alamos Scientific Laboratory (Taos, NM: Stables Art Gallery, c. 1963), p. 1 (unpaginated).

11. Ibid., p. 8 (unpaginated).

12. Quoted in "Mark Rothko, Artist, A Suicide Here at 66," *New York Times*, February 26, 1970, 38–39. The authors had originally written a letter to the *Times* in June 1943 responding to a critique of their work expressed by the critic Edward Alden Jewell, published June 2, 1943 ("Modern Painters Open Show Today").

13. Lloyd S. Swensen Jr. and James M. Grimwood, *This New Ocean: A History of Project Mercury*, NASA SP-4201 (Washington, DC: Government Printing Office, 1966), 70, 73. See also Charles LaFond, "Avco Develops 3-D Space Tracker," *Missiles and Rockets* 11, no. 9 (1962): 33–36.

14. Stumpf, *Titan II*, 2–3.

15. The Martin Company, *The Story of a Giant*, promotional booklet, 1960.

16. Stumpf, *Titan II*, 64.

17. George E. Mueller, "NASA Learning from Use of Atlas and Titan for Manned Flight," including "Summary Learning from the Use of Atlas and Titan for Manned Flight," reprinted in *Exploring the Unknown: Selected Documents in the History of the U.S. Civil Space Program, vol. IV: Accessing Space*, ed. John M. Logsdon et al., NASA SP-4407 (Washington, DC: Government Printing Office, 1999), 81–85.

18. Heather M. David, "Atlas, Titan II to Aid 'Hitchhikers,'" *Missiles and Rockets* 11, no. 6 (1962): 39–40.

19. Quoted in *Looking Closer 3: Classic Writings on Graphic Design*, ed. Michael Beirut, Jessica Helfand, Steven Heller, and Rick Poynor (New York: Allworth Press, 1999), 97.

20. Willi K. Baum, conversations with author, February, March, and August 2009.

21. Martin Company, *The Story of a Giant*.

ACKNOWLEDGMENTS

This book is the result of a rigorous learning process that took place between early 2006 and late 2009. During that period I went from being a fan to a contributor to the world of space history, and the learning curve was steep. The work would not have been possible without the assistance of many generous individuals along the way. Professional space historians in particular were extremely helpful with their time and knowledge. I've also benefited greatly from the counsel of aerospace industry professionals, design historians, space artists, archivists, librarians, and friends. Many people sat for interviews and gave me a window on an era that I could not see for myself. Several people read early drafts of chapters and gave thoughtful commentary that led to more mature finished versions.

Four people deserve special acknowledgment: Historians Roger Launius and Howard McCurdy generously shared both time and constructive criticism. Glenn Bugos gave research assistance and introduced me to the community of professional space historians. The graphic artist Willi K. Baum opened his entire portfolio to my research and allowed his memories and experiences to become anchor points in the book's narrative. My deepest thanks to all of them.

The following aerospace engineers, industry historians, industrial advertisers, and historians of art and graphic design made themselves available for substantial interviews that were critical to the book's development: Diane Bertolo, Val Corradi, Mike Davis, Carolina de Bartolo, Mike Machat, Steve Massey, Milton Minneman, Michael Patterson, and Elizabeth Prelinger. Those who helped by responding to queries and pointing the way to informational sources include: Charlene Anderson, Mike Boss, Heather Childress, Steven J. Dick, George Dyson, James Fleming, Bob Guerrini, and Tad Trainor.

The following artists, writers, researchers, and science fiction experts each contributed either research assistance or critical feedback on chapter and section development: Christa Aboitiz, Amy Balkin, Tim Caldwell, Mike Deckinger, Sandi Deckinger, Yves Feder, Maryanne Galvin, Pamela Jackson, Gabrielle Teschner, and Gary Wolf.

For assistance at institutional archives I offer my appreciation to Marge McNinch and the staff at the Hagley Museum and Library; Smithsonian National Air and Space Museum archivists Allan Janus and Melissa Keiser; the librarians at California College

of Arts; Julie Cooper at JPL; and Rebecca Collinsworth at the Los Alamos Historical Society. The NASA history department staff was also extremely supportive.

Thanks to Polly Prelinger and to Elizabeth Prelinger and Steven, Benjy, and Fred Messner for logistical support during research trips to Washington, D.C.

I tremendously appreciate the opportunity to collaborate on this volume with Blast Books.

The artists Nora Ligorano and Marshall Reese were supportive at a critical formative phase of the project. Craig Baldwin (Aerojet specialist) and the ATA community supported public presentations of work in progress. Special thanks to the Prelinger Library community of volunteers, regulars, and friends, and to my family. Spouse Rick Prelinger contributed research and editorial assistance, and moral support, on a scale that dwarfs the contributions of all others.

INDEX